UNDERSTANDING ART OBJECTS

Thinking through the Eye

UNDERSTANDING ART OBJECTS

Thinking through the Eye

Edited by
TONY GODFREY
with essays by
Megan Aldrich
Carrie Rebora Barratt
David Bellingham
Elisabeth Darby
Anthony Downey
Tony Godfrey
Juliet Hacking
Julia Hutt
James Malpas
Catherine Morel
Anna Moszynska
Eugene Tan
Bernard Vere

Lund Humphries

First published in 2009 by Lund Humphries
in association with Sotheby's Institute

Lund Humphries
Wey Court East
Union Road
Farnham
Surrey GU9 7PT
UK

Lund Humphries
Suite 420
101 Cherry Street
Burlington
VT 05401-4405
USA

www.lundhumphries.com

Lund Humphries is part of Ashgate Publishing

Sotheby's Institute
30 Bedford Square
London WC1B 3EE
UK

Sotheby's Institute
570 Lexington Avenue
New York
NY 10022
USA

Sotheby's Institute
82 Telok Ayer Street
#02-02 Far East Square
048467
Singapore

www.sothebysinstitute.com

British Library Cataloguing in Publication Data

Understanding art objects: thinking through the eye
 1. Art appreciation. 2. Art objects. 3. Aesthetics.
 I. Godfrey, Tony.
701.1-dc22

ISBN: 978-1-84822-016-4

Library of Congress Control Number: 2009920796

Edited by Richard Mason
Designed by Yvonne Dedman
Set in Fournier and Formata
Printed in Singapore

Contents

Preface 7

Introduction

Tony Godfrey What, Where and When: How and Why We Look at Works of Art 8

Section I: WHAT? 21

Carrie Rebora Barratt John Singleton Copley's Miniature Self-Portrait and Portrait of Moses Gill 23

Megan Aldrich The Countess of Dysart's Backstools 31

Julia Hutt What's in a Box? The Many Layers of a Seventeenth-Century Lacquer Casket 43

Eugene Tan Joseph Kosuth's *One and Three Chairs*, 1965 53

Tony Godfrey David Reed: *No. 286-2*, 1990–2 62

Section II: WHERE? 73

Catherine Morel *A L'Enseigne de Gersaint* by Jean-Antoine Watteau: From Shop Sign to Masterpiece 75

James Malpas *Kabuto* with Symbolic Tower and *Kazari*: Displaying the Decorative in Edo Japan 83

Juliet Hacking The Eroticised Victorian Child: Mrs Holford's Daughter 93

Anthony Downey *127 Cuerpos*: Teresa Margolles and the Aesthetics of Commemoration 105

Section III: WHEN? 115

David Bellingham The Jenkins Venus: Reception in the Art World and the Market 117

Bernard Vere On the Wings of a Dove: Jacob Epstein's *Doves – Third Version*, 1914–15 132

Elisabeth Darby Marcel Breuer's *Wassily* Chair: A Design Icon of the 1920s 145

Anna Moszynska Gerhard Richter's *Tante Marianne* Revisited 159

Further Reading 172
Index 174

Preface

The teaching of art history has many approaches. Since the days of Giorgio Vasari in the sixteenth century, it has been the perceived duty of the art historian to describe artists and keep them and their work from being forgotten. In the interval between Vasari and the present time, a great many writers about art, including Giovanni Pietro Bellori, Sir Joshua Reynolds, Johann Winckelmann, John Ruskin, Erwin Panofsky and Ernst Gombrich, have modified that view, but all would agree that one of the primary purposes of teaching art history is to open our eyes to works of art.

This book sets about doing precisely that through the description of 13 very different works of art. The authors are all from the same generation and teach at Sotheby's Institute, and yet how diverse are their approaches and how instructive are these differences? Decoding works of art, as we discover, can take many forms. The first essay is about the creative process and technique, the second introduces us to the history of taste. Others are concerned with the iconography of death and eroticism or the idea of art as a reflection of philosophical ideas, for instance how Gerhard Richter uses memory as a metaphor for collective history. We come back to earth to examine objects of apparent utility like helmets and chairs, but even they are the subjects of intense ritualistic and aesthetic concern.

As befits a book that bears Sotheby's name, one of the essays examines the triangular relationship between artist, dealer and collector: Jean-Antoine Watteau, Edmé-François Gersaint and Frederick the Great. That relationship touches another striking point about most of these essays, which reflects the curiosity of our own time. They nearly all describe the history of the object since its creation. This can be the way in which a work of art has been physically altered, but is more likely to be concerned with changing attitudes, sometimes economic, sometimes cultural. Art mutates and so do we, which is part of the process of learning.

There is much here to meditate on.

James Stourton
Chairman, Sotheby's UK

INTRODUCTION:

Tony Godfrey

What, Where and When: How and Why We Look at Works of Art

What, where and when? Those are the three major questions we ask when we look at any work of art. What are we looking at? Where are we looking at it? When are we looking at it?

Let me expand. What is it we are looking at? What sort of object is it? How is it made? If there is an image, what is it of? The way a thing is made may tell us a story about why it was made and what it means. Moreover, not only will looking hard and from different angles, literally and figuratively, lead us to new discoveries about an object, but it will often introduce us to new visual pleasures.

Where are we looking at it? Context determines a lot of our experience. Most of what we see as art today is in the wrong context: no-one making a chair or a lacquer box in the seventeenth century thought they were making something that would end up in the Victoria and Albert or the Cooper Hewitt museum. Raphael and Rembrandt did not paint to be shown in the National Gallery or the Metropolitan Museum of Art. Raphael was making things for churches and palaces: to be worshipped and adored, or else admired by the members of a privileged, aristocratic and intellectual elite. Rembrandt made objects for upper middle-class homes, things to be seen in a private environment. Chairs were made if not to be sat on, at least to be part of a domestic interior.

When? Objects change: they discolour, crack, warp, fade, fox and oxidise. They get cropped, polished, repaired, restored and vandalised. We, their owners, change even more; we forget their titles, their authors, their very purpose and meaning. The very philosophies by which we lead our lives change; we can no longer know or see those artworks in the same way as our forefathers and mothers did. Seeing a religious painting by Raphael today is not the same as seeing it as a practising Catholic would have done in 1500; the Reformation and the invention of photography have changed how we view religious images irrevocably.

If the past is a foreign country then all artworks come from that place. Are they then strangers to us, immigrants who will never learn our language? (Paradoxically, contemporary artworks can seem to be the opposite, to be messengers from that other foreign country, the future, bearing a report from the advanced guard – the 'avant-garde' – as to what lies ahead. Hence the particular excitement that contemporary art holds for us: its aura of the new and imminent.) The taxonomies of museums, where each type of object is pigeonholed into an established category, and the master narratives of history and theory, are all necessary mechanisms to give the 'strangers' a place; but putting art objects in place can be like putting hens in a battery or links in a chain – a restrictive

practice. Walking through any museum or any collection with one's senses awake and with a receptive mind tells us contrarily that art objects can be unpredictable, intriguing, surprising. An encounter with an art object by an attentive viewer is an encounter with that which is strange.

How do we experience artworks? Merely as information received just as when slouching passively on the sofa we are told by the TV (not always a presenter, perhaps teletext) that it will rain tomorrow? Or as a curious complex of experiences – of questions that need to be answered? What, where and when? The fourth question is of course 'How?' How do we actually look at and think about art? How do we rehearse and choreograph our encounter with the art object. How, crucially, do we talk and write about art?

These essays come from a teaching institute where the emphasis is on direct experience, on beginning neither with theory nor social history but just such an encounter with the actual physical object. The genesis for the Institute of Art was the concern of Sotheby's auction house that university art history courses had become too theoretical in their approach and were no longer directly training students to work in the professional art world. A more practical training course for future auction house experts was therefore launched in 1969. Students would learn by going to museums and the salerooms and looking hard at various objects, discussing them and then researching about them. Lectures of course backed this up. In this way of teaching the object was not the QED at the end of an argument, but the very beginning of the argument. The object in effect created the questions: 'How large? How old? Is it a fake? Who was it made for? Why? What does it mean? What else can we do to understand it?' This was historically a moment when there had been a shift in universities away from connoisseurship to the 'New Art History' where greater emphasis was laid on theory (feminist, psychoanalytical, etcetera) and social history. Indeed, as exemplified by Denis Mahon's 1947 book *Studies in Seicento Art and Theory*, even 'traditional' art history had for some time given a special emphasis to primary *literary* sources, to what was written about a work or type of art at the time of its making and initial reception.

Over the years this 'practical' course at Sotheby's developed into a group of fully fledged academic M.A. programmes at a separate Institute, validated by the University of Manchester, and shorter courses all at a separate site in central London. All these courses are ultimately based on an approach that has sometimes been called object-based, or ekphrastic.[1] The ekphrastic approach assumes that the best way to begin an examination of an artwork is to look closely and describe it. However, as will become evident in reading these essays, this is not 'head-in-the-sand, I only want to look at art' dilettante connoisseurship, for a discussion that begins as an encounter with, and analysis of, an art object may often go deep into social history or theory. Many of the writers come from a

background where theory or an emphasis on social history has been privileged. They do not abjure that background; rather they combine it with some traditional and some innovative ways of getting to know and explain the art object. Any decent art object has the potential to send the thoughtful viewer on more than one mental journey: There are always many journeys to be made.

Indeed it is very evident looking within this volume that, apart from a shared commitment to look attentively at individual works of art, there is a great variety not only of approaches but of voices; these vary from the formal to the informal, from the expository to the disputatious. For some the most profitable response to looking at and experiencing the art object is to think in terms of theory, for others it is to place the work in social history, and yet for others it is to search the archive for details of the commissioner, the receipt and so on. All these and other developments have validity – and are not, of course, mutually exclusive. Writing about an artwork is a conversation with an object. Therefore the tone of voice, the personality of the viewer or conversationalist who writes is an important factor too, for reading itself is not just a matter of decoding data but an experience in its own right.

We hope that this book gives some of the flavour of how we teach; for us the visit to the museum, gallery or auction house is our primary mode of teaching. Teaching can bring artworks to life but it also has the ability to kill them – to make their strangeness pedestrian, to reduce them to a point where they are nothing more than an illustration of social history or the confirmation of a theory. Teaching can also make the student's eye lazy. Being told explicitly and dogmatically what one is seeing is a tyranny; but discussing amongst ourselves what it is we are seeing is liberating. The goal is to enable students to engage with an artwork themselves, to have their own dialogue with it.

There are perhaps a surprising number of essays in this book on contemporary art, something that reflects its enormous popularity at this moment in time. (We now run M.A. programmes specifically on Contemporary Art in London, New York and Singapore.) But it also reflects the possible fact that the paradigm for art is no longer the Old Master painting but the contemporary art object: no longer a portrait by Rembrandt or a Madonna by Raphael but a dead shark by Damien Hirst or Carl Andre's *Equivalent VII* (120 firebricks arranged in a low rectangle). Contemporary art asks the sort of questions I have outlined above more explicitly than earlier art. It tends to be confrontational, is not based on that shared ideology of earlier centuries, and may not have the same aspiration to craftsmanship and beauty; it would be perverse to consider the object that Anthony Downey discusses in his essay in traditional terms of connoisseurship, 'these elegant twists of hessian and plastic string'. As I have suggested elsewhere,[2] the conceptual work of art (and since 1968 much art is, if not conceptual, made under its star)

functions as a question rather a statement, not assuming the viewer's acceptance of its status as a work of art (whether painting, sculpture, or fine porcelain) but rather asking, 'If I am an art object, what is art?'

The clamorous activity of the contemporary art market in recent years, and its carnival of novelties, has seduced many people into thinking that older artworks are less interesting. They may be less demanding of our attention, but like an old person with a fund of stories they are equally pertinent and interesting if one stops to listen. A well-rounded understanding of visual culture encompasses both old and new. Put simply, we learn a lot about contemporary art and design from studying older objects, just as thinking about contemporary art and design helps us experience old things more fully. For example, consider what at this moment I am holding in my hand (fig.1).

What is it? It is a small black and white print, less than 7 by 5 inches, made around 1580 by Hendrik Goltzius (1558–1617). In it a woman sits in a high-backed chair, leaning somewhat uncomfortably forward. Her hands are held together in rather an odd way with the right forefinger only on top of the left hand. In front of her is a table with a tablecloth and on it a book, probably a devotional book. She is presumably sitting outside by the corner of a stone building, as behind her, engraved more faintly, is a town with an onion-domed church and a stork's nest on one chimney top. Her dress is engraved with the greatest precision. Beneath the image is a Latin text which translates as: 'What do the ravages of time not injure? Our parents' age (worse than our grandparents') has produced us, more worthless still, who will soon give rise to a yet more immoral generation.'

What am I looking at? And how? I admire the skill. By 1580 Goltzius was at the beginning of a career that was to see him acknowledged as the pre-eminent printmaker of his time, perhaps the most skillful and innovative engraver ever. His international fame was such that when ten years later he went to Italy he had to go in disguise so as not to be recognised.[3] But something bothers me: if Goltzius was such a brilliant draughtsman, why is the head so awkwardly placed on the neck? Why such a clunky mistake by such a sophisticated artist? Roland Barthes writes of the *punctum* in those photographs that fascinate us, the element that stands out from the picture and gets our attention, or rather the element that bothers us and keeps catching our eye: 'A photograph's *punctum* is that accident which pricks me (but also bruises me, is poignant to me).'[4]

This awkward placement of the head on the neck seemed the *punctum*, but it transpired to be a false *punctum*. It was only when I started to research the print that I found the true *punctum*, the one that eventually caught and held my eye. What I had seen first was the fourth state of the print (which I own). The first state was a trial proof for Goltzius himself before he had engraved the background: only one impression of it exists. For the second state he engraved the background and changed the orientation of

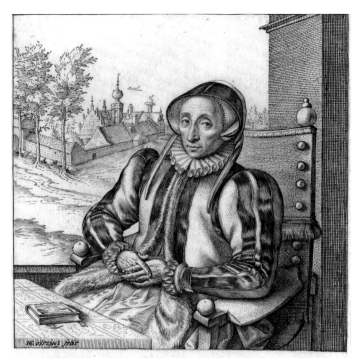

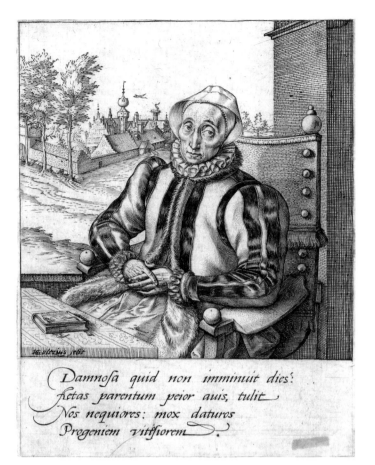

the body. This state was editioned (fig.2). But, and this is exceptional in Goltzius' extensive oeuvre, in a subsequent third state he changed the head entirely, so that it was younger and faced the viewer more directly. In the fourth and final state the nose is adjusted to be a little more rounded – an extraordinarily small and punctilious change.

This true *punctum* for me was a very personal one. The face, in the second state, was of the same woman but older, gaunter, and looking at one directly. It was a look eerily reminiscent of my own mother's when she became old and ill: weak-eyed, tired, half-vacant, half-worried. Was this a purely subjective, personal response on my part? How did such a response fit with my delight in, above all, the twiddly bits, the curlicues on either side of the inscription?

Who was the woman? Because of a handwritten inscription on a preparatory drawing, the image until recently was thought to be of Goltzius' mother-in-law, Agatha Scholiers. But that was not his mother-in-law's name. One impression has been annotated with the claim that this was an image of his actual mother, Anna Fullings. This accords with the inscription and is now generally accepted as correct. That there are also, uniquely in the artist's oeuvre, two preparatory drawings for this print suggest the sitter was readily available. It also seems probable that as Goltzius had recently made prints of his father

Left and right:

1. Hendrik Goltzius, *Portrait of Anna Fullings (The Artist's Mother)*, fourth state, *c*.1580
Engraving, 16.1 x 11.9 cm (6⅓ x 4⅝ in)
Courtesy of the Trustees of the British Museum

2. Hendrik Goltzius, *Portrait of Anna Fullings (The Artist's Mother)*, second state, *c*.1580
Engraving, 16.1 x 11.9 cm (6⅓ x 4⅝ in)
Courtesy of the Trustees of the British Museum

and wife, he would make one of his mother. That he should change it so much indicates that it was unusually important to him – but also highly problematic. The consensus is that the town behind is Kleve where she originated.[5] That the image therefore mattered so much to him, that it was of personal significance, would explain why he kept reworking it. Did his mother ask to be shown as younger or did he feel bad about making her look so vulnerable? Did the image need cheering up to make it more commercially viable? One doubts that: it was never going to make the cheese-cake shelf.

Artworks tell us as much by what they conceal as they expose: the mistakes and *pentimenti* in paintings, the altered states in prints like this. Just like Freudian slips they can 'let the cat out of the bag'. The drive towards realism that we find throughout Goltzius' career was not compatible with the public's desire for images of dignity, or *gravitas*. How his mother actually looked could not accord with the tropes of sixteenth-century portraiture. Can we not hypothesise that he was both changing the image to a more normative one for his period and enacting some personal act of compensation and filial love?

But as always in art the secret is in the making, and we should remember here that engraving, cutting directly into a sheet of copper, was a hard, slow and exhausting process. Goltzius did not only change the face but extended the six curlicues that begin or end the lines of poetry. (Curiously this is not mentioned in the literature.) Perhaps it is easier for someone like myself, who is not a sixteenth-century expert but engaged primarily with contemporary art, to see this as gesture. There was no need here for any filling in or extra ornamentation, or a further demonstration of his virtuosity. Do these flourishes not rather act as his commentary, however elliptical, on the image? Are they not the stuff of *jouissance*, either needed as gaiety to offset the gloomy sententiousness of the motto or to show his love of his mother?

We began with a simple image that probably does not seem to 'speak' to a twenty-first-century viewer. Nonetheless, by looking and thinking and asking questions we have arrived at a nexus of important issues: the meaning of gesture or ornamentation, the relationship of artistic process to personal emotions, the love of a son for his mother – or his guilt.

Where? I experienced this print in my sitting room with it literally held in my hand. It is difficult to think of a more intimate setting, but nowadays we normally expect to experience art in the art museum, a context that as we have already noted can sanitise it and reduce it to the state of being, as it were, in quotation marks, 'another artwork', 'a mannerist print', 'a post-feminist photograph'. Whether by the typologies of the traditional art museum or by the thematic presentations of more contemporary curators, artworks are put in a specific place. They are thereby made more readily understandable

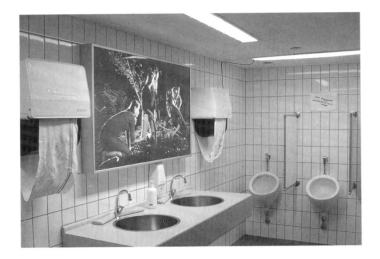
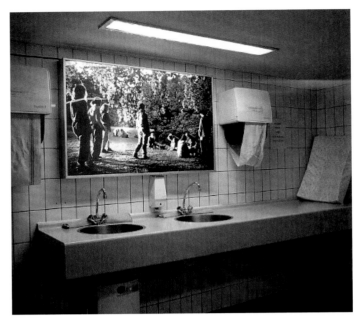

but the strangeness of each artwork and its uniqueness can be lost. But when we discover art in the 'wrong' place, we can experience a welcome uncertainty that allows all sorts of other questions to surge into our consciousness.

Where would one least expect to find a serious work of art? Perhaps in the toilet of a McDonalds in a shopping mall. In 2001 the American photographer Justine Kurland (b.1969) placed photographs from her series *Operation Girls in Park* (figs 3, 4) exactly there, as part of the 7th Sonsbeek exhibition in the Dutch town near Arnhem. Where previous exhibitions had sited work either in Arnhem's town centre or its Sonsbeek park, the curator Jan Hoet sited work in the suburban Kronenburg shopping mall. It is difficult to imagine a more difficult venue, for a shopping mall bombards one with images of products and lifestyle.[6] Where one finds imagery in a public or restaurant toilet it is normally associated with advertising, for contraceptives, tampons, or cleaning products. Kurland's images referred to advertising but advertised nothing. Set on lightboxes over washbasins, so they shone or glowed like those in a travel agent's, they projected images out into our space of nice Dutch girls planting tulips in parks. Like several other photographers of her generation, Kurland had become well known for photographing teenage girls at that moment between girlhood and womanhood. Very often, having seen some scene she would restage it with her models and photograph that. They were images that suggested notions of innocence, beauty and community. Her project here had been to photograph 100 teenage Dutch girls planting tulips in the park where most of the Sonsbeek exhibition of 2001 took place.

Looking at any of these images, one realises fairly quickly that the girls are posed quite deliberately. Is this an advertisement for the outdoor life, a celebration of womanhood, or is it an ironic statement? Kurland deliberately echoes Claude Lorraine's idyllic

Left and right:
3. Justine Kurland, *Operation Girls in Park*, 2003, as shown in Kronenburg Shopping Mall, Arnhem
Cibachrome transparency back-illuminated with fluorescent light and alumininium case, 76.2 x 101.6 cm (30 x 40 in)
Photograph courtesy of Sonsbeek

4. Justine Kurland, example of another *Operation Girls in Park*, 2003
Cibachrome transparency back-illuminated with fluorescent light and alumininium case, 76.2 x 101.6 cm (30 x 40 in)
Photograph courtesy of Sonsbeek

paintings of nymphs and swains wandering innocently in Arcadia. The meaning cannot of course be so easily summed up, for the meaning must be in our experience: our surprise and bewilderment at coming across the lightbox, the ideas it generates about the discomforting and somewhat squalid nature of the shopping centre.

The way things are changed by context is explored in a number of the essays that follow: obviously the work by Teresa Margolles discussed by Anthony Downey explicitly depends on its context to be recognised as art. The painting by Watteau discussed by Catherine Morel and the Kabuto helmet discussed by James Malpas are now safely ensconced and untouchable in museums, but once they had 'real' functions as a shop sign and headwear respectively.[7] As Juliet Hacking's essay on a *carte de visite* photograph demonstrates, where an image is meant to be shown and by whom can make it wholly innocent or horribly problematic. As Eugene Tan shows in his essay, where we see Joseph Kosuth's *One and Three Chairs* means we quite literally see a different thing! Similarly, although my essay on David Reed's *No. 286-2* is above all about looking at a work of art, I show how that act of looking is affected by the work's procession from one context to another. In Carrie Barratt's essay we see how the gold locket someone saw on a Portobello Road stall in London in 2005, though technically the same thing as what we now know as a rare John Singleton Copley in the Metropolitan Museum of Art, has miraculously changed from being a mere knick-knack to an early masterpiece of American art.

When? One of the most revealing things is to see certain artworks periodically. They do not normally change but our experience of them changes. Partly this is because one is growing older, hopefully more knowledgeable, more subtle in one's understanding, but it is also because one's society is changing. Think of how the attitudes about looking at images of beautiful young women have changed in the last 50 years; paradoxically, on the one hand we see nowadays an avalanche of eye candy, on the other the strictures of political correctness. I exaggerate of course, but our attitudes to many types of image and our consumption of them have changed and continue to change. An obvious example is how hard it is after years of media exposés to look at images of children as mere pictures of innocent charm rather than incitements to paedophiles. Juliet Hacking in her essay discusses this problematic issue very clearly.

Even if an artwork hasn't physically changed, its status or function often has. It may be the same but we cannot experience it as the same. One thing that as teachers we try to do is recover that original experience: what did Lorenzo de Medici think when he first saw Michelangelo's sculptures? How did a person in 1950 wandering into the studio of Mark Rothko (1903–1970) experience his painting *White Center (Yellow, Pink and Lavender on Rose)* (fig.5)? Very differently from someone seeing it in Sotheby's viewing

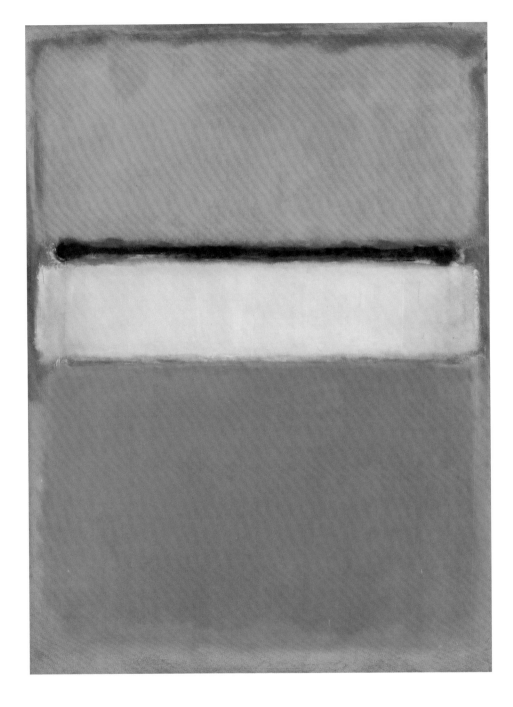

space at York Avenue, New York, in 2007 (fig.6). Very differently from how many experienced it after it sold for the then record price of $72,840,000.

Money does not change works of art but how we see them. I once met someone who had some years earlier bought a painting from a student exhibition at the Royal College of Art. He liked the painting and when the student who had painted it – who was called David Hockney – started to become famous he felt his taste had been vindicated. But as Hockney became more and more famous and his works became expensive, my

acquaintance started to become aware that the painting was valuable. Eventually, when he looked at the wall on which it hung, all he could see was in effect a bundle of ten-pound notes hanging there.

Money can, like it or not, invest an artwork with a sort of aura: $72,840,000 is a lot of money. It certainly makes us stop and look. In 1950 with the sale of *Number 1, 1949* to John D. Rockefeller III's wife Blanchette Ferry for a princely $1,000, the prices of Rothkos had moved into four figures; by 1960 when this painting was sold by Sidney Janis to David Rockefeller (John III's brother), Rothko's paintings were selling for on average $7,500. The mind boggles at this near million per cent return, at this outrageous investment – but that mind-boggling makes it very difficult for us actually to *see* or *experience* the painting.[8] We have to stand back, put our fascination with prices temporarily to one side, think of the original or ideal setting for the work, and look again.

Rothko is famous for emphasising the emotional status of his works, describing them as 'skins that are shed and hung on the wall'.[9] There is a famous photograph of him in his studio in 1964 slumped in his chair smoking a cigarette and looking at one of his paintings, seemingly lost in its spaces. Communing with art was for him a singular experience: 'when a crowd of people looks at a painting, I think of blasphemy' he later said.[10]

6. Mark Rothko, *White Center (Yellow, Pink and Lavender on Rose)*, 1950, as shown at Sotheby's New York, 2007
© Kate Rothko Prizel and Christopher Rothko, 2009, photography courtesy of Sotheby's

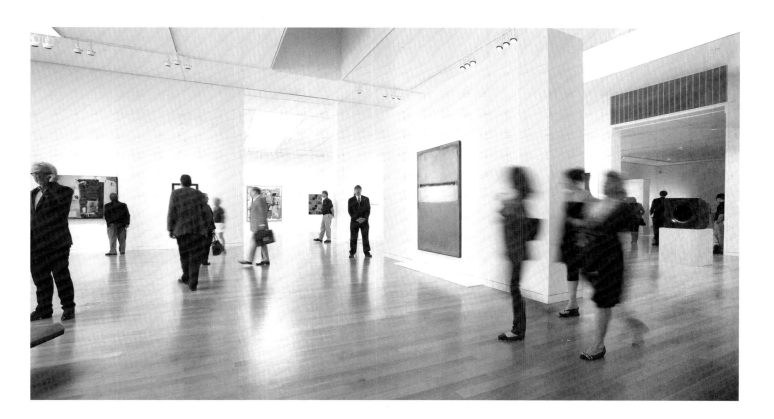

He was obsessed with his paintings as experiences rather than objects; he wanted them to be shown in the same domestic-sized room he had painted them in – very unlike the grand modernist space of York Avenue. He did not want them to be shown adjacent to the distracting and polluting presence of other art. He wanted the viewer to be immersed in them – 18 inches he once said was the ideal viewing distance.[11] The viewer was to be physically subsumed and then released in some way from his or her body. Increasingly through his career he wanted his paintings to be shown in low natural light:

> Since my pictures are large, colourful and unframed, and since museum walls are usually immense and formidable, there is the danger that the pictures relate themselves as decorative areas to the walls. This would be a distortion of their meaning, since the pictures are intimate and intense, and are the opposite of what is decorative; and have been painted in a scale of normal living rather than an institutional scale. I have on occasion successfully dealt with this problem by tending to crowd the show rather than making it spare. By saturating the room with the feeling of the work, the walls are defeated and the poignancy of each single work had for me become more visible.
>
> I also hang the largest pictures so that they must be first encountered at close quarters, so that the first experience is to be within the picture.[12]

But artists can rarely keep control of their work; although one may lament that so few of Rothko's paintings can be seen as he wished, one must accept that they change meaning with their context and time.

How works shift in meaning and significance with time is a subject touched on by many of the essays here. David Bellingham charts the extraordinary odyssey that a marble statue from Rome has made over two millennia. Elisabeth Darby likewise charts the peregrinations of a design classic since it was first made in 1925: its changes in status and function. Bernard Vere examines the subtle shifts within a two-year period of Jacob Epstein's life. Anna Moszynska looks at how a painting by Gerhard Richter can never seem the same once it has been revealed that it is a portrait of his aunt murdered by the Nazis. In an essay that centres on an intense examination of a cabinet, literally opening it up, Julia Hutt shows how both that work's physical state and its reception have changed.

And of course all these three questions – 'What? Where? When?', and that fourth question 'How?' – lead to the deeper and more important question: 'Why?' Why are we looking at a work of art? What is the nature of the experience we are having or could be having in looking at and thinking about it? I think this set of questions is implicit in all the 13 essays that follow.

Artworks can be windows into other worlds. Through the tiny ovals of Copley's miniatures we can see, as Carrie Barratt shows, colonial Boston in all its vigour,

ostentation and vanity. Through Megan Aldrich's analysis of a set of chairs we get an extraordinary view of how a seventeenth-century celebrity tried to present herself as ultra-chic. If artworks are windows, then art history and art criticism are what we need to pull the curtain on that window and let us see out and the light in.

Artworks are also normally products or commodities. As well as studying objects the Institute studies the business of art, and so it is fitting that two people involved in teaching such studies here look at two art objects. Catherine Morel shows us that a Watteau painting and its sale were themselves a reflection on the trader, while David Bellingham demonstrates that 'The Jenkins *Venus*' was irretrievably changed by the art trade – indeed in some respects invented by it. As we have seen with Rothko's painting, the transaction of valuing and selling an art object changes it.

But whether one will eventually focus, as writer or viewer, on history or value, whether one will focus on where and when, on the spatial or temporal context of a work and its meaning, one must always begin by looking and describing. Whether it be something as clearly 'art' as the miniature analysed by Carrie Barratt or something that initially seems as clearly not 'art' as the chair analysed by Eugene Tan, one always starts in front of the object, looking. Looking at the object and asking questions: or rather being asked questions by the object. 'What am I? Who do I represent? Who made me? For whom? Why?

NOTES

1. The term derives from the Greek *Ekphrasis*, a poetic description of an artwork.

2. Tony Godfrey, *Conceptual Art* (London: Phaidon, 1998), p.6.

3. Goltzius is also now seen as an innovator of colour woodcuts and a notable predecessor of seventeenth-century Dutch landscape and realist interior scenes. The paintings on which he concentrated almost exclusively after 1600, specialising in marmoreally pallid nudes and intense devotional images, have also received attention.

4. Roland Barthes, *Camera Lucida* (New York: Hill and Wang, 1981), p.27. Barthes also writes at the end of his meditation on photography: 'I now know that there exists another *punctum* than the "detail". This new *punctum*, which is no longer

of form but of intensity, is Time, the lacerating emphasis of the *noeme* ("that-has-been") its pure representation.' (p.96).

5. It also proved a hostile environment, many of the artworks being vandalised during the exhibition.

6. For example, by Rineke Dijkstra, Anna Gaskell, Sarah Jones, etcetera.

7. If the Watteau painting discussed in this volume by Catherine Morel were to come to market, it would probably cost more for it is an iconic and wholly unique painting. In this exceedingly unlikely event (for it is securely in a museum), its price would affect how we saw it, at least initially. Paintings by Watteau are very rare: the last time one came to auction (8 July 2008) it sold for £12,361,250 – but it was a very small

painting, a mere fiftieth the size of that discussed by Morel. (In contrast the Goltzius print I discussed above, which I purchased for 500 euros, is the cheapest object in the book.)

8. Quoted in James E.B. Breslin, *Mark Rothko: A Biography* (Chicago, IL: University of Chicago Press, 1993), p.418.

9. Quoted in John Fischer, 'Mark Rothko: Portrait of the Artist as an Angry Man', *Harper's Magazine*, vol.241 (July 1970), p.18.

10. Breslin, *op. cit.*, p.281.

11. Rothko to Katherine Kuh: letter of 25 September 1954, Art Institute of Chicago archives. Quoted in David Anfam, *Mark Rothko* (Yale University Press, 1998), p.75.

12. *ibid.*

David Reed, *No. 286-2*, 1990–92, as installed
in the Todd Gallery, London, 1994 (see fig.29)

Section I: WHAT?

'They have the concentration span of a gnat!' is a common sigh of despair by teachers today. The classic Hollywood shot used to be 8–10 seconds which was, more or less, the time that the average person would spend in front of a painting in the National Gallery or the Metropolitan Museum of Art. It is probably much less now. We live in a fast media culture where we can take a photo on our mobile phone and send it to a friend; where representation is ever present and speedy, and we inevitably grow impatient for a quick visual hit rather than stopping and looking hard. We are increasingly wired for the three-minute pop song, not the thirty-five-minute symphony.

We all suffer today to some degree from visual attention deficit syndrome; we want fast images just as we want fast food, a constant stream of visual stimuli. But much serious art fights this, demanding that we stop and contemplate and consider. Art historians do too, asking that we stop in front of an object and not just say 'Yeah, that's nice, what's next?' but ask questions of it – and indeed questions of ourselves.

In this section we should imagine Carrie Barratt at her desk in the Met, contemplating two miniature paintings by John Singleton Copley, and Julia Hutt meticulously taking apart a lacquer box, puzzling at the anomalies: they are asking questions. Or imagine Megan Aldrich at Ham House looking at a set of chairs and asking herself before going off to delve, like a detective, in the archives: 'When was this strange-looking chair in Ham House in London made? Where does it come from? Why is it here? Why are there so many of them? Who would have sat on it – indeed did people actually sit on it or was it as now just a prestige object? When we look closer at them we find the initials ED proudly displayed at the top of each chair. If we knew who this person was, we would have a key to open the door and look back to the time when it was commissioned, made and put in place.'

We are sharing an experience of looking, contemplating, questioning and researching. The act of questioning helps us to look longer and harder, to see and appreciate more. This experience of questioning may well be slow and methodical, and we must trust our guides that this will bear fruit.

The presence of Eugene Tan's essay in this context, given the seemingly wilful approach by artist Joseph Kosuth to his visual data – any chair it seems will do – may seem perverse, but it makes utterly clear how looking leads to thinking. And of course the question of 'What are we looking at?' will almost invariably lead to questions of 'where and when?' This is made explicit in my essay on David Reed's painting, which concludes the section.

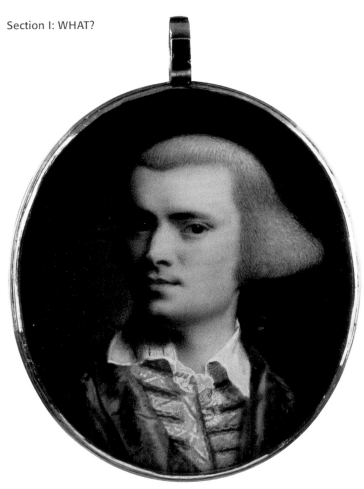

7. John Singleton Copley, *Portrait of the Artist*, 1769
Signed and dated lower right *I S C* [monogram] *1769*
Watercolour on ivory, 5.08 x 2.7 cm (2 x 1⅛ in)
Courtesy of The Metropolitan Museum of Art,
Dale T. Johnson Fund, 2006

Both miniatures shown enlarged

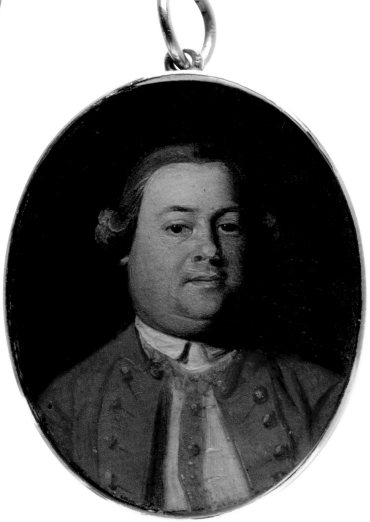

8. John Singleton Copley, *Moses Gill*, c.1758–9
Oil on gold-leaf primed copper, 4 x 3 cm (1⅝ x 1⅛ in)
Courtesy of The Metropolitan Museum of Art, Purchase,
Martha J. Fleischman Gift, in memory of her father,
Lawrence A. Fleischman, 2006

Carrie Rebora Barratt

John Singleton Copley's Miniature Self-Portrait and Portrait of Moses Gill

Only two portrait miniatures by the American master portraitist John Singleton Copley (1738–1815) have come to market in the past quarter century. In a field that fills auction rooms at all of the major houses twice a year, and then some, with much prize material going to galleries and independent dealers, one never sees a Copley portrait miniature, proof positive that these tiny gems are, as the saying goes, rare as hen's teeth and twice as dear. Far less prolific in this area than his British contemporaries – there are to date only 36 pieces in all known to be by Copley – he mastered a few different techniques for painting small portraits, but treated their production as a sideline to his astoundingly successful oil painting career.[1] It seems a shame, for the pieces are of a quality that match him with those artists who took miniature paintings as their mainstay. Art historians, students and collectors interested in his miniatures must study those that currently exist and raise a cheer for every new discovery that comes to light.

In 1979, a stunning watercolour-on-ivory self-portrait (fig.7) found its way through descendants of the artist to a Madison Avenue gallery, where it fetched a handsome price. In 2005 an exceptional oil-on-copper image of his young client, Moses Gill (fig.8), traded for a song at a stall in the Portobello Road to a savvy Saturday morning shopper. In 2006 both entered the collection of the Metropolitan Museum of Art, New York, where they join another Copley miniature of his patron, the merchant grandee Jeremiah Lee (fig.9), a piece acquired back in 1939. The three pieces encapsulate the artist's talent and range in this art form, which is precocious and astounding.

Before the age of 20, Copley had tried his hand at nearly every artistic medium available to him in colonial Boston. An industrious autodidact, he would test a new medium and then devise a means of improving upon it. He made his first serious, if flawed, drawings of the human figure at age 14. At 15 he tried printmaking. The stepson of the engraver Peter Pelham (1697–1751), young Copley rescraped a copperplate into a fairly accomplished mezzotint. But, for whatever reason, he did not persist at this art form.

Copley next tested and perfected pastel, a tricky, powdery medium in crayon sticks that were very difficult to get in Boston. How he knew the proper technique remains one of the mysteries of his early career, as he would soon produce vibrantly coloured, expertly rendered, gleaming portraits despite there being, as research shows, nothing similar to see in Boston. In 1762 he wrote to the Swiss pastellist Jean-Etienne Liotard (1702–1789) for advice and help with supplies: he wanted a proper assortment of crayons, 'a sett of the very best that can be got'.[2] Copley placed an order with J. Powell, a London art supplier, and proceeded to execute at least 55 pastel portraits before 1774.[3]

In 1755, at age 17, Copley added another art form to his kit: miniature portraiture. That year he created his first miniature, a portrait of a woman known only as Mrs Todd (Museum of Fine Arts, Boston). For the portrait, he set to work in oil on a recycled and cut-down copper printing plate, the sort that he would have had in abundance from his late stepfather's studio. These used copper plates had a textural tooth that remained from scoring made to prepare the slick surface to hold ink; this tooth would have also made successful the application of oil paint. Perhaps he had seen John Smibert's (1688–1751) oil on copper miniature of Samuel Browne (Private collection), a work from 1734 that he could easily have studied in the Smibert studio, which remained intact as a shop in Boston after the artist's death. Copley must also have seen some enamel miniatures, as his rather dense application of oil paint simulates the effect of that mediium. Early portraits of colonists wearing portrait miniatures document their existence in America; they are worn by the subjects, who presumably transported them from England, but few of these miniatures have been located. Moreover, very few miniatures had been made in the colonies until Copley gave the genre a try. As he demonstrated in pastel, graphite and on canvas, Copley had the capacity for results finer than anything he could have then seen in America.

A shrewd entrepreneur with a knack for self-promotion, Copley probably always kept examples of his work in various media on view in his studio to show prospective clients. His miniatures certainly caught the attention of Andrew and Peter Oliver, brothers who between them ordered seven pieces in 1758–9, all of which remain in the family.[4] Whether it was a case of rising to the occasion for this prominent family or seizing an opportunity to try something new – as he was wont to do – Copley created an incredible range of pieces for the Olivers. He also employed a variety of techniques for them: oil on ivory (an unusual and ultimately unsatisfactory combination), oil on copper and oil on gold-leaf primed copper. The latter had a few advantages; gold added material richness, preserved the surface of the potentially corrosive copper and, if worked properly, enhanced the radiance of the subject's face. The saturated and vivid aspect of a piece finished in this manner nearly achieved the look of enamel on gold-leaf on copper, a medium Copley might have been approximating to the best of his abilities in a town without the necessary materials for the process, in other words, powders and a kiln.

Copley deployed the oil on gold-leaf primed copper for his recently discovered portrait of the Charlestown, Massachusetts, merchant Moses Gill (1733–1800), one of only a few featuring this distinctive treatment.[5] Gill was previously thought to have broached his relationship with Copley in 1764 when he ordered large portraits of himself and his wife (both now in the Museum of Art, Rhode Island School of Design), but this miniature token of affection dates from five years earlier, about 1758–9, the same time as the

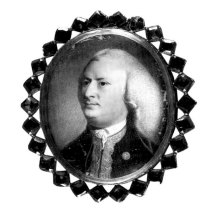

9. John Singleton Copley, *Jeremiah Lee,* 1769
Watercolour on ivory, 3.8 x 3.2 cm (1½ x 1¼ in)
Courtesy of The Metropolitan Museum of Art,
Harris Brisbane Dick Fund, 1939

10. Reverse of *Moses Gill* (see fig.8)

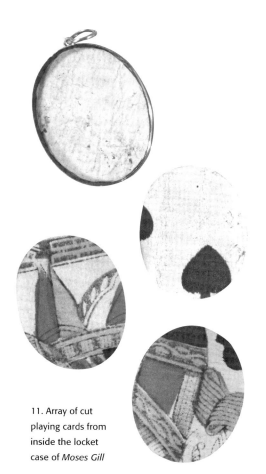

11. Array of cut playing cards from inside the locket case of *Moses Gill*

Oliver portraits. It is closest to the likeness of Andrew Oliver's wife, Mary Sanford (Yale University Art Gallery), which is the same size and same medium, and features the same nearly frontal pose and the same pleasant smile on a fleshy face. Like the smallest of the Oliver miniatures, Gill's portrait is framed in a tidy 18k gold locket, with a thin bezel around the outer edge that holds tight crystals front and back. The verso glass features locks of Gill's brown hair, plaited in a simple overlapping pattern (fig.10). The locket is original, but undocumented as to its maker. Copley is known to have purchased lockets from the silver and gold smiths Paul Revere (1735–1818) and Nathaniel Hurd (1730–1778), both of whose portraits he painted in the 1760s, and either of whom could have made Gill's elegant locket. Copley cut playing cards to fit between the copper oval and the hairwork, a clever device common in England to ensure a tight fit, and yet another indication that Copley knew the common tricks of the trade (fig.11). The bail at the top of the locket was designed to take a narrow velvet ribbon, such as would be worn by a woman.

The woman who would have slipped this image of Gill's amiable countenance around her neck and tucked it into the folds of her gown or her bosom was Sarah Prince (d.1771). Gill presumably commissioned this token of affection as an engagement gift to her not long before their marriage on 27 March 1759. From Copley, Gill received a dignified and formal, albeit kindly, image, as unerring in likeness as it was flattering. His double chin, ruddy complexion, and the shadow of his beard reveal the real man, who has donned a fine gold-trimmed waistcoat and smart red jacket of the sort suggesting Grand Tour travels, although Gill had never been out of Massachusetts. The complement of authentic face with tarted-up costume was Copley's forte, precisely the mode in which he excelled when he had a complicit patron like Gill.

One imagines Sarah Prince delighting in such a romantic and sophisticated gift, made poignant by the fact that her happy betrothal to Moses occurred in the wake of the death of her father, Reverend Thomas Prince (1687–1758), the pastor of Old South Church in Boston. Sarah herself died in 1771 without child.

The miniature of her husband seems to have passed through the English branch of the Gill family, then somehow – we may never know – having passed from hand to hand through generations of Gills and possibly others, it reached a display case in the Portobello Road and was spotted upside down for its American casework and peculiar hairwork. The fortunate finder was amazed to flip it over and find a Copley face staring back.

In the process of authentication and study by a number of scholars, the piece came to the Metropolitan Museum of Art for examination and remained, snapped up as its significance is far greater than its tiny size and far more critical than the delightful story of its finding would at first reveal. Discoveries in the oeuvre of an artist so thoroughly

studied, so scrupulously inventoried, so eagerly sought, are truly astonishing. When works of art are so small, the chances for loss or misplacement over the years are many. Copley painted very few miniatures on copper, making this one a rich document for study of the young painter's early efforts. As in the Todd and Oliver portraits, the over-application of oil paint over the leaf diminished the radiating enamel-like glow he desired. (It can be seen with the naked eye shimmering through a minute loss on his right nostril.) The application is deft, but thick and linear; the colours vivid, but overly saturated. Copley would continue to work out his technique through the 1760s, but at the same time began investigating a new medium that offered an entirely different effect.

Copley's earliest extant watercolour on ivory miniature dates from about 1762, a sweet and accomplished portrait of Deborah Scollay of Boston (Worcester Art Museum, Massachusetts), who married John Melville that year. Once more, there is the open question of what Copley could have seen to inspire such a gem. The American examples predating Copley's portrait of Mrs Melville take the same small form and compositional emphasis on the tiny face without embellishments: Mary Roberts (d.1761) and Jeremiah Theus (1716–1774) were both painting watercolour and ivory portraits in Charleston, South Carolina, and closer to home, John Hesselius (1728–1778), a local favourite with Philadelphians, and Copley's exact contemporary, Benjamin West (1738–1820), painted a very few tiny portraits. Chances of Copley having seen Roberts' or Theus' work are slim, and the works by Hesselius and West, with all due respect, do not offer much for Copley to have learned the technique that he used in Mrs Melville's portrait.

It is more likely, indeed, that in Boston Copley would have seen examples of miniatures by the British artist whose works must have inspired all of these American examples: the Dublin-born artist Thomas Frye (1710–1762), who gained relative superstar status in mid-century London for simultaneously painting miniatures and oils, developing successful porcelain recipes at the Bow Porcelain Factory, and making and marketing large-scale mezzotint portraits. Small tokens of affection by Frye for English patrons could easily have made their way to the colonies as gifts to extended family members. Moreover, Copley's stepfather, Pelham, would have certainly known Frye's work, undoubtedly had some of his mezzotints (Copley based many of his pastels on Frye's portrait prints), may have owned a miniature, and, as a fellow mezzotint engraver, would likely have known him in London before emigrating to the colonies. Like Frye's miniatures, Copley's are minutely detailed, tiny, stippled faces with elegant housings and few bells and whistles. Above all, Copley's miniatures are *retardetaire*, a throwback to Frye-style English miniatures of the modest period before mid-century, while current miniatures in London had developed by leaps and bounds. Copley would only get to see the work of his own generation of English miniaturists after he arrived in London in

1775. They included Jeremiah Meyer (1735–1789), Richard Cosway (1742–1821), John Smart (*c*.1740–1811), Samuel Cotes (1734–1818), and others who developed the capacity to work wonders with watercolour on ivory featuring better modeling, subtle washes, manipulated tiny strokes, and fulsome accoutrements such as clouds, hats and coiffures.

As Erica Hirshler has pointed out, Copley also probably had book knowledge: Robert Dossie's *Handmaid to the Arts* (1758) could be found at American bookshops by 1760. Although written as a primer for artists working on vellum, Claude Boutet's *Art of Painting in Miniature: Teaching the Speedy and Perfect Acquisition of That Art Without a Master* (1676) contained nearly everything Copley would have needed to know. It had been translated into English by 1730, abetted the training of many English eighteenth-century miniature painters, and one of its subsequent reprintings would have certainly been available in Boston.

In his definitive study and inventory of the artist's works, Jules D. Prown lists ten watercolour-on-ivory miniatures, starting chronologically with that of Mrs Melville and concluding with companion lockets of Mr and Mrs Samuel Cary in about 1773 (Private collection). Of the ten, seven derive from larger works, proving that Copley knew how to capitalise on a likeness that once taken was easily replicated by him in a different format for a willing, paying client. In 1769 the merchant grandee Jeremiah Lee commissioned opulent, full-length portraits of himself and his wife Martha (now in the Wadsworth Athenaeum, Hartford, Connecticut), for the majestic English-style townhouse he was building in Marblehead, Massachusetts, at the time. Copley could have effortlessly sold such an ostentatious client on the idea of portrait miniatures, so that not only would his life-size image loom over guests in the stair hall but his tiny visage could be pinned to the bosoms of his wife and daughters. Lee requested at least two miniatures (see fig.9 and Marblehead Historical Society, Massachusetts), both of which perfectly match the big portrait: the brown velvet waistcoat trimmed in galloon, the impressive bag wig, the noble gaze. In the watercolour versions, however, the skin tones are more subtle, as the rather florid man in the huge oil is translated into a slightly gentler fellow, a toned-down aspect appropriate for wear by his family.

Copley's self-portrait (see fig.7) probably postdates the Lee commission, as it reveals a more accomplished technique and a more fully realised deployment of the translucent qualities of watercolour on ivory.[6] Granted, for the self-portrait he had a complicit subject whose face he could study from life as often as necessary. Compared to the portrait of Lee, Copley's own is practically iridescent, with expert stippled and hatched strokes that allow the luminous ivory to glow through the paint. The cool blue aspect of his face is, in fact, the look recommended by Boutet and others for male countenances. Copley would have mixed cobalt with a touch of vermilion, a fugitive hue that has faded over

time. The colours Copley intended can be seen in an excellently preserved pastel portrait he painted of himself in the same year (Henry Francis Du Pont Winterthur Museum, Delaware), upon which the miniature is almost certainly based. In both, Copley wears his fastidiously, almost geometrically arranged hair, powdered with a braid in the back. His royal-blue figured damask banyan has violet silk lining and the crimson waistcoat is embellished with galloon trim. His crumpled linen collar offers a bit of carefully composed disarray as a foil to the lavish attire. There has been fairly recent debate as to whether Copley chose the clothing with a wish to appear affluent and gentlemanly or, on the contrary, to connect himself to the established tradition that the banyan in portraiture indicated the life of the mind.[7] The former argument favours the fact that Copley portrayed many of his wealthiest clients in *turquerie*, banyans and turbans derived from the British fashion for Middle Eastern at-home wear for men. The latter argument maintains that Copley would have got the idea of this costumed portrayal from portraits of artists and scientists, which abound in contemporary English painting. The boudoir clothing signifies removal from the daily grind in favour of studies, intellectual matters and artistic pursuits that require a more comfortable and informal manner of dress. There is, though, the matter of the incredibly dear fabric and trim in Copley's self-portrait; the yardage required for the banyan would have cost as much as a small house and the galloon – the same as in Jeremiah Lee's portrait – would be worth, as they say, a king's ransom. Indeed, both the banyan and the waistcoat could have been created only in the portrait, as Copley quite regularly dressed his dapper clients in portrait dress that they could not have got in the colonies. But he was entitled to these clothes. A celebrity figure in Boston society who by 1769 had an income equivalent to many of his best patrons, Copley had licence to portray himself as a gentleman and a scholar.

The other reason for the handsome fabrics and gimps would be that Copley created both portraits as gifts for his bride, Susanna Farnham Clarke, on the occasion of their marriage in November 1769. He painted a pastel of her (also at the Winterthur Museum, Delaware) as a companion to his (no matching miniature of her has as yet been found), and they are both dressed beautifully, as appropriate for the occasion. Susanna, known as Sukey, was the daughter of Richard Clarke, British agent in Boston for the East India Company (it was his tea that was offloaded into Boston Harbour that fateful night), and their marriage, while long-lasting and fruitful, was defined by political turmoil. Indeed the marriage played an enormous role in Copley's decision five years later to tour the European continent and move to London. He claimed the desire to advance his career, but the outbreak of the Revolution would have made life untenable for his loyalist family.

As far as anyone knows, once in London Copley limited his production to oil paintings and the requisite drawings for them. He did not engrave, paint in pastel, or make

miniatures of any sort. His descendants, a string of whom owned the self-portrait one generation after the next, generously lent it to exhibitions and on long-term loan to museums during the twentieth century so that this small but powerful work would be known by the burgeoning group of Copley scholars, students and collectors.[8] When it left the family in 1979, American portrait miniature collector Gloria Manney seized upon its brilliance and immediately purchased it. Following the Copley family's pattern and her own philanthropic streak, she lent it to exhibitions and for museum loan so that subsequent generations of students and scholars could persist in marvelling at it.

Alongside the two miniatures mentioned here as well as the 33 others, the self-portrait reveals extraordinary talent in incredibly arcane media that Copley could only have mastered by experimenting, trying his steady hand at varied media with limited resources. By figuring out British techniques for American clients, he set the stage for years to come, as miniature painting took hold in the United States.

NOTES

1. The primary sources on Copley are Jules David Prown, *John Singleton Copley*, 2 vols (Cambridge, MA: Harvard University Press, 1966), and Carrie Rebora and Paul Staiti *et al.*, *John Singleton Copley in America* (New York: Metropolitan Museum of Art, 1995). On his portrait miniatures, see Erica Hirshler, 'Copley in Miniature', in Rebora and Staiti, pp 117–42.

2. Copley to Liotard, 30 September 1762, in Guernsey Jones, ed., *Letters and Papers of John Singleton Copley and Henry Pelham, 1739–1776* (Boston, MA, 1914), p.26. See also Marjorie Shelley, 'Painting in Crayon: The Pastels of John Singleton Copley' in Rebora and Staiti, *John Singleton Copley in America*, pp.127–41.

3. See Marjorie Shelley, 'Copley in Pastel' in Rebora and Staiti, *John Singleton Copley in America*.

4. See Hirshler, *op. cit.*, pp 120–21.

5. See Theresa Fairbanks, 'Gold Discovered: John Singleton Copley's Portrait Miniatures on Copper' in *Yale University Art Gallery Bulletin* (1999), pp 75–91.

6. Two catalogue entries have been written on the self-portrait. See Dale T. Johnson, *American Portrait Miniatures in the Manney Collection* (New York: Metropolitan Museum of Art, 1990), pp 98–100. Erica Hirshler, catalogue entry in Rebora and Staiti, *John Singleton Copley in America*, pp 252–3.

7. See Carrie Rebora Barratt, 'Oriental Undress and the Artist,' *Porticus: Journal of the Memorial Art Gallery of the University of Rochester* (2001), pp 18–26; Brandon Brame Fortune, 'Banyans and the Scholarly Image' in *Franklin and His Friends: Portraying the Man of Science in Eighteenth-Century America* (Washington, D.C.: National Portrait Gallery), pp 51–65; Susan Rather, 'Carpenter, Tailor, Shoemaker, Artist: Copley and Portrait Painting Around 1770,' *Art Bulletin*, vol.79 (June 1997), pp 269–90.

8. Copley's self-portrait was exhibited at the National Gallery of Art, Washington, D.C., and at the Metropolitan Museum of Art in 1927, at the Museum of Fine Arts, Boston, in 1938, and again at the NGA and MMA in 1965. The provenance is as follows: the artist; to his daughter, Mrs Gardiner Greene, Boston; her grandson, the Rev. John Singleton Copley Greene Sr, Boston; his daughter, Mary Amory Copley Greene, Boston; her nephew, Henry Copley Greene, Cambridge; his daughter, Katrine Rosalind Copley Greene, New York; her sister, Mrs Gordon Sweet, who placed it on loan to the Museum of Fine Arts, Boston, 1971–2, and to Yale University Art Gallery, 1972–8, and consigned it to Hirschl and Adler Galleries, New York, 1979; purchased by Gloria Manney; sold by Mrs Manney to the Metropolitan Museum of Art, 2006.

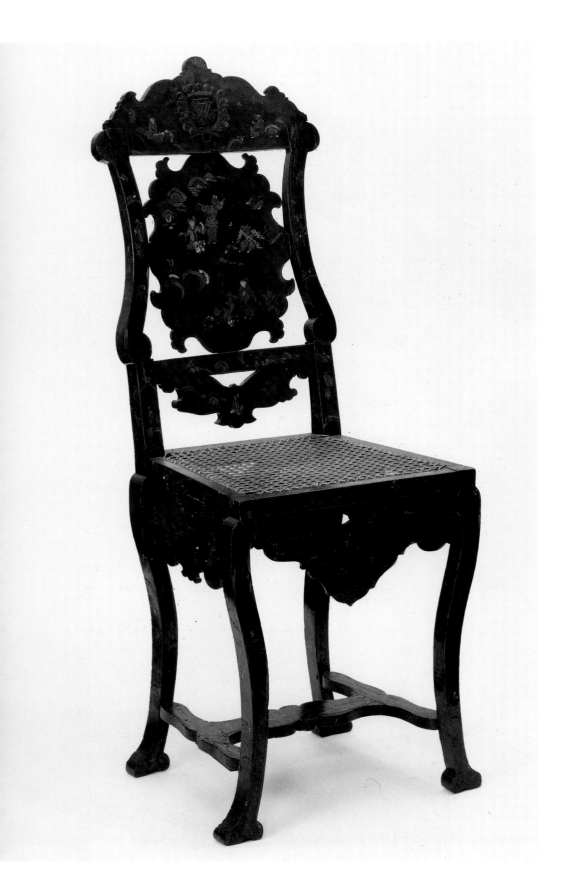

12. English polychrome japanned backstool, made *c.*1673, bearing the coronet and initials of John Maitland, Duke of Lauderdale

Megan Aldrich

The Countess of Dysart's Backstools

Elizabeth Murray, Countess of Dysart (*c*.1626–1698), was one of the great personalities of seventeenth-century England and a dedicated consumer of the luxury goods of her day. Her beauty, charisma and flame-coloured hair are well captured in a youthful portrait (fig.13) by Sir Peter Lely (1618–1680). Not all her contemporaries admired her, however, for despite her beauty and her education, she was described by one as 'restless in her ambition, profuse in her expense, and of a most ravenous covetousness'.[1] This ravenous covetousness is reflected in the extraordinary richness of the interiors and furnishings that survive today at Ham House, Surrey, and which bear witness to the evolution of fashionable taste in England from the 'Catholic Baroque' of the first half of the seventeenth century to the 'Chinamania' of the final quarter of the century.

Elizabeth was the eldest of four daughters of William Murray, 1st Earl of Dysart and a childhood friend of King Charles I, and she inherited her father's house and Scottish title at his death in 1655. It was unusual for a woman to inherit a title in her own right in England; perhaps this is why, in 1670, King Charles II awarded Elizabeth a patent by royal charter in order to confirm her title and to enable her to choose her heir. This event may have been celebrated by some updating of the furnishings of her redbrick villa on the River Thames, Ham House. Elizabeth's first marriage to Sir Lionel Tollemache, a baronet, ended after 21 years with his death in 1669.[2] Three years later she married John Maitland, Secretary of State for Scotland in the government of Charles II, whom she had known for some years. He was created 1st Duke of Lauderdale in May of 1672. As a consequence of their marriage, Elizabeth, a countess in her own right, acquired the more elevated rank of duchess.

Built in 1610 for a courtier to James I, Ham was a red-brick villa of fairly modest proportions, arranged on an H-plan and designed with contrasting light stone dressings. The north front faced the Thames, the main route between Whitehall Palace, London, and the palace of Hampton Court, allowing the owner of Ham to keep in touch with society and the court. Ham House had been acquired *c*.1630 by Elizabeth's father. During the 1630s, William Murray made changes to Ham in order to reflect contemporary developments from the Continent, including the creation of a luxurious suite of rooms, a state apartment, on the first floor of the house. This architectural innovation was *avant-garde* by the standards of the day, and rare outside of France. The creation of an apartment fit to receive a monarch in a relatively small villa on the Thames demonstrates the closeness of the Murrays to the court and the centre of power.[3] Their state apartment was decorated in a voluptuous and classicising version of the Baroque style of the Continent,

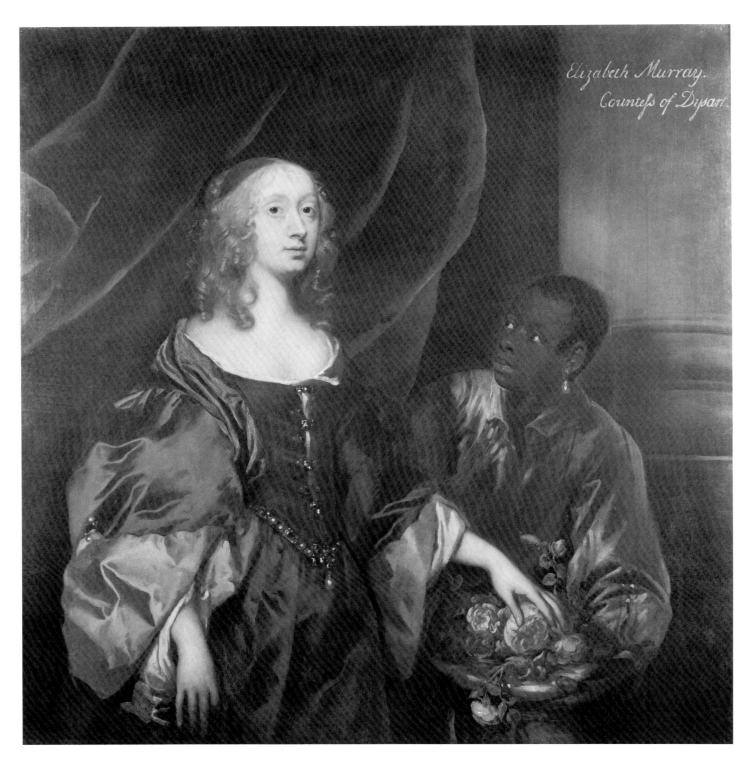

Elizabeth Murray.
Countess of Dysart

13. Sir Peter Lely, *Portrait of Elizabeth, Countess of Dysart, in her Youth*, c.1650

Oil on canvas

V&A Images/Courtesy of The National Trust

with tapestries, richly upholstered furniture, and a state bed hung in silk beside the ivory cabinet. This cabinet is one of the rarest pieces of luxury furniture remaining in the house, and it was placed next to the state bed in the original apartment, in what is now known as the North Drawing Room.[4] The team of craftsmen involved during the 1630s were most likely led by the court designer, Franz Cleyn, director of the Mortlake Tapestry Works under Charles I, whose painted ceiling and sumptuous chimney-piece design with fat *putti* climbing its Solomonic columns remain in the state apartment. Cleyn had trained in Rome and worked at the court of Christian IV of Denmark, the brother of James I's queen and the leading patron of art in northern Europe at the start of the seventeenth century.[5] Such a connection reinforces the close relationship between Murray and the English court of the early Stuarts, which looked to Continental Europe in all matters of design.

Despite the family's close connection to the English court, they managed to survive the Civil War (1642–9) and keep their property intact during the Protectorate of Cromwell (1653–8), thanks to the active role played by Elizabeth. This, and the fact that the house was never substantially altered in its subsequent history, explains why Ham has survived with its contents and seventeenth-century decor reasonably complete. Moreover, Ham has been well studied because of the survival of detailed inventories of the house taken in *c.*1654, 1677, 1679 and 1683.[6] Elizabeth seems to have updated her father's state apartment during the 1650s, but the clustering of the last three dates indicates the focus of furnishing activity, which must relate to Charles II's reaffirmation of Elizabeth's title as Countess of Dysart in 1670, as well as her becoming a duchess in 1672. Close study of these Ham House inventories tracks a shift in fashionable taste away from the classically based, seventeenth-century Baroque towards an early phase of chinoiserie, where the consumer desire for imported luxury goods from Asia eclipsed earlier, Continental Baroque models.

The Lauderdale's new rank and close connections to the court of Charles II had meant that the creation of an updated state apartment in the latest fashionable taste was a necessity. During the 1670s Elizabeth spent a considerable amount of money adding a new suite of state rooms across the south, or garden front of her house (fig.14), and modernised its furnishings. The new state apartment had the now-classic formula of antechamber, bedchamber and closet, and was approached off the Long Gallery on the first floor, a survival of the early seventeenth-century layout. The diarist John Evelyn (1620–1706) visited the house in 1678 and recorded his impression of it thus:

> After dinner I walked to Ham, to see the House & Garden of the Duke of Laderdaile, which is indeede inferiour to few of the best Villas in Italy itselfe, the House furnishd like

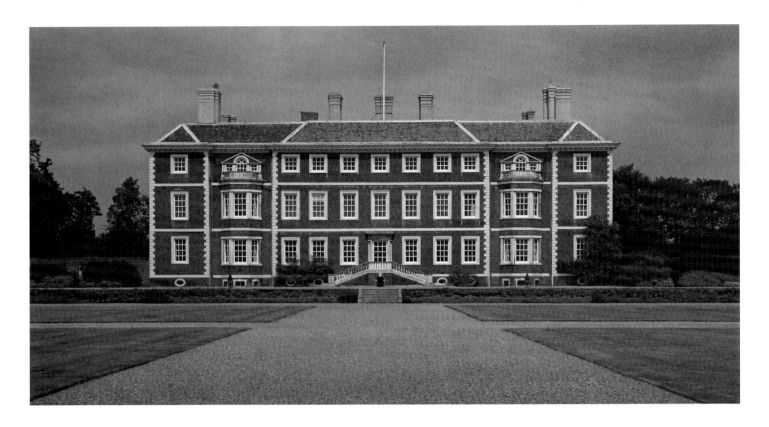

a great Princes; The Parterres, flo; Gardens, Orangeries, Groves, Avenues, Courts, Statues, Perspectives, fountaines, Aviaries, and all this at the banks of the sweetest river in the World, must needes be surprizing.[7]

Evelyn's reference to Italian villas with their formal gardens is a flattering one, and may apply more to the exterior of Ham, but the new furnishings of the 1670s were beginning to show a distinctly Asian flavour.

The curious-looking chair, or 'backstool', shown here (fig.12) was made in the 1670s for Ham as part of a large suite of beechwood seat furniture decorated in a painted imitation of Asian lacquer in two different colourings. In all, the suite probably numbered two dozen chairs, of which 18 were decorated principally with black and raised gold paintwork in imitation of Japanese lacquer, and a further six with polychromatic raised work on a black ground in imitation of Chinese lacquer. All the chairs have caned seats, a very new feature for European furniture copied from Chinese furniture of the Ming dynasty.[8] The *faux*-lacquer backstools from Ham have a gracefully shaped back profile with curved side rails terminating in volutes surmounted by a pyramid-shaped cresting on which are displayed – on the black and gold versions – the initials 'ED' for Elizabeth Murray, Countess of Dysart, and – on the polychrome versions – the initials 'JL' for John Maitland, Duke of Lauderdale. The initials are surmounted by a coronet. Between the curved side rails of the chairs is a back panel shaped in a distinctive scrolled and cusped cartouche form, like a pointed cloud, and this form was taken directly from the

14. Garden (south) façade of Ham House in Surrey, remodelled c.1675 by William Samwell, showing the new three-storey block filling in the H-plan at the back of the house

Courtesy of The National Trust Photo Library

engraved brass lockplates observed on imported Asian lacquer boxes. Attached to the bottom of the central cartouche is a swag, a common design feature in European Baroque furniture, with a shape like a stylised butterfly. The same shape is repeated in the swags attached around all four sides of the seat rail. The legs, which echo the scrolled forms of the side rails, terminate in double volute feet connected by a waved, H-form stretcher. The decorative motifs on the chair feature baskets of flowers and enlarged designs of birds, accompanied by decorative foliage, chinoiserie figures and landscape elements.

Therefore, despite some obvious European features of design in these chairs, nonetheless there are several features – the caning, the cartouche form of the back, the stiffly curved front leg, and the painted technique itself, copying lacquer – which are borrowed directly from Chinese and Japanese sources, in particular, black and gold lacquer, which Elizabeth was collecting for Ham during the 1670s. The back cresting which displays the initials of Elizabeth Murray as Countess of Dysart suggests a date of manufacture sometime between 1670, when she received her royal patent from the king, and May 1672, when she became Duchess of Lauderdale. This is supported by documentation, for among the papers of the house is an entry for the purchase of two dozen 'Cane bottome backe stooles' from one John Dutton in 1673. The sophisticated shape and decoration of the Ham chairs strongly suggest a maker working in the capital and in touch with the latest ideas.[9] It is possible that Dutton was a merchant or supplier of household furnishings, and that another firm, or individual, made the chairs. Their shape is certainly highly original, without any close comparison, and the decoration, while fashionable at the time, is refined and shows a familiarity with Asian lacquer objects.

However, the six polychrome chairs of this suite from Ham House, although identical in form to the black and gold versions, present slight complications in dating. The painted decoration of this important but smaller group of chairs is very fine, in orange-red, blue-green, white and warm brown in low relief over a glossy black ground, with the edges of the chairs outlined in gold lines and some gold foliate patterns. The refined decoration consists of small groups of figures, either seated or standing, with landscape elements such as hills rendered by means of curved, repeated bands of the principal colours. These mounds display in some cases what appear to be pine trees arranged in a line along the top. There is evidence of much detailed painting, especially of the figures' garments, in black and gold to make textile patterns, and the decoration strongly suggests that observation of real lacquer – perhaps objects in Ham House – provided the inspiration. The cresting at the top of these polychrome chairs bears a ducal coronet (with strawberry leaves) and the initials JL, for John Maitland, Duke of Lauderdale (see fig.12), which means they cannot have been made before the month of May, 1672, when he acquired his dukedom.

This fact, plus the date of 1673 on the bill for two dozen backstools from John Dutton, suggests a date for these chairs, but raises the question as to why the black and gold chairs bear Elizabeth's initials as a countess, as opposed to a duchess. In addition, some of the black and gold chairs bear a countess's coronet, with pearls, whilst others appear to have been overpainted with the ducal coronet. There was often a time lag of several years in invoicing patrons for art and furnishings, so it is entirely possible that the 18 black and gold chairs in the style of 'Japan' were made to commemorate the royal patent that the widowed Elizabeth received in 1670, reaffirming her right to the title of countess. The additional six chairs in the polychromatic palette could have been added – in some haste – in honour of the dukedom received by her new husband two years later. She would, of course, have become a duchess at this point. It is perhaps possible that Elizabeth Murray would have chosen to have her set of black and gold chairs made up at the same time as those for her husband in order to celebrate her own title, independent of her husband's dukedom, but this seems less likely than the explanation that the set of polychrome chairs were made a little later, and that some of them were repainted on the back cresting to update the countess's coronet to that of a duchess.

The distinctive and colourful palette of the smaller group of chairs is interesting in its own right, for it derives directly from Coromandel lacquer, a Chinese form of lacquer used to decorate incised wooden screens and other objects shipped to Europe from the Coromandel coast of India. It is a technique that is well represented at Ham, where it was called 'Indian' in the house inventories to distinguish it from 'Japan', or the classic black and gold Japanese lacquer; either Elizabeth or her second husband clearly had a taste for it. As it is his coronet and monogram on the polychrome backstools, this may suggest it was the duke's preference, or the different palette may have been used to call attention to the new rank of the Lauderdales. There is an intact Coromandel screen (fig.15) among the furnishings at Ham House which first appears in the inventory of 1677, and was at that time placed in the duke's apartment.[10] Also part of the 1670s furnishings at Ham is a cabinet on a carved and gilded English stand, which has been made by chopping up another screen and joining the parts together,[11] and a side table with large scrolled consoles for legs that originally had two candle stands *en suite*. It was made – presumably in a London workshop – in imitation of Coromandel lacquer, with the same palette of tempera colours on a black ground, and incising.[12] All of these pieces date to the 1670s period of refurbishing the house, in which many lacquer and imitation lacquer objects were used at Ham, apparently for the first time.

During the seventeenth century the commonly used term to describe this polychromatic lacquer was 'Bantam work', a reference to the Dutch port of Bantam in southeast Asia. The term appears in the foremost manual of imitative techniques of this period,

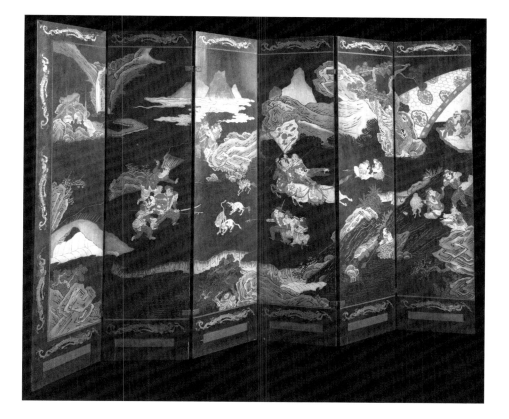

A Treatise of Japanning and Varnishing, Being a compleat Discovery of those Arts with the best way of making all sorts of Varnish for Japan, Wood, Prints or Pictures, published in 1688 by John Stalker and George Parker. Chapter XIII, entitled 'Of Bantam Work', begins:

> I think it most proper in this place to speak of the manner of working at Bantam, because the way of preparing the wood is much the same with that of priming with Whiting. There are two sorts of Bantam, as well as Japan-work: for as the Japan hath flat lying even with the black, and other lying high, even with embossed work; so the Bantam hath flat also, and incut or carved into the wood, as a survey of some large Screens, and other things that come from those parts, will beyond all scruple convince and satisfie you: with this difference however, that the Japan-Artist works most of all in Gold, and other metals, the Bantam for the generality in Colours, with a very small sprinkling of Gold here and there ...[13]

This passage makes it clear that, although there is no evidence of cutting into the wood of the Ham House backstools, nonetheless the polychromatic palette would have been understood as representing 'Bantam' work, or Coromandel lacquer, described as 'Indian' in the house inventories, whereas those backstools from the suite decorated principally in black and gold would have been understood at the time to represent Japanese *hira-makie* lacquer, which is also well represented at Ham House.

There are numerous examples of 'Japan' at Ham House, a term used to signify both real, imported Japanese black and gold lacquer, as well as the painted imitations of it made in Europe. Several black and gold lacquer cabinets on carved and gilded English stands survive at Ham, objects of conspicuous consumption in rich European households of the later seventeenth century. These lacquer objects are not mentioned in the Ham House inventory of 1654, and so must have arrived subsequently. By 1677, despite the presence of some lacquer and japanned objects in the duke's bedchamber and the duchess's closet downstairs, they were overwhelmingly concentrated upstairs in the house,[14] thus forming part of the 1670s refurbishment of the 1630s state apartment, and the new apartment created in honour of Catherine of Braganza, wife of Charles II. The most outstanding of the lacquer objects at Ham are a pair of cabinets inlaid with mother-of-pearl, which are thought to come from Kyoto and date to about 1630.[15] Of exquisite quality, they are rare furnishings for European houses (fig.16).

Analysis of the contents of the new state apartment at Ham, prepared during the 1670s or early 1680s for an intended visit by Charles II's queen, demonstrates the ascendancy of lacquer as the new, luxury commodity for interiors. In the apartment were plentiful lacquer and imitation lacquer objects. For example, in the Long Gallery, the inventory of 1683 tells us there were a 'fine Japan Cabinet with a Carved guilt frame' and two 'fine Japan Screens with flower pots'. At the south end of the Gallery, one enters the later state apartment beginning with the antechamber, where a dozen of the countess's backstools were placed in 1679, being described as 'Japan caned chairs'. This clearly refers to the black and gold chairs from the suite. In the room there were also, by 1679, no fewer than three 'Japan' cabinets and a 'Japan' screen, which was of black and gold lacquer. By 1683 this lacquer furniture had been removed and replaced by an 'Indian Screene', presumably the Coromandel lacquer screen still in place in this interior today. In the state bedchamber next door, the focal point of the apartment, the 1677 and 1679 inventories mention a Japan cabinet and Japan screen; in 1683 there is a 'fine Japan Screen with birds & plants' and an Indian screen. At the end of the apartment, the small closet had a 'little Indian screen' and another 'fine Japan screen'.

Despite John Evelyn's comparison to the villas of Italy, it is clear from the Ham House inventories that it is Asia which began to emerge as the significant influence on the later interiors during this period of transformation in the 1670s and early 1680s. Asian influence, however, was confined to actual objects, whereas the decoration of the state apartment remained firmly rooted in contemporary European practice. The creation of a suite of imitation lacquer backstools made initially for the Countess of Dysart in black and gold, and supplemented by six extra chairs in polychrome work for her new husband, falls at the beginning of this period of Asian influence at Ham. The increasing

16. One of a pair of cabinets from Kyoto, *c.*1630–50, situated in the Green Closet of Ham
Lacquer and mother-of-pearl
V&A Images/Courtesy of The National Trust

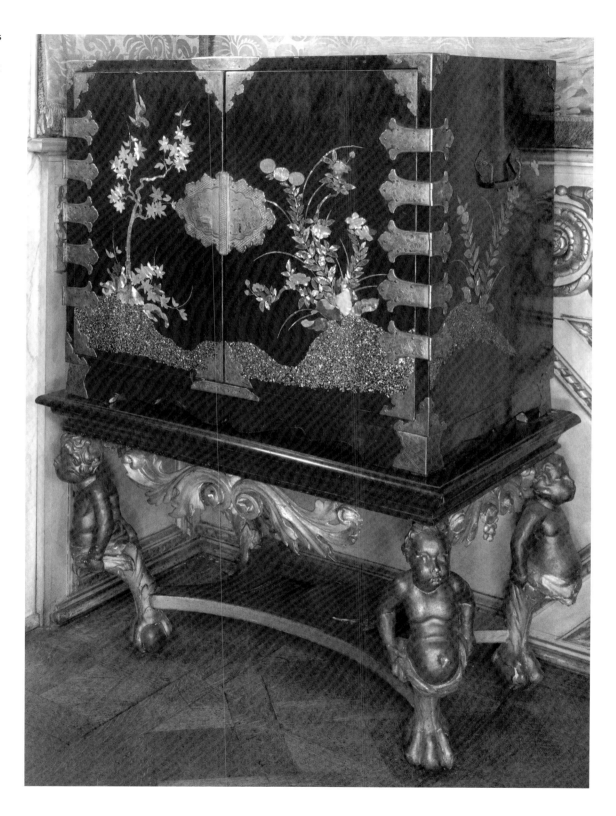

mercantile activity of the European East India companies and the trading relationship between Britain, the Netherlands, Portugal and the Far East would have contributed to this shift in taste and made the acquisition of objects possible on a far greater scale than had been the case earlier in the century. Stalker and Parker illuminate just how far such 'Chinamania' had progressed by the 1680s in Britain. After discussing the virtues of lacquer, with its 'Varnish more glossy and reflecting than polisht Marble', they continue:

> Let not the Europeans any longer flatter themselves with the empty notions of having surpassed all the world beside in stately Palaces, costly Temples, and sumptuous Fabricks; Ancient and modern Rome must now give place: The glory of one Country, Japan alone, has exceeded in beauty and magnificence all the Pride of the Vatican at this time, and the Pantheon heretofore ...[16]

From a study of the inventories and the interiors at Ham House, therefore, it emerges that the Countess of Dysart's backstools were created to complement a sizeable collection of Japanese and 'Coromandel' lacquer objects acquired around the same time for the refurnishing of Ham during the 1670s. Her lacquer objects included screens, cabinets and small boxes, all of which had varying degrees of use in European interiors of the seventeenth century. Lacquer seat furniture, however, was unknown in Japan, and in China it emerged only during the eighteenth century, with the carved red lacquer favoured by Emperor Ch'ien Lung.[17] Nor did Stalker and Parker offer any ideas for imitation lacquer seat furniture in their treatise of 1688.

It seems that the enterprising and formidable Elizabeth Murray was not to be discouraged by such lack of exact models. She was not going to do without lacquer seat furniture for her sumptuous and innovative interiors at Ham in the style of 'Japan'. Therefore, she had the chairs created, perhaps issuing the instructions herself to John Dutton of London, and using an example from her own collection of lacquer for inspiration. The result is a completely unique set of chairs which remain in the house today.[18] They impress upon visitors that Elizabeth Murray was a woman of style and some magnificence, operating at the forefront of fashionability in England in the 1670s.

NOTES

The author wishes to thank Frances Collard of the V&A for her kind assistance in locating images of Ham House.

1. See the Introduction to the guidebook to the house, *Ham House* (London: The National Trust,

1995), p.5. Various portraits of Elizabeth Murray, who strongly resembled her Scottish mother, Katherine Bruce, remain in the house today. See *ibid.*, Chapter 3, 'The First Earl and Countess of Dysart'. The author is extremely grateful to Christopher Rowell of the National Trust for

reading through this article in draft form and making valuable comments and suggestions. For a more in-depth understanding of Elizabeth Murray as a patron and collector, see Rowell's forthcoming article in the *Institute of Historical Research*, *Collecting and Display* series.

2. After acquiring the title of countess in 1655, as her father's heir, she then outranked her first husband. For more on her second marriage, see *Ham House*, Chapter 4, 'The Duke and Duchess of Lauderdale', pp 64–9.

3. Charles I's queen, Henrietta, was, of course, a French princess and the aunt of the future Apollo of the arts, Louis XIV. Such apartments were just becoming standardised in French royal residences at this time. See Peter Thornton, *Seventeenth-Century Interiors in England, France and Holland* (New Haven, CT, and London: Yale University Press, 1978), Chapter 3, 'The Architectural Framework'; and Daniel Alcouffe *et al.*, *Un temps d'exubérance: les arts décoratifs sous Louis XIII et Anne d'Autriche*, ex.cat. (Paris: Réunion des musées nationaux, 2002), Chapter 1, 'Hommes et décors'.

4. The 1630s state apartment consisted of the following: a reception room, or antechamber, which was later opened up and converted into the present Gallery above the Hall; the present North Drawing Room, which as the state bedchamber originally contained the state bed, with the ivory cabinet beside it; and the Green Closet, which could have been entered from the state bed-chamber. The latter two rooms of the house are particular survivals from the period of the 1630s. They are well illustrated in Maurice Tomlin, *Ham House* (London: Victoria and Albert Museum, 1986), pp 59–65. The ivory cabinet relates closely in style to the early production of ebony-veneered cabinets being produced in France at this time. See Alcouffe *et al.*, *Un temps d'exubérance*, pp 232–41. However, Reinier Baarsen has recently suggested its origin as Dutch. (See Baarsen, 'Wilhelm de Rots and early cabinet-making in The Hague', the *Burlington Magazine* [June 2008], p.380.) In the Victoria and Albert Museum is a later and more elaborate ivory cabinet with floral marquetry, almost certainly made *c*.1665 by Pierre Golle for Henrietta, Duchess of Orleans and favourite sister of Charles II (museum number W.38-1983).

5. For more on Cleyn, whose name is also spelled 'Clein', see the article by David Cast in Joanna Banham, ed., *The Encyclopedia of Interior Design*, vol.1 (London and Chicago, IL: Fitzroy Dearborn, 1997), pp 277–9.

6. The Ham inventories were published by Peter Thornton and Maurice Tomlin as volume XVI of the journal *Furniture History* (1980). These remain the single most useful source for studying the collections during the seventeenth century.

7. Guy de la Bedouyère, ed., *The Diary of John Evelyn* (Woodbridge: Boydell Press, 1995), p.223.

8. Four of these black and gold backstools appear to have left Ham House.

9. There is no entry for a cabinet-maker named John Dutton in *The Dictionary of English Furniture Makers, 1660–1840*, Geoffrey Beard and Christopher Gilbert, eds (Leeds: Furniture History Society and W.S. Maney and Sons, 1996).

10. Described as 'One Indian scrine' in the 1677 inventory, it is mentioned again in the 1679 inventory; in both documents it was located in the duke's Dressing Room on the ground floor, further supporting the idea that he had a particular taste for Coromandel lacquer. In addition, the duke had 'two Indean boxes wt colors' in the same room. See Peter Thornton and Maurice Tomlin, 'The Furnishing and Decoration of Ham House', *Furniture History*, vol.XVI (1980), pp 50–51; the screen is illustrated as figure 59. There were other such screens at Ham during the 1670s, such as in Lady Maynard's bedchamber; she was the sister of Elizabeth Murray. (See *ibid.*, pp 104–05 and 119.)

11. The cabinet is illustrated in *ibid.*, figure 104. It is not clear from the inventories, which are analysed by Thornton and Tomlin, exactly where this cabinet stood during the 1670s period, when the newly created Duke and Duchess of Lauderdale were refurbishing the house and creating a new state apartment.

12. The table is illustrated in *ibid.*, figure 77, with a similarly decorated reading stand bearing the coronet and monogram of the Countess of Dysart, suggesting a date before 1672 when it was placed in the duchess's bedchamber. See *ibid.*, p.57. See also figure 103, a pier suite with later alterations, also in the imitative Coromandel technique.

13. John Stalker and George Parker, *A Treatise of Japanning and Varnishing* (1688), facs. ed. (Reading: Alec Tiranti, 1998), p.35. There are 24 plates at the back of the book with designs for japanning, or imitation lacquer decoration. One or two of these designs are roughly similar to the floral and bird motifs on the black and gold chairs, but there is nothing very similar to the figures that appear on the polychrome chairs.

14. For example, the inventories of 1677 and 1679 tell us that in the duke's bedchamber there were a 'Japan' screen, probably of real, imported lacquer, with the annotation 'sent to London' in 1679 – presumably to the Lauderdales' town house – and three looking glasses with 'Japan frames', almost certainly a reference to Japanned objects. The backstools under discussion in this essay were being arranged in the duchess's private closet by 1677, along with a 'Japan box for sweetmeats & tea', mentioned in the 1683 inventory. (See Thornton and Tomlin, 'The Furnishing and Decoration of Ham House', pp 83–4.) A suite of 'Japan' is listed in the 1679 inventory for the room above the chapel, and in 1683 a 'Japan Cabinet' on a carved and gilt frame is listed in this room. There was much 'Japan' used in the state apartments.

15. For more on this rich lacquer technique, which stretches back to antiquity, see Denise Patry Leidy, *Mother-of-Pearl: A Tradition in Asian Lacquer*, exh.cat. (New York: Metropolitan Museum of Art, 2006).

16. Stalker and Parker, *op. cit.*, Preface, p.xi.

17. Oscar Luzzato-Bilitz, *Oriental Lacquer*, Pauline Phillips, trans. (London: Cassell, 1988), p.97.

18. Elizabeth outlived her powerful second husband by 16 years, dying at Ham House in 1698 in what can be described as reduced circumstances. Four of the original two dozen backstools have evidently disappeared, but 20 remain today at Ham House, illustrating both designs of this extraordinary set.

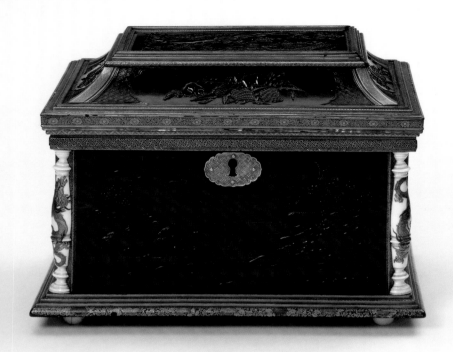

17. Casket, Japanese for the European market, late 1630s
Carved wood covered in black lacquer, ivory columns with gold *hiramaki-e*, 20.1 x 28.4 x 19.6 cm (approx. 7⁷/₈ x 11¹/₈ x 7³/₄)
Victoria and Albert Museum, inventory no.628-1868

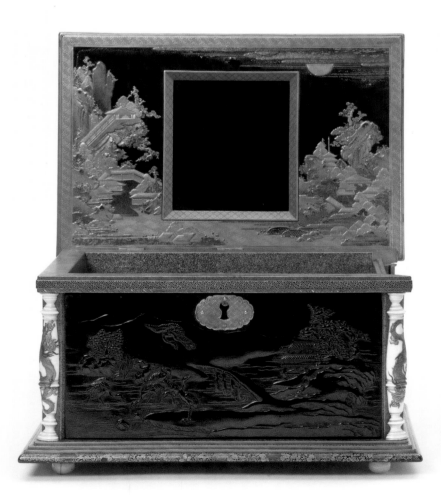

18. The casket shown with its lid open
Black lacquered wood with gold and silver *hiramaki-e* and *takamaki-e* with mother-of-pearl shell

Julia Hutt

What's in a Box? The Many Layers
of a Seventeenth-Century Lacquer Casket

What is immediately striking about this casket (fig.17) is that the material of which it is made, lacquer, and its decoration, is unmistakably Japanese, yet the form appears to be European. More specifically it resembles the highly ornate caskets of the late Renaissance, which were often made from lavish materials, such as mounted hardstones or precious metal.[1] What then were the circumstances that made this exotic juxtaposition of East and West possible, and at such an early date? Is this an example of lacquer made in Japan specifically for export to Europe?

The casket is of architectural form and stands on a stepped base which is raised on four ivory feet. The slanting roof has a truncated flat top, which slides open to reveal a recessed rectangular interior, the dimensions of which correspond to those of the sliding lid, while the depth is equivalent to that of the lid. The inner surface of the sliding lid is elaborately decorated with *shishi* (Chinese mythical lion-dogs) in gold *takamaki-e* ('high sprinkled-picture') lacquer on a lacquer ground densely sprinkled with gold and silver powder. The flat interior base of the recessed area depicts a landscape, with a pagoda and boats at the water's edge, in black *urushi-e* ('lacquer painting') and black, silver and red *hiramaki-e* ('low sprinkled-picture') lacquer on a gold lacquer ground. The casket's exterior is made up of panels of carved and lacquered hardwood, with an ornate ivory column decorated with a dragon in gold *hiramaki-e* at each corner. The front panel depicts cranes at the water's edge, the back reveals *shishi* frolicking among peonies, while the left-hand side depicts Chinese children with bundles of brushwood, and the right-hand side a miniature garden in a rectangular container. The flat top of the roof portrays a pair of phoenixes in flight among flowers, with lychees and squirrels on the curved sides within cartouches, and a geometric design at each end of each long side.

The main lid of the casket is hinged at the back and opens to reveal a craggy mountain landscape with a pagoda, buildings and galleries on either side of a lake under a moon partly obscured by clouds, in gold and silver *hiramaki-e* and *takamaki-e*, with details in gold and silver (fig.18). The scene is broken in the middle by a rectangular-shaped border with bevelled edges decorated with a geometric pattern in gold *hiramaki-e*. Since this frames an undecorated area on a lower level, which is finished in *ro-iro*, black lacquer polished to a deep gloss, the highly lustrous surface was almost certainly intended to act as a mirror.[2] As well as the concealed area in the roof, the casket also has a hidden drawer. The right-hand side of the base is made up of a panel which can be slid up and removed altogether when the casket lid is open. This reveals, on the base, two shaped cartouches, one above the other, against a ground with a key-fret pattern in gold on black

togidashi-e ('polished-out picture') lacquer. The upper and more elaborate cartouche, which is formed by silver lacquer, portrays a *shishi* training its young by throwing it off a rock, in gold, silver and red *hiramaki-e* and *takamaki-e*, with details in silver. By contrast, the lower and smaller cartouche, which is made of silver and gold lacquer, depicts a building and pine tree at the water's edge, with a pair of birds in a flowering prunus tree depicted in similar techniques. In addition, the relief decoration of both cartouches is recessed so that it does not rub against the sliding panel when it is moved up and down. The lower cartouche forms the front of the drawer that runs under the main well of the casket. Very unusually, the remaining three sides of the drawer also reveal recessed decoration of landscapes and buildings using the same extremely lavish and high-quality lacquer techniques, also against the same key-fret ground that is found on the front. Contained within the casket is a tray on four small ivory feet.[3] It is decorated with a scene of court ladies in a garden within a shaped cartouche, in gold, black and silver *hiramaki-e* and *takamaki-e*, against a *nashi-ji* ('pear-skin ground') lacquer ground within a rectangular border of gold lacquer; this, in turn, is set into a sparser *nashi-ji* lacquer ground (fig.19). The design within this cartouche, moreover, bears a striking similarity to that on the inside of the sliding panel. In addition, all the main areas of decoration of the casket are framed by numerous extremely thin borders of geometric and floral patterns in gold and black *hiramaki-e* lacquer, inlaid with mother-of-pearl shell. The inside of the casket also reveals a very ornate version of *nashi-ji*, which is embellished by larger and irregular flakes of gold. The casket also includes a gilt metal lockplate.

Europeans first reached Japan in 1543 and, from around the 1570s onwards, Japanese lacquerware became an important trade commodity. Being quite unlike any Western material, lacquer rapidly became highly prized in Europe. From the outset, Japanese export lacquer was made in a hybrid style that combined Western forms with an exotic manner of decoration. Knowing nothing of their Western clients and believing that their own domestic styles would not be to Western taste, Japanese craftsmen evolved a type of decoration that derived from the only foreign lacquer with which the Japanese were familiar, namely those of China, Korea and Gujarat, combined with their own native traditions.[4] During the late 1620s or early 1630s, however, a new style of decoration emerged that reflected the taste of northern Europe, especially the Dutch, who by 1639 were the only westerners allowed limited trade with Japan.

The casket belongs to this new style of export lacquer. Of the very few objects in this style – perhaps only nine in all, all of exceptionally high quality, hereafter referred to as 'the superlative group' – two others are caskets.[5] These two are more complex in form and are much closer to those of the late Renaissance; they are both roughly pyramidal with a double roof, and with double columns at each corner, as well as a pair of columns

19. Casket, Japanese for the European market, late 1630s (date and place of manufacture of varnish unknown). Inside of side panel and tray, illustrating chapter 28, *Nowaki*, of the *Tale of Genji*
Sliding panel, black, gold, silver and red varnish on wood imitating lacquer; tray, wood covered with *nashi-ji*, black, gold, silver and red *hiramaki-e* and *takamaki-e*
Victoria and Albert Museum, inventory no.628-1868

at the front. One, referred to as the Chiddingstone casket (fig.20), is part of the Denys Eyre Bower Collection, held in trust at Chiddingstone Castle, Kent; while the other, known as the Vienna casket, is in the Museum für Angewandte Kunst, Vienna.[6] There are also in existence a considerable number of export lacquer caskets of varying form, size and quality that date from at least the same period (fig.21).[7]

Since the V&A's lacquer casket was made for the export market, it was essentially an item of trade, albeit one of exceptional quality. However, it is remarkable to note the changing reception to items of export lacquer in Europe over the centuries. When lacquerware first reached Europe in considerable numbers from the late sixteenth century onwards, it generally met with widespread approbation. It was in pre-Revolutionary France, however, and Paris in particular, that several important European lacquer collections were formed during the eighteenth century. Most notable were those of Madame de Pompadour (1721–1764) and Marie Antoinette (1755–1793), whose taste and connoisseurship ranged from lacquer for the export market to that for domestic consumption. It was undoubtedly while on several extended trips to Paris between 1777 and 1814 that the Englishman and avid collector, William Beckford (1760–1844), was first exposed to

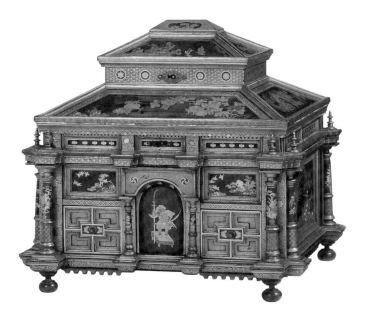

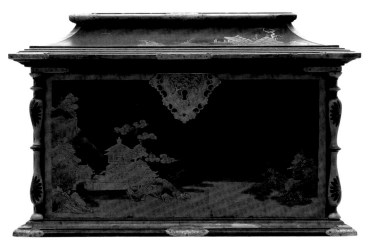

Japanese lacquer.[8] Influenced by such royal collectors, he too began to amass one of the most significant collections of rare lacquer in Europe at that time. The Chiddingstone casket was also almost certainly owned by Beckford[9] and, in the sale of his collection at Fonthill Abbey in 1823 it was sold for £14 14s.[10] Like the related Chiddingstone casket, it is quite possible that the V&A casket was also owned by William Beckford. According to a letter dated 19 April 1826 to Beckford from Gregorio Franchi, his agent in Paris, the description of an object that he urged Beckford to buy would appear to match that of the V&A casket or, if not, referred to one very similar:

> Your casket [and?] tray is in good condition … until yesterday I had it in my hands, we must buy it. The great [object?] of ebony and ivory is very curious; one of the ebony panels is cracked, the other warped and the rest is perfect. Every element can be considered perfect in its type. Inside is a drawer decorated on the exterior with cartouches, on the interior with rich mosaics … The type of carving in ebony is of the most artistically refined; one side? with a scene with cranes, the other side with two magical chimers, and the sides with flowers and everything in the best possible taste.[11]

Whether or not the casket was owned by Beckford, it entered the collection of the V&A in 1868, bought for the then substantial sum of £140.

The V&A casket is lavish, ornate and exotic, designed to appeal directly to European taste of the seventeenth century. Although it was an export item, it nevertheless reveals elements of composition and design that have much in common with lacquer for the

Above left and right:
20. Casket, Japanese for the European market, late 1630s
Black-lacquered wood with gold and silver *hiramaki-e* and *takamaki-e* with mother-of-pearl shell, 35.6 x 37.5 x 31 cm (14 x 14¾ x 12¼ in)
The Trustees of the Denys Eyre Bower Collection, held in Trust at Chiddingstone Castle, Kent

21. Casket, Japanese for the European market, late 1630s
Black-lacquered wood with gold and silver *hiramaki-e* and *takamaki-e*, 41.5 x 28 x 29 cm (16⅜ x 11 x 11¼ in)
Wilanów Palace Museum, Warsaw

domestic Japanese market. According to conventions associated with the decoration of Japanese lacquer, the box was generally conceived as a whole, with the interior and exterior being connected. Not only was the subject or theme depicted on the outside carried through to the inside, but it was usually also executed in different lacquer techniques, deliberately resulting in contrasting colour effects. When the box was opened, the result was often, as here, a complete and unexpected visual surprise. Many such elements can be found on the casket in question. Visually, one of the first impressions of the casket is that the carved wood is somewhat dark and subdued. Yet the columns provide a contrast in terms of material and colour, together with the profusion of thin geometric and floral borders. However, when the main lid of the casket is opened, the overwhelming effect is one of sumptuous gold lacquer, with the landscape carried out in detailed and complex lacquer techniques, resulting in a feast for the eyes.

The exterior decoration, lavishness and exoticism of the V&A casket also displays unmistakable similarities to the Kara-mon and Yōmei-mon gates of the Tōshō-gu Shrine, Nikkō, the mausoleum of the first Tokugawa shogun, Tokugawa Ieyasu (1542–1616), built by 1617 but altered extensively between 1634 and 1636 (fig.22). At the heart of the reconstruction were the lavish and exotic Yōmei-mon and Kara-mon gates, both of which were constructed using the *kara-yo* (literally 'Chinese style', but also meaning 'foreign style'), which was introduced during the Kamakura period (1185–1336). Although neither the Yōmei-mon nor the Kara-mon are typical Chinese-style gates, they both reveal a prevalence of Chinese features, such as strongly curved gables, decorative motifs of Chinese origin, such as mythical dragons, phoenixes and *shishi*, the imitation of Chinese techniques and the exotic colour scheme of white, black and gold. The pillars of both gates, for example, consist of wood, carved in geometric patterns reminiscent of Chinese carved lacquer. These were subsequently whitewashed and decorated with gilt metalwork and exotic woods. In particular the columns of the Kara-mon reveal dragons on a white ground, which are strikingly similar to the gold lacquer dragons found on the ivory columns of the V&A casket. Since the Tōshō-gu Shrine was the lavish mausoleum for the first Tokugawa shogun, it was undoubtedly intended to make a bold political statement. Lacquerers in Kyoto who made the V&A casket must have been aware of the shrine. It seems clear, therefore, that the casket was influenced by the two gates and must have been made at a slightly later date; that is, after 1636.

Built at a time when the Tokugawa shogunate had only recently achieved political dominion over Japan, the Tōshō-gu Shrine made frequent allusion to China, if only partly in an imaginary sense, as a means of legitimising its authority. Such allusion to China on the V&A casket includes carved and lacquered wood imitating carved lacquer, lacquer decoration imitating Chinese ink painting, as well as such Chinese motifs as

22. Kara-mon gate, Tōshō-gu shrine, Nikkō, 1617, altered 1634–6
Photo: J. Hutt

dragons, *shishi* and phoenixes.[12] Chinese influence can also be found in yet another element of decoration of the V&A casket. All lacquer items of the superlative group portray more or less elaborate scenes of buildings around a lake, often within a larger and more complex landscape. This, I have recently argued elsewhere, is almost certainly an allusion to the *Ōmi hakkei* (Eight Views of Ōmi), the eight famous scenic spots on the shores of Lake Biwa in Ōmi province (now Shiga prefecture), when the buildings look Japanese.[13] But when they appear Chinese or mock-Chinese, these waterscapes almost certainly refer to the earlier Chinese Eight Views of the Xiaoxiang, the Xiao and Xiang being rivers in modern Hunan province which flow into Lake Dongting (see fig.18, inside of lid). Originally a theme in Chinese poetry, the eleventh-century artist Song Di (*c*.1015–*c*.1080) originated the Eight Views of the Xiaoxiang in the painting medium, a subject evocative of the atmospheric river scenery near Lake Dongting. The theme, which was introduced to Japan in the fourteenth century, achieved considerable popularity there and, by the fifteenth century, was often adapted to a Japanese setting, hence the Eight Views of Ōmi.

In addition to the landscape scenes, almost all items of the superlative group also include scenes that allude to the *Genji monogatari* (*Tale of Genji*), the early eleventh-century novel written by the court lady, Murasaki Shikibu, which follows the life and loves of Prince Genji. The Genji reference on the V&A casket is confined to two virtually identical scenes on the removable tray and the inside of the sliding panel, which unmistakably allude to 'Nowaki' ('The Typhoon'), chapter 28. Following the typhoon described in this part of the book, Genji's cousin Akikonomu sent women and girls to put out insect cages and also search for any stray flowers untouched by the storm. But since earlier lacquerers went to great lengths to decorate export lacquer with subjects and designs that were meaningful to their European clients, why did they choose the *Tale of Genji* which would have been virtually unknown to them? The connection was, as I have recently suggested, that it was at the Ishiyama temple, one of the Eight Views of Ōmi, that Murasaki Shikibu is reputed to have started writing the novel.[14] And it is for this reason that the *Tale of Genji* and either the Eight Views of the Xiaoxiang or the Eight Views of Ōmi were depicted on export lacquer of the superlative group. Since the subject matter of each is distinct, this resulted in parts of the chests, boxes or caskets that were specifically Japanese or Chinese in iconography, medium or technique, whether real or implicit. Whereas the *Tale of Genji* represented the Japanese element, allusions to either the Eight Views of the Xiaoxiang or the Eight Views of Ōmi could represent the Chinese or Japanese element respectively.

Why is the design on the inside of the sliding panel and the tray virtually identical? What, if any, is the function of the tray (see fig.19)? Indeed, as it does not sit comfort-

ably inside the casket we may ask whether it is actually original? If one examines the Genji design on the inside of the sliding panel, it is not only somewhat clumsy in its execution, but the very material seems not to be true lacquer but a Western imitation. By comparison, the reverse is true of the same design on the tray. Moreover, since the dimensions of the rectangular 'frame' surrounding the Genji scene on the tray appear to correspond to the inside of the sliding panel, it is probable that, although this was originally part of the inside of the sliding panel, it was subsequently removed. To cut and remove the thin topmost decorative layers from an otherwise perfectly sound lacquer object without damaging either, was a highly risky procedure, yet it was not infrequently carried out in eighteenth-century France. Since Japanese lacquer was not only in short supply in Europe but, what little did exist, was also in outmoded forms, French *marchands merciers* readily purloined pieces of export lacquer and incorporated them into fashionable pieces of contemporary furniture. But although one can understand, even if not condone, such action, why was a piece of lacquer, albeit one that was not immediately visible, cut out and removed from an item of export lacquer if it were simply to be retained with the original? The answer would seem to be that, by using other pieces of Japanese lacquer from the already existing stock in Europe, a superb casket could be even further 'improved'. Although it is not clear who commissioned this extra work on the casket, it is possible that a certain 'Dugart Esq(?)' was involved in some way, since his name was found written in pencil on the casket during conservation work at the V&A in 1985.[15]

A close inspection of the sides and corners of the tray reveals that the craftsmen went to considerable lengths to make it. Since it is evident that they did not have at their disposal a piece of lacquer of suitable size or thickness, they used instead various different pieces of old Japanese lacquer which were cut and glued together. The base is made up of a piece of lacquer decorated with gold floral scrolls on the outside, on top of which a thicker section of wood covered in *nashi-ji* lacquer was fixed. To help disguise the fact that the tray was made from composite pieces, sections of matching floral scrolls were added to the outer sections as necessary in the form of veneers, including vertical strips at each corner. The upper surface of the tray consists of *nashi-ji*, into which the framed rectangle enclosing the original Genji scene was set.

Similarly a close inspection of the inside of the casket's drawer reveals that a piece of lacquered wood was inserted at either short end. On one of these, there are even the vestiges of a floral motif from the design on the original object. Since the drawer is in excellent condition, the lacquered wood additions would appear to serve no purpose connected with its original function. However, it is possible to determine a likely use for the casket's tray. As mentioned earlier, the drawer was lavishly decorated in sumptuous

techniques on all four sides. Not only was the drawer effectively 'hidden' behind the sliding panel but also, with the exception of the drawer front, the remaining sides would only be seen if the drawer were removed altogether. While the drawer was slightly smaller than the interior of the casket, the tray was even smaller, allowing it to be taken in and out of the main body. For someone trying to improve and elaborate on an already superb object, it would seem a logical step to make the drawer into an important object in its own right. This could be achieved relatively easily by providing a lid for the drawer, thereby making it into a box. And what better way of doing this than by removing the Genji scene from the inside of the sliding panel and making it the focal point of a newly-made tray. However since the tray needed to be stored inside the casket, it was essential that it was of slightly smaller dimensions than the inside of the drawer. When placed on top of the drawer as a 'lid', therefore, it would inevitably fall in. This undoubtedly accounts for the addition of small pieces of lacquered wood at either side of the drawer interior. By placing a small ivory foot on the underside of each corner of the tray, it could also be made into a decorative object in its own right. When stored inside the casket, the ivory feet also minimised damage caused by friction. The one major flaw in this new arrangement, however, is the size of the tray. Since there is no room for a person's fingers when inserting or removing the tray from the casket, it is extremely difficult to perform either of these activities without causing damage.

When the original Genji design was removed from the inside of the sliding panel, it would undoubtedly have left a somewhat unsightly and uneven surface, even though this was not immediately visible. A Western varnish has been added to the inside of the sliding panel, closely following the design of the original, now on the tray. Oral tradition in the V&A relates that this was done by Gunji Koizumi (1885–1965), who arrived in England from Japan in 1905. Apart from introducing judo to England, he also set up an antiques business in London which dealt, among other things, in Chinese and Japanese lacquer. Before long, he had also branched out into a highly successful enterprise making japanned furniture and smaller items in a chinoiserie style. It is known that Koizumi assisted Lieutenant-Colonel Edward F. Strange (CBE), Keeper of the Department of Woodwork at the V&A, in many projects.

Whoever copied the original design onto the sliding panel and, indeed, whenever it was carried out, the quality of the work is a pale shadow of the original. In addition, the combination of removing a section of the original surface, using Western varnish on the resulting exposed inside of the panel and lacquer on the exterior, has, over time, produced stresses and strains that have resulted in irreversible cracking. For many years now, the panel has warped so badly that it has been impossible to insert it into the casket.

The Japanese export lacquer casket is a complex object that has been subject to many alterations and additions over time. It not only bears witness to seventeenth-century Japanese understanding of European taste but also eighteenth-century French concepts of luxury objects, as well as later European misunderstanding of how to 'improve' an already remarkable object.

NOTES

1. For examples see Derek E. Ostergard, ed., *William Beckford, 1760–1844: An Eye for the Magnificent* (New Haven, CT, and London: Yale University Press, 2001), p.375, cat.no.105, and Marta Ajmar-Wollheim and Flora Dennis, eds, *At Home in Renaissance Italy* (London: V&A Publications, 2006), p.178, plate 13.5, left.

2. It is worth noting that in 1735 Father Jean-Baptiste du Halde (d.1743) wrote of polished black Chinese lacquer (made of the same material as that of Japan) that it 'resembles a looking-glass'; Margaret Jourdain and R. Soame Jenyns, *Chinese Export Art in the Eighteenth Century* (Feltham, Middlesex: Spring Books, 1967), p.17, quoting from Charles Lockyer, *An Account of the Trade in India* (1711); du Halde, *Description de la Chine*, vol.II (1735), p.177.

3. When the casket was bought by the V&A in 1868, it also contained two lacquer combs. Since these are not considered to be part of the original object, they will not be discussed.

4. For an example see Oliver Impey and Christiaan Jörg, *Japanese Export Lacquer 1580–1850* (Amsterdam: Hotei Publishing, 2005), plate 225.

5. The constituents of this group were first defined by Joe Earle, in 'Genji Meets Yang Guifei: A Group of Japanese Export Lacquers', *Transactions of the Oriental Ceramic Society*, vol.47 (1982–3), pp.45–75. Apart from sharing very specific characteristics, lacquer in this group was also made roughly between 1630 and 1640 and is of exceptionally high quality.

6. The Vienna casket (inv. no. LA 260/1946) is illustrated in Impey and Jörg, *op. cit.*, plate 135. Like the V&A casket, the Vienna casket also has ivory columns with gold lacquer dragons.

7. Many of these are illustrated in Impey and Jörg, *op. cit.*, pp 168–71.

8. Anne Eschapasse, 'William Beckford in Paris, 1788-1814: *Le Faste Solitaire*', p.99, and Oliver Impey & John Whitehead, 'Observations on Japanese Lacquer in the Collection of William Beckford', p.217, both in Ostergard, Derek E. (ed.), *William Beckford, 1760–1844: An Eye for the Magnificent* (New Haven, CT, and London: Yale University Press, 2001).

9. Impey and Whitehead, *op. cit.*, pp 221–2.

10. Lot 908 on the 18th day of the sale, 2 October 1923.

11. Fol.80, 80v. MS Beckford c.12, translated from the Portuguese by Pedro Moura de Carvalho, and quoted in Impey and Whitehead, *op. cit.*, p.222.

12. Lacquer imitating Chinese ink painting can also be found on the Vienna casket and the inner tray of the Van Diemen Box, V&A inventory no.W.49-1916, which are also constituents of the 'superlative group'.

13. Julia Hutt, 'From the *Eight Views of the Xiaoxiang* to the *Ōmi hakkei*: A New Interpretation of the Iconography of the Mazarin Chest', *Transactions of the Oriental Ceramic Society*, vol.71 (2006-7), pp 3–18.

14. Hutt, *op. cit.*

15. At present, it has not been possible to identify Dugart Esq(?).

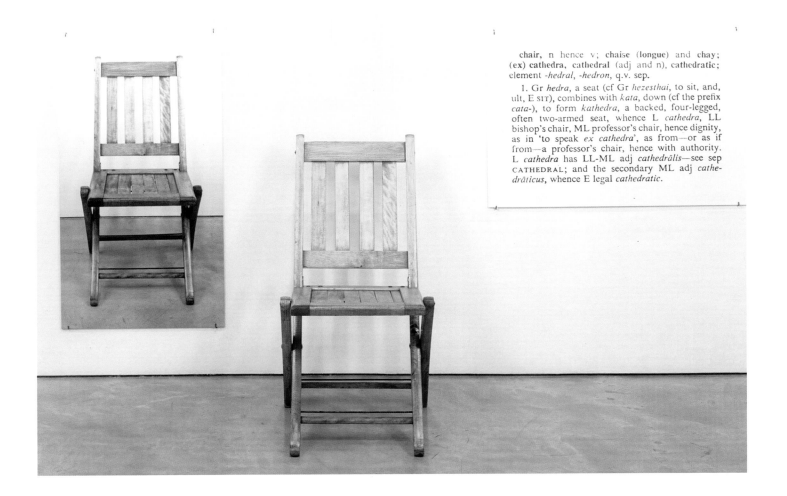

23. Joseph Kosuth, *One and Three Chairs*, (Ety.),
1965
Chair, photograph of a chair and photographic
enlargement of dictionary definition (Etymological)
of a chair, original photo-certificate
Museum of Modern Art, New York, courtesy Sean
Kelly Gallery, New York

Joseph Kosuth's *One and Three Chairs*, 1965

A photograph of a chair, an actual chair and a photocopied, enlarged dictionary definition of the word 'chair' are all placed side by side (fig.23). This is what a viewer encountering Joseph Kosuth's (b.1945) *One and Three Chairs* would find him or herself being faced with. The chair itself, a nondescript common wooden chair, is not particularly distinctive, while the enlarged dictionary definition tells us what we know a chair to be, that it is a piece of furniture to sit on. The black and white photograph, however, provides some further insights into the work. Upon closer examination, we become aware that the chair in the photograph is the same chair we see before us. What becomes further apparent is that not only is the chair in the photograph the same chair we see before us, the image in the photograph is of the chair *in situ*; it was taken in the same place and position that we see the chair in. So what do these three objects tell us? What is Kosuth attempting to express through the juxtaposition of these three objects? By presenting three different concepts of 'chair', Kosuth seems to be questioning or defining the essence of what 'chair' is, or 'chairness'. However, another and perhaps more interesting way to approach this work is to see it as questioning the concept of representation itself, or highlighting the inadequacies of representational systems. By presenting three different representations of a chair, Kosuth can be seen to be representing the idea of representation itself through photographic and linguistic means. *One and Three Chairs* forms part of a series of works by Kosuth titled *Protoinvestigations*. Further works within this series include *One and Three Hammers*, *One and Three Tables* and *One and Five Clocks*, among others. These works all share a common format, which comprises an object, a photograph of the object and one, or more, blown-up dictionary definitions. (*One and Five Clocks*, for example, consists of three dictionary definitions – of 'time', 'machination' and 'object'.)

A good starting point to analyse *One and Three Chairs* is the date of the work. Kosuth himself dates it from 1965, the year he began his *Protoinvestigations*. However, the historian and critic Benjamin Buchloh has questioned the authenticity of this information in his well-known essay on conceptual art. In a footnote to that 1989 essay entitled 'From the Aesthetic of Administration to Institutional Critique (Some Aspects of Conceptual Art 1962–1989)', Buchloh argued that no documentary evidence exists 'which would confirm with definite credibility Kosuth's claim that these works of the *Protoinvestigations* were actually produced and physically existed in 1965, when he (then twenty years old) was still a student at the School of Visual Arts in New York'.[1] Buchloh goes on to write that these works by Kosuth were not exhibited until 1967. In his response to Buchloh,

which was published in the same exhibition catalogue, Kosuth retorted that *One and Three Chairs* existed as a concept from 1965, even though it was never physically realised until 1967: 'These works existed only in notes or drawings and were fabricated after I had the financial resources due to interest in the somewhat later work.' In addition, further in his published response, he provides some indication of the relationship between the conceptual nature of his work and the validity of its existence in the absence of any material manifestation: 'I simply had no funds at that age to fabricate works, and frankly, with no hope to exhibit them at the time – and with the nature of the work being what it was – there really was no point.'[2] Can an artwork therefore exist as a concept before it is actually realised materially, as Kosuth posits? This point is crucial in understanding conceptual art, of which *One and Three Chairs* is an early and famous example. Kosuth continued: 'This work is titled Proto-investigations, clearly from the vantage point of the Investigations. Is the physically exhibited presence of a work the only criterion for its existence? It isn't, if you know anything about Conceptual Art.'[3]

This exchange between Buchloh and Kosuth is not untypical of the debates about historical accounts during the late 1960s. Paul Wood has highlighted the infighting between the various factions and artist collectives as to the accuracy of their historical accounts of conceptual art:

> As early as 1973, the American artist Mel Bochner greeted the critic Lucy Lippard's attempt to catalogue developments in conceptual art from 1966 to 1972 in her book, *Six Years*, with a root and branch condemnation in the pages of *Artforum*, the leading art magazine of the period. For Bochner, Lippard's account was 'confusing' and 'arbitrary', and [an] 'act of bad faith' that resulted in little more than a 'parody' of what actually happened.[4]

Therefore, apart from the discussion as to whether a work of art can exist purely as a concept, as Kosuth argued, where the conceptual premise behind a work is important – perhaps even more than any material manifestation of that concept – the significance of Buchloh's and Kosuth's exchange also lies in the attempt of the latter to position himself as a pioneer of conceptual art. The late 1960s has been acknowledged as the period when conceptual art first emerged, as Lucy Lippard recounted in her seminal (albeit heavily criticised) book on the subject, *Six Years: The Dematerialization of the Art Object from 1966 to 1972*.[5] As such, dating *One and Three Chairs* two years earlier than the year Buchloh argued for is crucial for supporting Kosuth's claim to be one of the earliest artists engaging with this new tendency. His claim that the *Protoinvestigations* dated from 1965 would, in effect, mean that they predate the practices of almost all other conceptual artists and cement his claim as the pioneer of conceptual art. What therefore is the significance

of *One and Three Chairs* in its development? In order to address this, it is perhaps necessary to examine the influences and rationale behind Kosuth's work.

One and Three Chairs is Kosuth's most well-known work and has also come to be one of the most iconic works of conceptual art. Although Sol Lewitt has been acknowledged as the first artist to articulate and write about conceptual art in his 'Paragraphs of Conceptual Art' published in *Artforum* in 1967,[6] Kosuth was, nevertheless, among the earliest artists who also wrote about the new tendency. In his 1969 essay 'Art after Philosophy' Kosuth established his position as one of conceptual art's leading spokespersons, as well as laying down his position on the rationale and aim of conceptual art. He wrote in 'Art after Philosophy' that:

> The twentieth century brought in a time which could be called 'the end of philosophy and the beginning of art' … I bring all this up to analyze art's function and subsequently its viability. And I do so to enable others to understand the reasoning of my art, and by extension, other artists', as well as to provide a clearer understanding of the term 'Conceptual art'.[7]

For Kosuth, conceptual art was an exploration of the nature and meaning of the conventions themselves. It was a 'deconstructive' art responsive to the changes in the philosophy of the time. This concern for the problem of art's definition led to his interest in the writings of Ludwig Wittgenstein (1889–1951). The philosopher's inquiry into the meaning and boundaries of concepts was the point of departure for Kosuth's work, which examined the concept, nature and boundaries of art. It was, in particular, Wittgenstein's theories on meaning and language that interested Kosuth most, as Kosuth believed that art was primarily linguistic. He often described art as a 'language' and works of art as 'propositions' within that language. His inquiry into the meaning of language was, therefore, at the same time an inquiry into the nature of art. Texts by and about Wittgenstein are constantly alluded to and used in the production of Kosuth's own *Art Investigations*. The very term *Art Investigations* which he gave to his artwork manifests his art as a form of conceptual inquiry. He used art institutions, language and objects to investigate the limits, meaning and boundaries of the concept 'art', subjecting art to a radical deconstruction, emptying it of all traditional value in his exploration of its boundaries. For him, the importance of particular artists can only be 'weighed according to how much they questioned the nature of art'.[8] This questioning of art, therefore, was for Kosuth intimately tied to the questioning of meaning. He argued retrospectively in 1988 that what differentiated conceptual art from other post-minimalist tendencies during the late 1960s was its concern with issues of meaning, explaining: 'post-Minimalism's primary concern is with a radicalization of alternative *materials* rather

than alternative *meanings*. But it is issues of meaning – the process of signification – that define conceptual art.'[9]

Critics such as Buchloh and Charles Harrison have similarly credited conceptual art with effecting a paradigmatic break from modernist art. Buchloh argued that this functioned through the manner in which conceptual artists 'performed the most rigorous investigation of the conventions of pictorial representation and a critique of the traditional paradigms of visuality in the post-war period'.[10] They have, in turn, argued that one of the most significant aspects of this 'investigation' was into the construction of meaning and processes of signification that Kosuth also highlighted. This mode of investigation has, similarly, been attributed to the linguistic turn[11] that characterised the humanities during the 1960s. Conceptual art's linguistic turn is rooted in the unassisted readymades of Marcel Duchamp (1887–1968), which date from the 1910s. Thierry de Duve recently argued that Duchamp's readymades had achieved the ultimate modernist reduction of art from the visual to the linguistic, a model from which conceptual art was to go on to develop. De Duve also argued that the reason artists did not act on this model until the 1960s was because 'not until the sixties had the humanities accomplished their own linguistic turn, when Saussurian linguistics provided the matrix for structuralism'.[12] Kosuth's work was, therefore, one of the earliest manifestations of conceptual art's linguistic turn. In 'Art after Philosophy' Kosuth articulated a model of conceptual art, or 'analytic' conceptual art, which was closely predicated upon his own practice and those of Art & Language.[13] Kosuth therefore posited art as a form of conceptual inquiry into the definition of art, which was largely based on the logical positivism of A.J. Ayer, as well as the linguistic philosophy of Wittgenstein. As previously discussed, in *One and Three Chairs* Kosuth was not attempting to define the concepts of 'chair', but was instead representing the idea of representation through photographic and linguistic means. The work therefore functioned in a tautological manner, making a statement of fact, and in doing so also highlighting the relationship of meaning to language. It was through this examination of language and meaning that Kosuth sought to examine the nature of art. His *Protoinvestigation* works such as *One and Three Chairs* adopt Wittgenstein's theories as posited in *Tractatus Logico-Philosophicus* (published 1921), in which its propositions are for the most part concerned with spelling out Wittgenstein's account of the logical structure of language.[14] In *Tractatus* his 'picture theory of meaning' shows how language and reality share the same logical form so that 'proposition, language, thought, [and] word stand in line one behind the other, each equivalent to each'. And because words are immediately correlated with things in the *Tractatus*, speaking the name of the thing in the physical presence of that thing, or pointing to it and saying 'this', seems to provide an irreproachable example of the relation between language and reality. Kosuth here indeed

seems to be pointing to these objects in this way. Even if he does not say 'this is', he certainly appears to be making that gesture. In *One and Three Chairs* the bare representational style and the sense of redundancy do in fact suggest a sequence of object, image and word, 'each equivalent to each other', with Kosuth seemingly succeeding in creating a suitable 'picture' of Wittgenstein's 'picture theory of meaning'. The significance of Wittgenstein's influence on Kosuth can be further seen in the way the artist uses his later work to explore issues that were also central to Wittgenstein's later theories as argued in his *Philosophical Investigations*; the relation of word to thing and of meaning to context, the limits of logic and the fluidity of conceptual boundaries.[15]

In 'Art after Philosophy' Kosuth had further acknowledged the significance of Duchamp's readymades in his analytic mode of conceptual art:

> [With Duchamp's] unassisted readymades, art changed its focus from the form of the language to what was being said. Which means that it changed the nature of art from a question of morphology to a question of function. This change – one from 'appearance' to 'conception' – was the beginning of 'modern' art and the beginning of 'conceptual' art. All art (after Duchamp) is conceptual (in nature) because art only exists conceptually.[16]

Kosuth's works can therefore also be seen to function in a linguistic manner similar to Duchamp's readymades, where the 'meaning' of an object can be transformed through the change in context brought about purely through the act of nomination. This can be seen in the subsequent series of work that developed out of Kosuth's *Protoinvestigations* into meaning and representation in art, as exemplified by *One and Three Chairs*. In his *First Investigation* (1966–8) Kosuth extended his analysis to the shifting and mutable nature of meaning and signification. In *VI. Time (Art as Idea as Idea)* (1968), by presenting the viewer with numerous definitions for the concept of time, the work forces its viewer to shift between the different definitions. No single definition achieves authority, for there is ultimately not one stable definition of a word so much as fluid, shifting and overlapping definitions of it. Wittgenstein's work, particularly regarding the undermining of the 'ostensive definition', was especially relevant in the formulation of Kosuth's linguistically derived conceptual inquiry. Wittgenstein argued in *Philosophical Investigations* how the notion of the 'ostensive definition', or the centrepiece of definition, was something he felt did not exist due to its inherent ambiguities, arguing that it 'can be variously interpreted in every case'.[17] This related in many ways to the structuralist linguistic theories developed by Ferdinand de Saussure (1857–1913) in the 1910s, the same period from which Duchamp's unassisted readymades derives, and to which the linguistic turn of the 1960s has frequently been attributed. Saussure articulated his theories on language and meaning in his *Cours de Linguistique Générale* (*Course in General Linguistics*), which was

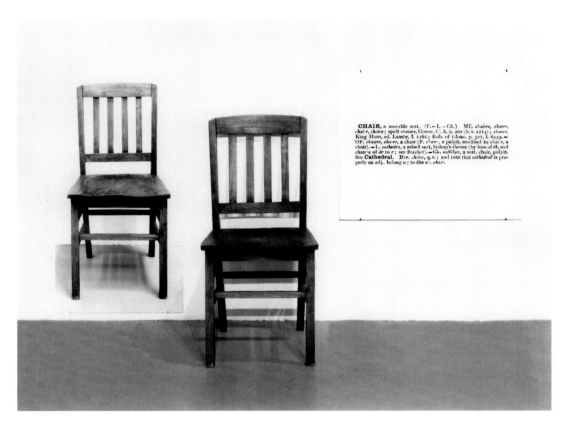

Above and below:

24.Joseph Kosuth, *One and Three Chairs***, (Ety.), 1965**
Chair, photograph of a chair and photographic enlargement of dictionary definition (Etymological) of a chair, original photo-certificate Museum of Modern Art, New York, courtesy Sean Kelly Gallery, New York

25. Joseph Kosuth, *One and Three Chairs***, (Ety.), 1965**
Chair, photograph of a chair and photographic enlargement of dictionary definition (Etymological) of a chair, original photo-certificate Museum of Modern Art, New York, courtesy Sean Kelly Gallery, New York

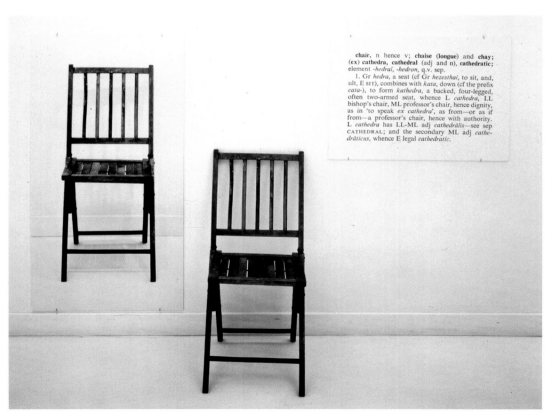

27. David Reed, *No. 286-2*, 1990–2
Oil and alkyd on linen, 68.6 x 259 cm
(27 x 102 in)
Private Collection, Germany, courtesy Galerie
Schmidt Maczollek, Cologne

complex discourse in these writings, but I am concerned with what happens when we move in front of a painting for the first time: what can our eye, body and mind tell us unaided?

What we began with was a very bald description. Every time we encounter a painting we would like to pretend that we are a *tabula rasa*, a blank slate, responsive only to the painting, unclouded by preconception and prejudice. That is of course only momentarily possible: the walls may be white, but the room is not a laboratory; we are each a human being with a complex history, not a photosensitive lens or a scientist's rat. No wonder the description above feels unduly restrained. We keep wishing to say that some element of the paintings is like something else, or reminds us of something else. Words such as 'cinemascope', 'buttery', 'velvet' may bob up in our consciousness. Paintings work by associations and therefore to evoke the sensation of experiencing any painting we have to accept the not always predictable rule of metaphor. For example, we may describe the marks as rolling one over another like cloth gathered together or like the motions of some viscous liquid agitated. Or we may say that these curves are done with the panache of a writing exercise: a hand seeking fluidity. We may go for a low-life

reference and say they look like the soapy marks that window-cleaners with their squeegees cover windows with before wiping them dry; or we may go for a high-art reference and say how much they look like the drapery in seventeenth-century Italian paintings, in those by Guercino (1591–1666) for example.

Allowing the multivalence of such associations into our mind may take us into a reverie that leads us away from the painting or else leads us back to look more closely at it. If the yellow and blue and red seem smoothed out, almost photographic in their blended softness, the black that overlays them is very sharply defined, so much so that one can see or even feel with our fingers the ridges and furrows left by the brush dragging through the swiftly drying paint. These marks seem coarser, more workman-like than the other more opulent forms. The spots at the bottom look like soup or coffee spilt and congealed on the floor. However, they connote not casualness but speed and freedom of expression, implying that the painting was made quickly, with a few deft vigorous motions. The sense of motion is clearly important here. The seeming casualness of such marks and then the seemingly arbitrary nature of the imposition of rectangular overlays upon the serpentine wrigglings seem wilful. Yet we sense this is a painting that in all its apparent oddities is very carefully considered.

Grandiloquent gestures and arbitrary boundaries; this painting works by sharp contrasts. All is extremely sensuous, like folding crushed velvet in our hands or running our fingers through cream, but the harsher, lumpier, blacker black repels us. Except where the surface is so smooth that it seems flat – photographic even. We imagine spreading very soft butter on bread, then scraping it and scraping it till it is as smooth as a mirror. We wonder whether the painter spent more time sanding the paint back to get this effect than he did actually painting it. The artist wrote:

> I should make a clarification: the paintings are not sanded after the marks are made. Often people think that they have been sanded in this way. The fine sanding marks that sometimes show are on the under-layer below the more liquid top layer of paint. We do the sanding to make sure that the more liquid paint sticks to the underlying surface. The alkyd paints flatten as they dry and this also suggests that the surfaces have been sanded.

But the overlaid band seems put on so abruptly, as if to break the flow or put it, as it were, in quotation marks.

So, we are held in a limbo between shared sensuality and a conceptual uncertainty, as if a beautiful, soothing song is constantly being interrupted by a harsher, more literal spoken voice. Or, as if we were listening to the radio where a woman with a beautiful voice is singing but another channel – the news in Serbo-Croatian perhaps – keeps cutting in and interrupting. These interventions, the impositions of these other areas, seem

to put the sweeping brush-marks as it were into quotation marks. I would like to say that if we have entered the space of the painting, that if we in some way are imagining ourselves there, we are now being held in some sort of liminal space between statement and the quotation of a statement.

There is an argument here between gesture and structure, between the organic and the geometric, between an idea of freedom, of sensuous liberation and order. This is, we sense, a painting about painting, but where painting is understood to stand for a psychic need, or desire, for sensuous freedom and pleasure.

We may only think we are looking but sensations of hearing and touch have also come into play. Also coming into play whenever we look at a painting is what may be argued is the sixth sense: kinaesthesia, the sense of motion in our own body. This is key. We walk up to and back from the painting to look closely at a detail or get an overall feel, we walk along it, as though miming its movement. It is as though we were performing some strange courtship ritual or dance. Our whole body is involved and in effect the painting is about the human body – in kinesis and fleshliness. The American painter Brice Marden (b.1938) speaks beautifully of this:

> How you look at a painting physically is very important. A good way to approach a painting is to look at it from a distance roughly equivalent to its height, then double the distance, then go back and look at it in detail where you can begin to answer the questions you've posed at each of these various viewing distances. If you go through a museum and you look at a lot of paintings in that way, it's like a little dance; it's almost a ritual of involvement.[2]

But in what place does one 'make' this 'dance'? It isn't only in museums that one encounters paintings – and of course museums themselves vary a good deal. When one performs such a 'dance' in a popular museum like the Tate or MOMA, one is distracted by the need not to bump into someone else. As we have said above, one does not encounter any painting in some virtual laboratory. In what context did I or do I see *No. 286-2*? Three times, each one in a very different context: in a private gallery (Todd Gallery; fig.29), a public space (John Hansard Gallery; fig.28) and a private collection (fig.30). I saw it first in 1994, in a mixed exhibition entitled *Chance, Choice and Irony* where it was shown alongside paintings by, among others, Colin Crumplin (also the curator of the show), Bernard Frize, Jonathan Lasker and Fiona Rae.[3] A common theme was how the art adapted chance elements or apparently intuitive, subconscious gestures to make large and highly conscious statements. Put another way all these artists, including those who made objects rather than paintings, navigated across that grey ocean between the instinctive, the considered and the arbitrary.

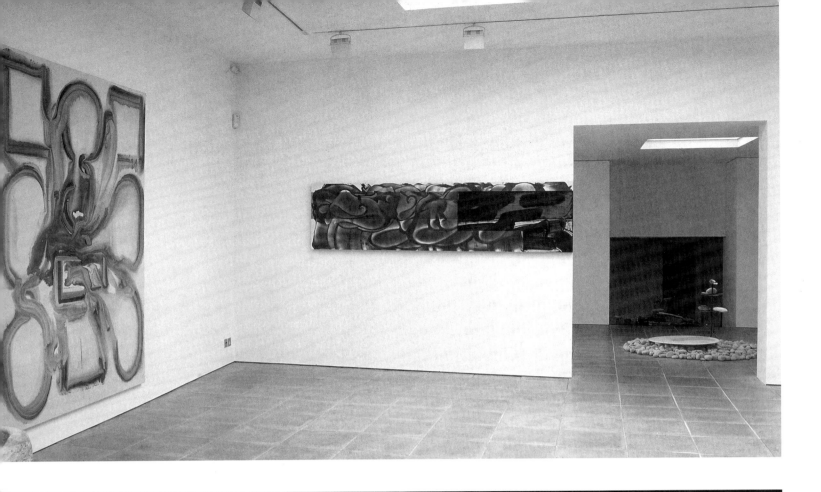

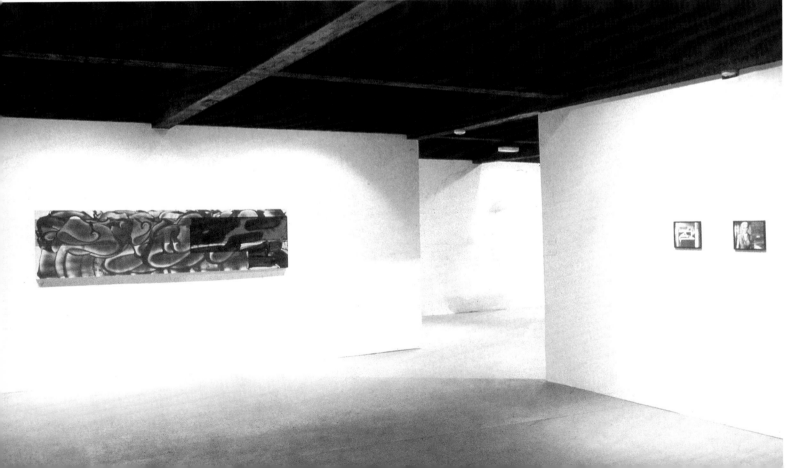

Opposite above and below:

28. David Reed, *No. 286-2*, 1990–2, as installed in the John Hansard Gallery, University of Southampton, 1994

29. David Reed, *No. 286-2*, 1990–2, as installed in the Todd Gallery, London, 1994

Right:

30. David Reed, *No. 286-2*, 1990–2, as installed in a Private Collection, Germany

In both the Todd Gallery, London, and then the John Hansard Gallery at the University of Southampton, *No. 286-2* was shown on white walls with lots of empty space around it. This is a norm nowadays, firstly because it allows us to concentrate on the work, secondly because it makes it look significant. But in each case if one cared to stand back and scan the entire space, there was the inevitability of a conversation being set up between the various works. The painting's apparent arbitrariness seemed less perverse when placed next to other works that used painterly gesture in a way that was perhaps ironic or self-conscious. At my instigation in the Todd Gallery it was hung abutted to the edge of the wall so the movement of the brush-marks seemed about to flow out into empty space. (I had seen in exhibitions elsewhere Reed himself install smaller works thus.) The sense of both strangeness and incompletion in the work was thereby emphasised.

Fourteen years later I see *No. 286-2* again in a private collection in Germany. It has not changed, though I obviously have for I am older, my views and expectations have changed. And the context is very different: it is no longer hung on a clinical white wall but high on a dark red-brick wall, above a concrete RSJ. It is very constrained by space now for the wires of the lights hanging above a table go in front of it, whilst a large structural column in the centre of the room impinges the view from directly ahead. It is no

31. David Reed, #579, 2005–08
Oil and alkyd on linen, 66 x 264 cm (26 x 104 in)
Courtesy David Reed Studio

longer master of all it surveys but is held in a much more insistent conversation with the other 40 or so artworks in the room. In particular, beneath the concrete RSJ is a line of smaller works including a painting by Joseph Marioni (b.1943), a mask from Peru, reliefs by Jan Schoonhoven (1914–1994) and Gunther Uecker (b.1930), and an early painting by Gotthard Graubner (b.1930). All are very contained objects, far more 'silent' than Reed's, showing no apparent narrative or movement. The silence of these works accentuates the movement of Reed's painting: it seems very supple and elusive next to these forthright objects that seem to stare back at the viewer so implacably.

Hanging on the column in the room are the solitary figurative works: one by Horst Antes (b.1936) of a walking man, which rhymes, as it were, with the movement of *No. 286-2*, as does the relief by Joel Shapiro (b.1941) that hangs near the bottom of the column, showing two legs in motion abstracted – his first figurative sculpture. The implicit sense of bodily motion in *No. 286-2* becomes more apparent in this context.

Now *No. 286-2* no longer seems to float in space but is anchored in an archipelago of references, from art, design, architecture, nature (it hangs beside a window that opens onto a leafy garden) and everyday life. This is a house, not a laboratory or a museum, and it has both the clutter that any house with two children has (the boy shows me the

wooden models he has made of characters from *Star Wars*) and the conversation between a host and a guest. We talk about art: how the owner started collecting; about how he and his wife initially lived with barely any furniture, all their money having gone on modern art; about conversations with David Reed. A collection is always as much a story as a place filled with objects.

Artworks are, as is remarked elsewhere in this volume, travellers through time. They may change from time to time, but we change constantly and how we view them is always under negotiation. After the visit to the private collection, I travelled to Düsseldorf to see recent works by Reed at Galerie Thomas Flor. One of the paintings there, *#579* (fig.31), seems like a compendium of his career; on the right in two insets are single horizontal brush-marks similar to those that constituted his work in the 1970s when, like other painters, he was trying to deal with the degree zero with which minimalism had confronted the art world; on the left and behind them the smoothed-out but opulent brush-marks that characterised the period when *No. 286-2* was made. The whole painting is in those vivid, acid, spectral colours that have characterised recent works. One experiences the artwork as an unique object but also as part of a career or an oeuvre; as I try and remember the earlier painting, *#579* lingers in my mind like an after-image.

We are wont to do two things when we discuss artworks: place them in the personal narrative of an artist and place them in a wider art history. We look for clues. Surely one cannot paint a painting today with the three primary colours without echoing, however faintly, Piet Mondrian (1872–1944) – even if it's done, as in *No. 286-2*, surreptitiously? This is perhaps an ironic reference to Mondrian's belief in perfection, in an ideal world. But we may recall that Barnett Newman (1905–1970) made paintings entitled *Who is afraid of red, yellow and blue* where he tried to *détourne* (re-route) the primaries into a much more environmental, sublime experience. Although his Californian background may have given him a taste for cinemascope proportions and Hollywood colours, David Reed is a New York painter and hence must reflect the legacy of the heroic period of the New York School with its grand ambitions. (The suture that runs through some other of his paintings in the Düsseldorf exhibition is clearly a reference to Newman's vertical zips.) It is difficult not to see his folds and curves as descendants of the endlessly curling lines in Jackson Pollock's (1912–1956) drip paintings or the endless cursive handwriting in Cy Twombly's (b.1928) blackboard paintings. But those Reed makes are far more self-conscious and far more sensuous. In the hands of several thousand followers of William de Kooning (1904–1997) any abstract gesturalism had become mannered and vapid. Reed works in a postmodern period when direct expressionism has become difficult; in a time when, as Umberto Eco notes, the words 'I love you' sound too much like what one reads in a Barbara Cartland novel, one can use them ironically to make an un-ironic statement: 'As Barbara Cartland would say, "I love you".' This sense of quotation, of bracketing with arbitrary structures, of seeming to speak in a liminal space, all seem currently necessary to avoid vulgarity and self-indulgence.

Many writers on Reed's paintings have drawn comparisons with drapery in Baroque painting. (In part this may be a response to his own enthusiasm for such painting. I doubt many other artists list on their CV, as he has, that he went to Malta to study the Baroque painter Mattia Preti.) When we look at the works of seventeenth-century painters such as Preti or Guercino, we often find passages of drapery that are quite excessive and wholly unnecessary for the painting's ostensible subject or narrative: lengths of fabric that stream out, coil, roll and fold in labyrinthine complexity. They stream out as if blown by winds that do not touch anything else in the painting. They allow colour contrasts delightful in themselves: honey yellow against pale blue against cherry pink. There is a *jouissance* to be found in such passages that is more than decoratively necessary: a sense of libidinal pleasure.

On the whole such references reinforce what we feel in looking at *No. 286-2*. It is about contrast or choice: the desire for pleasure (libido) and the necessity of structure (geometry). The mood or space it creates for us as viewers is one where that choice is

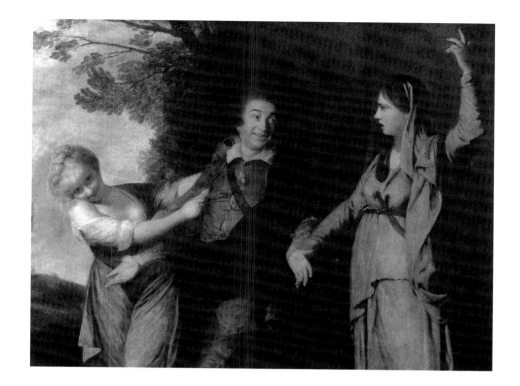

32. Sir Joshua Reynolds, *Garrick between Tragedy and Comedy,* 1760
Oil on canvas, 148 x 183 cm (58¼ x 72 in)
Private Collection

always being made, always being delayed. We could say the painting is about a choice of style: opulent or austere, discursive or direct. Perhaps we may recall the somewhat comic painting by Sir Joshua Reynolds (1723–1792), which, aping the choice of Hercules between Vice and Virtue, shows the actor and theatre manager David Garrick (1717–1779) having to choose between Comedy and Tragedy (fig.32). In this painting Comedy is painted in the soft, flowery style of Correggio (*c*.1494–1534), and Tragedy in the more austere, heroic style of Guido Reni (1575–1642). Like Garrick, David Reed knows he should like Guido more but he does have an awfully soft spot for Correggio. What at the last is crucial in David Reed's *No. 286-2* is that both poles – the geometric and the organic, the architectural and the fleshy, the arbitrary and the natural, the law and desire, Guido and Corregio – are held in balance, permanently.

NOTES

1. As far back as 1972, Lawrence Alloway was writing of how interviews with artists were being overused, of how a reliance on them was inhibiting writers from taking the discussion of their work in new directions. 'The authority of the interview has the effect of freezing critical discussion', in 'Network: the Art World Described as a System', *Artforum*, vol.XI/1, 1972, reprinted in Lawrence Alloway, *Network* (Ann Arbor, MI, 1984), p.7.

2. Brice Marden in a talk on Jackson Pollock at the Museum of Modern Art, New York City, 16 November 1989. Quoted in 'The Way to Cold Mountain' by Brenda Richardson in exh.cat. *Brice Marden – Cold Mountain* (Houston, TX: Menil Collection, 1992), p.43.
3. See exh.cat., *Chance, Choice and Irony* (John Hansard Gallery, Southampton, 1994); this includes ten articles by Tony Godfrey, including an interview with David Reed.

Teresa Margolles, *Vaporización*, 2001 (see fig.48)

Section II: WHERE?

We have in the previous essays seen artworks in stately homes, private modernist houses, museums, specifically modern art museums, commercial galleries, auction houses and even a shopping mall.

Artworks may be made for a specific place but they get taken away from it, as did the painting by Watteau discussed below by Catherine Morel: taken from the shop of a parvenu to a palace that has since become a museum. Or in the case of the helmet discussed by James Malpas, what once stood proud on a samurai's head is now silent and unmoving in a museum's sealed glass case. In the case of Juliet Hacking's *carte de visite*, it has travelled from the home where it was a memento (perhaps!) to one where it is an example of photographic art. In each case what has changed above all else is the way the object is seen – what expectations the viewer has and what reasons exist for his or her eye to linger and muse upon.

What makes artworks 'art' has been a topic much debated by critics and philosophers. How do they attain such a state of 'specialness'? One banal explanation is that a thing becomes art by being in an art museum or context. Certainly what makes the 127 scraps of string discussed by Anthony Downey 'art' is that they have been placed in a public art gallery and named as being authored by an artist. But as he points out this is no mere linguistic nomination, no slap-happy 'This is art because I say it is!' Rather, the act of translation from one place to another is here a journey from life to death and back for, as we learn, these scraps have been already in the house of death. Places have meanings and atmospheres; places imbue the objects that pass through them with associations and meaning – with a latent aura.

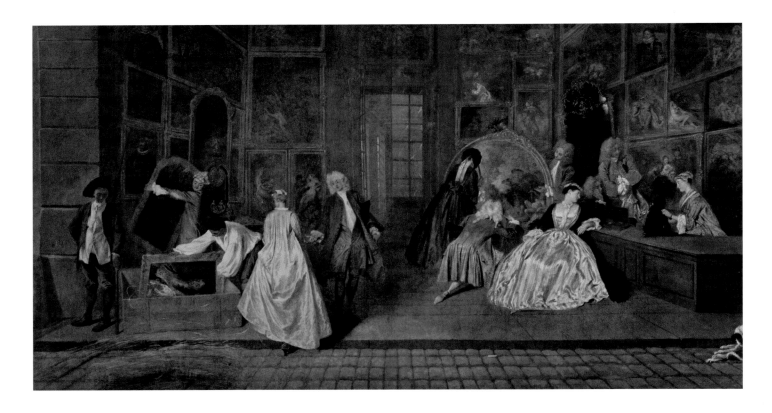

33. Jean-Antoine Watteau, *A L'Enseigne de Gersaint*
Oil on canvas, 165 x 308 cm (65 x 121¼ in)
Charlottenburg Palace, Berlin

Catherine Morel

A L'Enseigne de Gersaint by Jean-Antoine Watteau:
From Shop Sign to Masterpiece

In the summer of 1720 Jean-Antoine Watteau (1684–1721) returned to Paris from a few months' stay in London. In poor health and with no home to go to, he asked a young Parisian merchant, Edmé-François Gersaint (1694–1750), whether he could stay with him. Gersaint, who knew the 'Valenciennes master' through his father-in-law, the art dealer Pierre Sirois, accepted. As a sign of gratitude – and probably to keep himself busy – Watteau offered to paint a shop sign for his host's boutique front. This must have appeared as a rather odd suggestion to Gersaint, as sign-painting was usually seen as hack work for the novice rather than a celebrated painter of courtly scenes such as Watteau (fig.33).[1]

According to Gersaint, who some years later documented the painter's life, Watteau painted the sign within eight days, working mainly in the mornings due to his declining health. *A L'Enseigne de Gersaint* is now commonly presented as Watteau's masterpiece and artistic testament. It has inspired so much literature and generated so many interpretations that saying something new about it seems almost impossible. However, the transformation of what was once a commonplace sign advertising a mercantile establishment into a painting of great aesthetic and monetary value constitutes probably one of the most endearing aspects of *L'Enseigne* and still has something to tell us.

The sign is supposed to represent the interior of Gersaint's boutique where, as an eighteenth-century *marchand mercier*, he sold artefacts contributing to the furnishing and decoration of interiors from paintings and mirrors to clocks, toilet sets and other tasteful knick-knacks. The walls of the shop are indeed covered with large mirrors and paintings evoking seventeenth-century Flemish and sixteenth-century Venetian masters. A closer look reveals that all the pictures are in fact pastiches with two noticeable exceptions: the painting by Jakob Jordaens (1593–1678) in the top right corner and the portrait being encased, which is a detail of Hyacinthe Rigaud's (1659–1743) state portrait of Louis XIV and a direct reference to the name of Gersaint's shop, 'Au Grand Monarque'.[2] In that respect, *L'Enseigne* is quite different from those seventeenth-century Flemish views of *cabinets d'amateurs*[3] where the depicted artworks were the exact representations of existing paintings.[4] But how could it be otherwise? If one considers the hasty and difficult conditions in which the work was painted and its initial advertising function, one understands why Watteau had probably little inclination and certainly no time to give a detailed pictorial description of the artworks on display. Moreover, it is now common knowledge that the gallery depicted is not that of Gersaint who, at the time, certainly didn't have the means to stock famous and expensive Old Masters. Watteau painted an

imaginary collection according to his personal preferences, and used it as a perfect and prestigious background to his representation of the social rituals of art trading.

So, what exactly is happening in this imaginary gallery? Whilst on the left-hand side two employees are busy packing a painting and a mirror, an elegant couple enter the shop (as potential customers) where several other characters are already present. First, there are a couple engrossed in admiring an oval painting. The all-black clad widow is busy looking at the landscape with her *face à main* (lorgnette) whereas her male companion has kneeled down to get a closer look at the female nudes. They are being attended to, and advised by, a gentleman who could be the owner of the boutique. Not far from him is a group of three younger-looking people (a woman and two men) gathered around a wooden counter where they are being shown a table mirror by a female sales assistant. Whether they are genuinely admiring the artefacts presented to them or their own reflection in the mirror (or that of their respective object of desire) is open to debate. But it seems fair to say that in contrast to the older couple they appear more as dilettantes than as keen buyers. Could their visit to the shop be part of an ongoing courting game? Oblivious to the social and commercial interactions taking place inside the shop, a porter with a spiked carrying device stands on his own waiting in the left-hand corner. In the right corner, a scratching flea-ridden dog is here to remind us of the filth of cobblestone streets in contrast with the neatness and beauty of the shop. As viewers, we look as if we were in the street and the façade and entrance has dissolved.

Although no direct preparatory drawings are known for this work, two earlier sketches representing a 'draper's shop' (*c.*1705–6) and a 'barber's shop' (*c.*1709–10) show that Watteau had already worked on depicting various trades. The boutiques he describes are always well defined in space as they are carefully framed vertically with stone walls or draped stone pedestals and horizontally with a strip of pavement. In effect, they look like theatre stages where the main 'actors' are members of the French aristocracy who were used to sophisticated social role-playing at the court of the Regent, Philip Duke of Orleans, and that of his successor, Louis XV. Watteau's insistence on painting an art dealer's boutique might be explained by the opportunity it gave him to display such theatrical *tableaux vivants*[5] alongside Old Master paintings and to frame them both within the boutique space. Watteau also chooses to show men and women of the trade alongside their glamorous clients.

Just as he did with the art collection, so Watteau completely invented the space, and the only fixture that probably truly featured in Gersaint's shop is the double glass door leading to the back of the shop. His boutique was located on the bridge of Notre Dame, number 35, but in contrast to the shop shown in *L'Enseigne* it was extremely tiny (3.56 metres wide and 9.75 metres deep), crowded, dark and rather messy. But then we

have to remember that this painting was originally designed as a shop sign. Its function was to lure pedestrians crossing the bridge to come inside Gersaint's boutique. The depiction of a little crammed space with second-rate works would certainly not have been very enticing!

Gersaint's shop (ground floor of 35 Notre Dame bridge) looked as follows[6]:

An image of a spacious gallery full of remarkable works and elegant people had a lot of appeal. What Watteau has brilliantly achieved with *L'Enseigne* is to ennoble and heighten the ordinary boutique and make the promise of a first-class social and aesthetic experience to would-be punters. This formidable *trompe-l'oeil* was all the more needed at the time as the art boutiques on the Notre Dame bridge had a rather poor reputation. Indeed the expression 'artwork from Notre Dame' was a synonym for a daub! There is no doubt that Watteau's shop sign did help Gersaint in differentiating himself from the other art dealers on the bridge who were mainly selling second-rate paintings, 'mass produced' by young artists.[7] Ironically Watteau himself had worked as an impoverished young artist on the Notre Dame bridge at the beginning of his career in Paris.

At this point it might be worth mentioning that the shop sign was actually a *plafond*, or an over-the-door decoration, which was of the same width as the storefront (3.56 metres). Today the work, as it can be seen at Charlottenburg Castle in Berlin, has a standard rectangular format; it is 3.06 metres wide and 1.66 metres high (11 centimetres higher than the original version), and it is made of two panels. Recent research shows that the sign was transformed into a rectangle and cut into halves after 1732.[8] To reshape the work into a more standard painting, pieces were cut from the sides and partially reused at the top. It has been suggested that the haystack and the porter were added to replace an original hay cart, and that they were painted at a later stage by an artist other than Watteau – probably Jean-Baptiste Pater (1695–1736), who had been one of his pupils. The two panels remained separately framed until the 1920s.[9]

According to a 1732 article in *Le Mercure de France*, the *plafond* when hung over the shop was a true and immediate success, and it drew the crowds (probably in the same way as a famous contemporary artist's installation would today). Contrary to what he might have expected initially, Gersaint realised that he could probably sell the work and within two weeks took it down so that it would not get damaged. Some time later, most probably after Watteau's death in July 1721, the sign was sold to Monsieur Claude Glucq.[10] By 1744 it was in the hands of Glucq's cousin, Jean de Julienne (1686–1766), an astute art market operator who sold the painting in 1760 to Frederick II (the Great) of Prussia (1712–1786) through the Marquis d'Argens, the king's art adviser. Reputedly bought for 8,000 livres, the work was displayed in Frederick's favourite room – the music room – in the new wing at Charlottenburg castle. Here it was to act as the centrepiece of his *cabinet d'amateur* where he gathered some 27 masterpieces by various French, Dutch and Italian painters. It seemed that the wheel had come full circle: a painting that pastiched the *cabinet d'amateur* had now become part of one.

Today 12 of the original works have been brought back together in the music room, and *L'Enseigne de Gersaint* is still the focal point of the bright and unostentatious white wood-panelled room. It is rather moving to see the work where its owner intended it to hang, and to imagine the king sitting and gazing at it whilst entertaining his hosts (unfortunately no such comfort as a chair is offered to today's admirer of the painting!).

However, the visitor cannot help but wonder what made the Prussian king buy this large, bizarrely shaped, two-piece shop sign with a rather unusual subject, beautifully but hastily painted. There is no doubt that he was a dedicated admirer of contemporary French painting, and more specifically of Watteau. Indeed, several elements of the sign are quite reminiscent of the *fêtes galantes* that Frederick enjoyed and avidly collected. First, there is the characters' graceful gallantry. Thus, just as ladies are invited by their companions to embark for the Island of Love in Watteau's *Pilgrimage to Cythera*

(the second version of which is also in Frederick's collection), the woman in the pink dress is gently invited by her companion's refined and polished gesture (reminiscent of a minuet) to enter the shop and step with him into another world altogether. It is love in a shop instead of a garden and the celebration of painting instead of music, but Watteau's favourite themes are still here. The figures might not be in fancy dress but they are still wearing fashionable sparkling silk clothes whose sensual elegance contrasts with plainer fabrics like the white linen shirt of the man handling the portrait of Louis XIV. The eroticism of *fête galante* is no longer conveyed through the presence of cupids but by the nudes in some of the pictures on the walls and quite blatantly in the large *baignade* being examined so closely by the kneeling man. In the mixed group on the right there might also be some romantic undercurrent; pretending to look at a mirror gives the two men the opportunity to observe both their aristocratic female friend and the young shop assistant. Could art here be instrumental in the art of seduction? Does men's demonstration of their fine taste help to reassure women as to their honourable intentions? In any case, since selling is the art of seducing it is easy to imagine that female shop proprietors and assistants would also gladly engage in the game of love with their customers, as demonstrated by this gentleman's comment on Madame Dulac and her shop in 1765: 'that extravagant and expensive shop; where the Mistress was as tempting as the Things she sold ...'[11]

In his wish to depict an ideal world, Watteau spares us the details of anything subsequent to this elegant minuet of seduction. To a certain extent, the same is true of the art world shown in *L'Enseigne*. It is supposed to depict the selling and buying of artworks, but no money has been exchanged and the customers seem to be in the gallery not to do business but to enjoy looking at art and meet their peers in what appears as another 'stop' in the aristocratic social circuit. The shop, just as a *cabinet d'amateur*, is represented as a place that helps aristocratic characters distinguish themselves from the rest of the population. The messy (and rather vulgar) business of price setting and of payment arrangements are not to be represented. (In fact, getting money in cash from aristocratic clients was often quite difficult and credit was a widespread practice.) Similarly, the exquisite and perfect behaviour of the characters in the shop contrasts with the apparently frequent occurrences of brawls and thefts in the real world – as documented in the police records.[12] But this obviously doesn't interest Watteau who wants to show how going to an art dealer can be such an elevating and distinguished experience, made all the more pleasant by the dedicated and impeccably mannered (and good-looking) staff.

As a dedicated art collector and buyer himself, we could imagine that Frederick II was particularly drawn to the subject of *L'Enseigne*. He would certainly identify with most of the aristocratic characters represented. He had once been a budding amateur who had

keenly joined the higher realm of the art world, just as the woman in the pink dress is being invited to come and share the aesthetic and social experience that art collecting can offer. Perhaps now he saw himself more like the sophisticated older couple minutely examining the painting? Was the painting acting as a mirror to the king, sending him back a flattering image of himself as an art connoisseur?

No doubt the king's decision to buy *L'Enseigne* was also influenced by contemporary art critics and the art world in general who, it would seem, were quite unanimous in considering it as a work of great merit. Even Count Caylus, who at times could be a virulent art critic and who usually did not like Watteau's work, did consider *L'Enseigne* as one of the best works he had done. However, the work that Gersaint did to shed some light on the genesis of the work must have added to the king's eagerness to own it. As the astute dealer he was, Gersaint knew that his job was to add value to the works he was selling. *Marchands merciers*, who according to Denis Diderot were 'sellers of everything and makers of nothing', were actually transforming the form, decoration and function of many of the goods they were stocking to suit their clientele's needs. The practice of *enjolivement* (embellishment) was their trademark and it differentiated them from other intermediaries.[13] Gersaint also knew that selling an artwork is all about telling a story. That is exactly what he did when he wrote a biography of Watteau in a *catalogue raisonné* that he put together for the sale of Monsieur de Lorangère's collection in 1744. He therefore embarked on documenting not only the Master's life but also their friendship, presenting *L'Enseigne* as the best token of it. By doing so, he certainly made a major contribution to the myth of Watteau and *L'Enseigne*. Numerous accounts of Watteau's life today still use the stories told by Gersaint.

So how much credence should be given to his account of Watteau's life? The merchant certainly had access to first-hand information from his father-in-law and through his own experience of living with Watteau. But he probably could not resist embellishing the truth in an exercise of promotion (he needed to sell Watteau's work at the best price possible) and self-aggrandisement (he wanted to be remembered as a great friend of the artist). Although we cannot be sure that he did some *enjolivement* to the painting itself, we can safely assume that the story he tells is not completely the truth. Can we actually believe him, for instance, when he says that Watteau, who was apparently the fiercest critic of his own work, declared that he was quite content with *L'Enseigne*? Similarly, to say that it was painted in eight mornings certainly adds to the aura of the work but has never been really documented. Needless to say, *L'Enseigne* was not actually the very last work of Watteau, as it would seem that he painted a crucifixion (now lost) for the parish priest of Nogent who was the last person he stayed with. But a story had to be created in order to sell at a premium a work that originally was a simple

shop sign. Possessing the alleged last work of an artist is probably the ultimate homage a collector can pay to the revered creator. As any keen collector, the Prussian king must have been yearning for what was presented as the 'testament' and the last work of a painter he admired so much – not to mention that the strange format of the painting was actually one of its most endearing features.[14] Jean de Julienne, who was a big speculator of Watteau's work, probably instigated the cutting of the work into two panels. He knew, no doubt, that pendants were very fashionable at that time.

Almost three hundred years after its creation, *L'Enseigne* (unlike most of Watteau's *fêtes galantes*) still has the power to resonate with a modern viewer – most probably because the work of an art dealer has not changed dramatically since Watteau so brilliantly described it. It is still based on a close personal relationship with customers who need a lot of personal attention. It is still intertwined with the worlds of money, style and fashion. The role of the dealer is still to add value to any work with which he or she is entrusted. Similarly, although challenged by the Internet and art fairs, today's art gallery continues to play an important role as a social marker and a sign of distinction. The story of Watteau's shop sign also tells us a lot about the relationships between dealers and artists. Thanks to the business talent and support of the former, we can enjoy works that might otherwise have got lost or forgotten. However, an artist's success can also ensure a place for his or her dealer in art history. This is not very different from what a patron might expect from his support for an artist, in other words to be remembered by posterity. Does that make Gersaint a patron of the arts? Probably not. One of the most enlightened marketeers of his time? Almost certainly.

NOTES

1. D. Posner, *Antoine Watteau* (London: Weidenfeld and Nicolson, 1984), p.75.

2. *Watteau 1684-1721*, exh.cat., Galerie Nationale du Grand Palais (Paris: Ministère de la Culture, Editions de la Réunion des musées nationaux, 1984), p.452.

3. M. Vidal, *Watteau's Painted Conversations* (London: Yale University Press, 1992), p.183.

4. Gallery pictures painted by David Teniers the Younger (1610–1690) for Leopold Wilhelm are good examples of the genre. Such pictures enabled viewers to experience and admire the collector's acquisitions but also enhanced his prestige. See exh.cat., *David Teniers and The Theatre of Painting* (London: Courtauld Institute, 2006).

5. Vidal, *op. cit.*, p.192.

6. Adapted from a drawing in G. Glorieux, *A l'enseigne de Gersaint, Edmé François Gersaint, Marchand d'art sur le pont Notre Dame (1694–1750)* (Epoques: Champ Vallon, 2002), p.551.

7. *ibid.*, p.64.

8. C.M. Vogtherr and E. Wenders de Calisse, 'Watteau's "Shopsign", the Long Creation of a Masterpiece', *Burlington Magazine*, May 2007, pp 296–304.

9. C.M. Vogtherr, *Antoine Watteau: 'Das Ladenschild des Kunsthandlers Gersaint'* (Berlin: Stiftung Preussische Schloesser und Gaerten Berlin Brandenburg, Abteilung Marketing, 2005).

10. Glorieux, *op. cit.*

11. Quoted in C. Sargentson, *Merchants and Luxury Markets: The Marchand Merciers of Eighteenth-Century Paris* (London: Victoria and Albert Museum, 1996), p.235.

12. *ibid.*, p.136.

13. *ibid.*, p.144.

14. Vogtherr and Wenders de Calisse, *op. cit.*

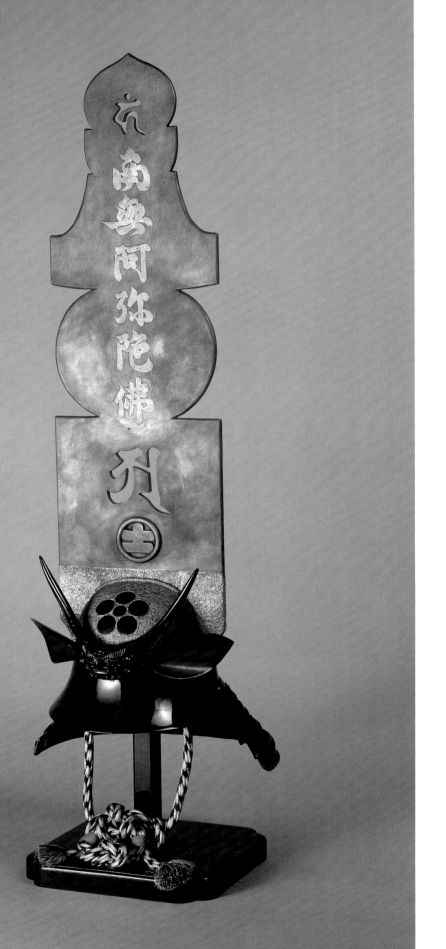

34. Kawari-Kabuto ('spectacular helmet') with
symbolic tower made for Matsudaira Sadamoto,
18th century
Iron, wood and lacquer, height of helmet bowl
16.9 cm (6⅝ in)
Kyoto National Museum

James Malpas

Kabuto with Symbolic Tower and *Kazari*:
Displaying the Decorative in Edo Japan

In examining this object (fig.34) and this concept separately and together, this chapter hopes to illuminate several aspects of the teaching ethos at Sotheby's Institute, developed over several decades in response to requirements from the art world for a visually literate, clear and lucid assessment of artworks and their context by students aiming for a career in the art world. Much of the teaching is not just about the individual characteristics of the finished work of art, its method of production, materials, geographical origins and assessments of its quality, aesthetic and monetary, but also the changing nature of its status through differences in taste, valuation, contextual setting and happenstance of history in its subsequent 'career'. We believe it is crucial to remember the fluidity of the 'reception' that works of art receive. (Are they responsible for their subsequent fame or ignominy and if so, to what degree?) Indeed, at its most extreme, a work can become so denigrated that its destruction ensues.

What, then, privileges works of art? In the case of this helmet, how far was it designed as a functioning piece of ceremonial wear, to display power and prestige and, as will become clear, its owner's religious beliefs? What role did it perhaps otherwise have? Within Japanese culture there was a very different appraisal of aesthetic items from the separatist western concept of the 'beautiful object' or 'art object', especially as conceived by the aesthetic movement's champions who were most enthused about the art of Japan as they explored it in the second half of the nineteenth century.

The culture of early modern Japan affords a clear and in some ways precise illustration of this fundamental cross-cultural problem of creation and perception. Can one perceive the intended nature of an object created in another culture without becoming part of that culture oneself or 'reinventing' one's viewpoints and perceptions so as to knock out the habitual responses one has to the art one 'usually sees'. And isn't this freshness of vision, of truly seeing, as if for the first time, a crucial element in the aesthetic experience? Strangeness, or the uncanny, a physical, indeed visceral response (what André Breton characterised as 'a plume of breeze across the temples') demarcates not so much the shock of the new as the shock of the strangely familiar.

That sense of 'familiarity' would, of course, have been quite different in Japan itself. From 1615, a strongly articulated, rigidified society emerging from the chaos of a century of war stipulated, through various social codes, just how and to what degree various objects should be shown and appreciated in the new environments (castles for the *daimyo*, villas for the princes and merchants) being created in the newly ordered country. The novelty of peace, and the economic boom that accompanied it by 1615, ironically allowed

for greater attention to elements from the past, particularly from China, whose own culture was always a lodestone to aspiring Japanese, who found the espousal of Chinese art and culture a convenient shorthand way of displaying their cultural sophistication, worldliness and taste – important attributes for warriors previously too busy on campaigns to cultivate the arts of peace.

Early modern Japanese concerns with space and time, elaborated through religious and philosophical concerns (Shinto, Confucian and Buddhist elements) are a very useful arena for the exploration of how works of art can be 'read' as an empire of signs for the society that is its context of creation and/or display. Indeed, a school of North American scholars working on Japanese topics seems to be emerging, particularly on the west coast of the USA, that is impatient with the theory-driven art historical exegesis that dominated the preceding decades. These scholars find those strictures too great and constraining for the interdisciplinary approach they wish to pursue – so as to make sense of the 'total works of art' that architectural developments around 1600 and their contents presented to the world, in the guise of either castles, monasteries or temples.[1]

In this approach scholars are aided by the fact that the divisions of artistic production so frequently employed in the West – high and low art, fine and decorative – are less watertight in Japanese history. Accoutrements of war were seen as fine-art objects and warrior *daimyo* were proud of their accomplishments in *Ikebana* (flower-arranging), on the basic premise that the level and intensity of consciousness and awareness applied were what matters, not the intrinsic nature and format that the consciousness is applied to. This is certainly a legacy of Zen to a great extent, and other types of Buddhism practised in Japan to a lesser degree.

With this in mind, it should be possible to reconstruct a great deal of context for the creation of an object, even if it is not on the scale of a temple, monastery, or castle. The object we are focusing on here is the *Kawari-Kabuto* ('spectacular helmet') with symbolic tower from the eighteenth century (mid-Edo period), made for Matsudaira Sadamoto (1686–1759), now in the Kyoto National Museum. It is made of iron, wood and lacquer.

Holding and wearing this object would give us a more accurate appraisal of its qualities than just seeing it, but this is unfortunately not possible in today's museum. In order to examine how rich and strange this object is, and how what you see isn't necessarily what you get, it will be necessary to chart the development of the *kawari kabuto* as a 'badge of office' for the *daimyo* warrior-rulers of Japan from the early fifteenth century onwards, when, in the period of the great wars, local chieftains and fiefs were continually trying to overawe their neighbours and stress their own importance. The *kabuto* also had to be useful and practical as well as flamboyantly noticeable, and the craftsmen

were to become increasingly inventive in adapting shapes and materials that would square these two requirements, as we shall see.

The rank-and-file foot soldiers had simple, beaten-metal 'coolie'-shaped bowls for helmets, which indeed doubled as food bowls on campaign from the Momoyama period onward (1573–1603). However, the higher-rank samurais couldn't use these as food utensils or helmets as there was no central hole for their top-knot (a badge of rank) to be pulled through, which normally kept their helmets in place.

Suji-kabuto is the term for the basic design of the samurai helmet. It is usually of riveted metal bands, which can then be lacquered to protect against the elements, and has a neck guard and two winged protection panels each side of the face. (These became smaller after the Heian period, 794–1185, probably because of visibility problems.)

Variations on these were brought in through contact with the Portuguese soldiers accompanying the Christian missionaries in the sixteenth century; scavengers on the battlefields or souvenir hunters and purchasers would get the familiar domed 'conquistador'-type helmets and add specifically Japanese elements to them. The same procedure applied to Momoyama pieces of armour too.

As the aggrandisement of the *daimyo* and their military power grew, so did their need to be visible and seen to be in control on the battlefield. The use of firearms reduced the impact of hand-to-hand combat in the early parts of a battle, at any rate, therefore signalling and the location of the army headquarters became more strategically crucial. Hilltops were favoured and occasions of sunlight catching the gleaming tops of *daimyo* helmets were frequently attested to.

Hence, decoration and function went together in the open-air world of samurai battles in the sixteenth and early seventeenth centuries. When they weren't fighting, the *daimyo* also strove to show their authority by display – *kazari* – and this element, which had always been a feature of Japanese military life from the Heian period onward, spilled over into the interludes of armed peacetime between campaigns. This is perhaps best understood through Akira Kurosawa's reconstructions of Momoyama buildings and interiors in such films as *Kagemusha* and *Ran*; here it is evident how the display of ceremonial armour on stands by the side of the *daimyo*-in-audience, along with his swords (his ultimate seal of authority), in an otherwise sparsely decorated room, focused the attention of supplicants and underlings mightily.

Soon variants on the basic *suji-kabuto* were developed. The *koshozan* (high-sided) *suji-bashi* consisted of 62 individual plates, riveted together, each strip of metal being garnished with a Buddhist prayer or invocation picked out in hard gold lacquer. One such is signed Yoshimichi (active 1521–31), showing that by this period almost as much attention was being paid to helmets as swords. As well as such Buddhist religious insignia,

Shinto or Taoist decorations might also be used, as in one example from the 1530s whereon silver dragons cavort over the visor and plant tendrils curl up the metal strips.

Other shapes for the helmet-bowl that developed in the sixteenth century were the *momonari* – a nectarine-stone shape, usually lacquered so as to resemble the pit of the fruit, and lacquered brown for the same reason. Any use of lacquer was a time-consuming process and so the sense of the helmet being special, if not spectacular, would have been easily gauged by observers. The horns or other additions to the bowl would be kept light – usually hollow wood, and then lacquered (horns in gold are frequently found), which adds little weight but gives the illusion of real metal.

The frequent use of appropriate animalistic elements is understandable from the Shinto point of view, which required the adoption of animal qualities on the battlefield. Much of this shamanistic sympathetic magic would also derive from imported Chinese ideas of Taoist ritual and exercises which have survived to this day in the Tai Chi and other specifically Chinese 'soft' martial arts. Tusks, horns, grinning devil faces would all fall into this category, and even the use of horsehair or boar or bear fur would add to the conception the warrior had of his prowess. The covering of a helmet with wild boar fur would signify a maniacal intensity in the wearer (something for him to live up to), since the wild boar is a ferocious adversary.

Obviously, once peace broke out and the Tokugawa regime (1603–1867) established its garrison-government with the ritualistic processionals of the *daimyo* from their provinces to the Bakufu Headquarters in Edo, the function and role of the samurai's armour shifted. It became less of a life or death matter, and took on more of its other role as the imposer of status and worth on its owner. It is hard to overestimate this in such a stratified and feudal social structure as was in place by 1625.

Examples of decoration become increasingly fanciful, to capture the imagination of the 'audience' on the road along which the *daimyo* and his retinue travelled with monotonous regularity. Much of it adheres to the animalistic patterns of the past. An example from around 1630–50 has a *shashihoko*, or mythical dolphin, superimposed on a simple six-plate bowl which is almost overwhelmed by the arching torso of the big red grinning-mouthed beast which is built up in worked leather and then lacquered black (again, this is not particularly heavy to wear). This *kawari-kabuto* is then highlighted in red and gold, gleaming against the glossy black, and the helmet is then mounted with silver. The effect hovers between the resplendent and the comic. Such *kawari-kabuto* were worn only by the highest of classes. Tokugawa Ieyasu, for example, on hearing that Hideyoshi had referred to him as the 'cow of the Kanto' (the plain on which Edo lies), had a *kabuto* made which had huge horns protruding from its sides, and all the plates of the helmet were covered with cowhide on which the hair had been left on. Kuroda Nagamasa

fought many battles in a *kabuto* that represented the cliff down which the twelfth-century hero Minamoto Yoshitsune attacked the Taira at Ichi-no-Tani, presumably hoping to emulate Yoshitsune's heroic deeds. Honda Tadakatsu, one of Ieyasu's generals, was immediately recognisable in his impressive antler *kabuto* while the Hosokawa house of Kumamoto adorned their helmets with long pheasant tail feathers. Kato Kiyomasa is often depicted killing a tiger in Korea wearing his *naga-eboshi* – a large court hat or shaped *kabuto* which was bright silver with a sun disc on either side. The *kawari kabuto* flaunted their owner's wealth: one of the most 'bling' elements was the use of rare yak hair, which could only be imported from Yuan province in China and was barely affordable.

In the sixteenth century, as armourers began to sign their work (both armour and helmets) – Nobuiye (1504–1564) and Yoshimichi (active 1521–31) are examples – a tradition began that extends to this day. Descendants of both families produced work into the twentieth century, and are now employed by national Japanese museums as restorers and conservers.

The development of *uichidashi-do*, or embossed armour, while more decorative and useful on parade, caused consternation to those who advocated return to the austere, ascetic principals of true *bushido*, arguing that such display reflected a decline in moral fibre and stature in a class of samurai more prepared for tiresome clerical work than war. The purists believed that if it was ever used, the armour would be flawed by its complexity and weapons would soon be entangled in it. Besides, the metal was far too thin to be of much use. Signed and dated, often compiled from pieces of old armour and regilded or lacquered, such display pieces of armour were luckily never to be tested – except by a few diehard traditionalists in the rebellions of the late nineteenth century (like the Satsuma rebellion of 1877), and were indeed then found wanting.

Other crests that have been found adorning ceremonial helmets include a *ken*, or ancient straight sword, in gold, extending straight up from the centre of the helmet front; the sword has an Indian-style *vraja* hilt, which dates from the eighteenth century. Earlier a helmet in the shape of the cap worn by the Nichiren sect of Buddhists, made in copper and with a *maedate* (fore crest) in the shape of an *oni* (devil), may have conceptual links with our central piece, the tower-topped helmet. One of the most complicated *maedate* I've seen is of a wild boar with tusks, made in gold, mounted on the front of the helmet and as though leaping off it; it has glass eyes and a moving tongue!

The tower-topped helmet is in some ways the culmination of this *kawari-kabuto* development that began in the seventeenth century. It refines further the occasional religious elements found earlier (the *Nichiren*-style cap, the use of Buddhist inscriptions on the helmet bowl referred to before), and makes a much more blatant espousal of the beliefs and status of its owner-wearer.

It also seems to defy physical laws, seeming to be much heavier than it is, so that the wearer might seem – to workers in the rice paddies he was processing past, or the towns-folk – possessed of superhuman powers in being able to bear such a weight on his head (and shoulders). The shape of the tower as a gravestone adds a vein of seriousness different from the stylistic frivolity of some other *kawari-kabuto*, and would again impress an onlooker with the determination to encounter, deal with, or at least face up to the question of mortality and/or the afterlife, which purists claimed was the sole function of the Bushido. So that although flamboyant in one sense, in another this helmet might claim that its wearer was cleaving to the old and traditional concerns of the warrior class.

Self-evidently Matsudaira Sadamoto, for whom the helmet was made, was a fervent Buddhist, and in this case shows allegiance to the Pure Land sect. Interestingly, this was not one of the sophisticated, primarily ritual-based sects of the higher class such as Shingon or Tendai, which depended greatly on priests for their efficacy. Although not as austere as Zen, with its adherence to 'direct pointing to Reality, without dependence on word or ritual', the Pure Land did advocate a simple chanting of the mantra *Amida Butsu Nama*; this was a recital of Buddha's name, which it was believed would guarantee a sort of guardian angel-like protection whatever the circumstances, and enable rebirth in the Pure Land of the Buddhist paradise (traditionally sited at Mount Sumeru, the mystical mountain in the heart of China, probably the Himalayas). This would be equally supportive to a warrior in the heat of battle, whose circumstances would preclude doing more than the most elementary of life-saving and soul-saving chants.

As for the materials of the *kawari kabuto* in question, the unusual feature is that the 'gravestone' has an inbuilt and deliberately aged, 'distressed' appearance. This was quite unlike the glossy, shiny nature of many other spectacular helmets which, even if exposed to the elements on the processions to and from Edo, would have been polished up and restored for display at each destination. The sense of spiritual authority is enhanced by the idea of age and tradition and 'weathering', summed up as 'wabi' and 'sabi' in Japanese aesthetics and not usual in the military culture, and the weathering seems to have intruded here to influence the helmet's timeworn appearance. In comparison with other such helmets, whose animalistic forms are often streamlined and engaged with the conical shape of the bowl to which they are attached, this is unusually rectilinear, insofar as this shape is accurate as a funerary stone. There is also an impression, given perhaps by the pale silver-grey colour of the tower in comparison with the black helmet, that the tower is a somewhat unworldly, phantasmal accretion, which might reinforce a viewer's perception of a supernatural element; the eighteenth century in Japan teems with supernatural tales and the mindset of a parallel universe, spirit-haunted, was a cultural given to which this helmet might also be appealing.

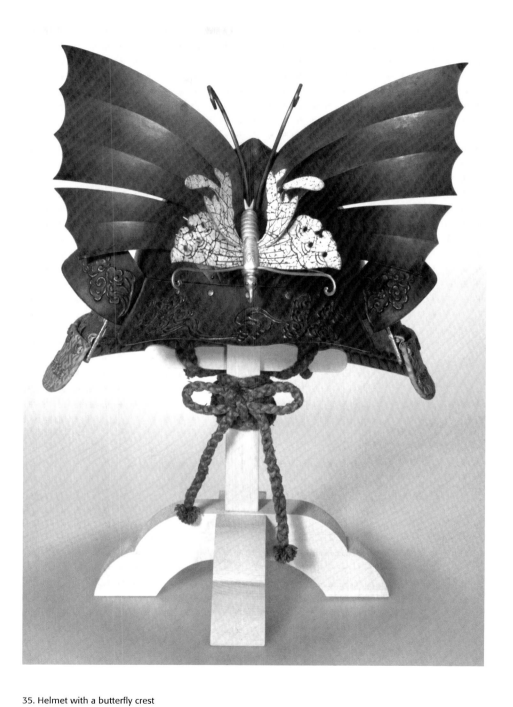

35. Helmet with a butterfly crest
Iron, boarhair, lacquer and gold, height of helmet
bowl 26.5 cm (approx. 10½ in)
Courtesy of the National Museum of Japanese History,
Chiba

Apart from the tower, the helmet is conventional enough; the horns at the front, as the *maedate*, are not particularly flamboyant and don't distract from the tower itself. The crest is bold and simple, in contrast to the suffused tones and colours of the tower. In this sense the *kawari-kabuto* differs from that of the gilded seashell which is much more organically fused, in its crustacean form, with the helmet; another variant of this has 'wings' added on in the shape of stylised waves in gold. At the other end of the scale is the helmet with the straightforward curved metal wings, undecorated, smooth and catching the light. The tower is a powerful emblem, merging an abstracted oblong shape with the recognisable 'natural' features of a tombstone but without natural materials such as the boarhair as used in other helmets (fig.35). What it possesses, that puts it in a class of its own, is the transcendental element of the prayer, which is not integral to the helmet design as in the *kuji-kabuto* referred to earlier, with gold lacquer and inscribed Buddhist invocations, but is most definitely an imposing add-on.

Another suggestion, which is being researched currently, is that there might be a link between the tower helmet and the sixteenth-century alternative to secular Samurai governing and fighting culture – namely, the warrior-monks of Mt. Hiei, outside Kyoto, who were finally subjugated by Oda Nobunaga at the end of the 1570s. These warriors were obviously relating their activities directly to their religious status, which (as with western crusaders) didn't stop them being ferocious opponents. Their main tactic was to swarm down from their fortified monasteries, occupy Kyoto and hold it to ransom; this was usually provoked by a rash and ill-considered attempt by the city's authorities to get the warrior-monks to pay some (or any) taxes. This strand of history might make the appearance of such an overt religious reference on a martial object less strange than it perhaps seems to us, although I haven't found any evidence that the sixteenth-century warrior-monks themselves used such religious imagery as part of their own armour.

NOTE

1. Leading scholars in this development include Andrew Watsky, whose intensive on-site examination of the creation and reception of the retreat belonging to the ruler of Chikubushima Island during the Momoyama period, findings that were revealed in his 2004 eponymous publication, set the pace and tone for subsequent topics of research; they included Daitokuji temple and the handling of its artefacts by Gregory Levine (2006), and Momuji temple by Sherry Fowler (2006). See Andrew M. Watsky, *Chikubushima: Deploying the Sacred Arts in Momoyama Japan* (Seattle, WA, and London: University of Washington Press, 2004); Gregory P.A. Levine, *Daitokuji: The Visual Culture of a Zen Monastery* (Seattle, WA, and London: University of Washington Press, 2005); Sherry D. Fowler, *Muroji* (Honolulu, HA: University of Hawaii Press, 2006).

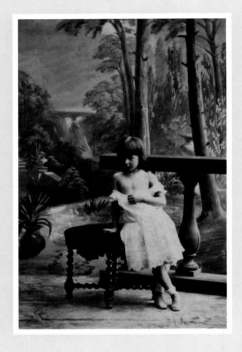

36. Camille Silvy, [*Mrs Holford's Daughter*], *c*.1860
Albumen print mounted as a *carte-de-visite*,
8.55 x 5.6 cm (3⅓ x 2¼ in), reproduced here actual size
Ken & Jenny Jacobson Collection, UK.

The Eroticised Victorian Child: Mrs Holford's Daughter

Why are we looking at this nineteenth-century photograph (fig.36)? It is a tiny, commercially produced studio portrait, and the little girl who sat for it was not famous. The composition is conventional: the sitter is depicted full-length with a stool, a fake balustrade and painted backdrop behind her. But of course there *is* something remarkable about the image. The little girl appears to be wearing a chemise that has been slipped down over her shoulders, exposing her bare chest to the camera. For the twenty-first-century viewer, this portrayal is disquieting. What we see is not necessarily titillating and yet we are conscious that if a woman were substituted for the child, it would be. Child pornography, that illicit category of photographic production, comes to mind. Fortunately, there is an alibi for the extended look demanded by this essay: it is a nineteenth-century image and not a contemporary one. Whether, at the time of its making, this photograph could have also provoked eroticised readings is the subject of this essay.

Although highly unusual, the depiction of the little girl is not entirely without precedent. The photograph is thought to have been taken around 1860, shortly after Charles Lutwidge Dodgson (Lewis Carroll, 1832–1898) began photographing young girls and shortly before Julia Margaret Cameron (1815-1879) made studies of children a distinctive feature of her *oeuvre*. Both Dodgson and Cameron photographed their child sitters in various states of undress and the most well-known photographic study by Dodgson, that of Alice Liddell dressed in rags, depicts a brown-haired, boyish little girl with her chest partly exposed (fig.37). Although the photographs taken by Dodgson were not widely known in the period, there was a precedent from the fine arts for such a portrayal; the (usually white) dresses that feature in eighteenth-century painted portraits of young girls are often worn very low on the chest. Nonetheless, this miniature photograph (fig.36) is not a painting, it is a photographic portrait; there was a real *broderie anglaise* chemise and it was, at a precise historical moment, pulled down below the child's sternum. Moreover, there is no alibi for the child's partial nudity: she is not dressed as Alfred Lord Tennyson's 'Beggar Maid' nor made to personify Cupid. There is no other figure (real or notional) in the image for whose gaze she is offered up; she is on display for us, the viewer. In whatever epoch, we are complicit.

In order to understand more about this curious image, we must consider it as an object, one made under specific historical conditions. Once we understand how it was created and intended to be seen, we can then begin to explore the question as to which particular ideas regarding childhood, sexuality and photographic imagery it would have,

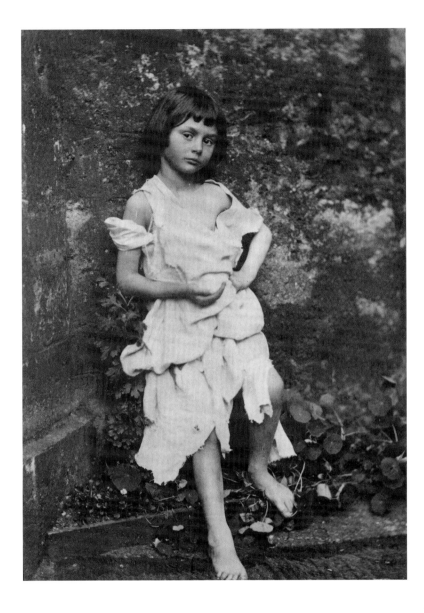

37. Charles Lutwidge Dodgson (Lewis Carroll),
*Alice Liddell as 'The Beggar Maid', c.*1859
[Carroll image No. 354]
Albumen print, 16.3 by 10.9 cm (6⅜ x 4⅓ in)
The Metropolitan Museum of Art, New York, Gilman
Collection, Gift of The Howard Gilman Foundation,
2005 (2005.100.20)

or could have, invoked. We can say almost anything we like about an *image*; an *object* is a much more challenging proposition.

The photograph is a *carte-de-visite*, a miniature photograph glued to a mount the size of a calling card.[1] The term *carte-de-visite* emphatically designated a portrait image because it had been invented and promoted as a portrait format, first in Paris and then in London.[2] The novelty of the format was that each sitter received a number of these small mounted prints to exchange with family and friends; these were then usually arranged in albums. The craze for collecting *carte* portraits of friends and family, and those of

royalty, celebrity and politicians reached a peak in the early 1860s in Europe and North America. At this time very few private individuals had the money, time and skill to make photographs themselves; photographic portraiture was the virtual monopoly of the commercial photographer.

The popularisation of *carte* photography was still a couple of years away when this photograph was made; in 1860 the *carte* was a chic photographic novelty recently imported from Paris. If we turn over the *carte* of the little girl, we find that the studio credit is printed on the reverse of the card mount. The portrait was taken in the studio of Camille Silvy (1834–1910), a French diplomat who became one of the most fashionable *carte-de-visite* photographers in London.[3] Silvy's daybooks from his studio in Bayswater (*c.*1859–68) have been preserved, and in volume one are two images that feature the same little girl, here identified as 'Mrs Holford (Daughter of)' (figs 38 and 39).[4]

Below, left and right:

38. Camille Silvy, [*Mrs Holford's Daughter*], *c.*1860
Albumen proof print, 8.6 by 5.7 cm (3⅓ x 2¼ in)
Silvy daybooks vol.1, no.941, National Portrait Gallery Collection, London

39. Camille Silvy, [*Mrs Holford's Daughter*], *c.*1860
Albumen proof print, 8.6 by 5.9 cm (3⅓ x 2⅓ in)
Silvy daybooks, vol.1, no.942, National Portrait Gallery Collection, London

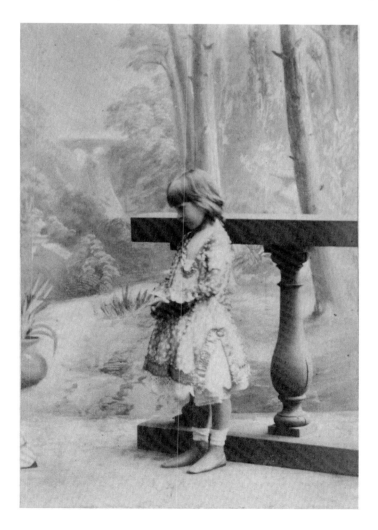
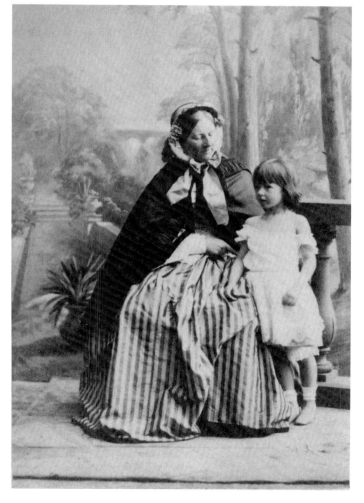

From the daybooks we learn that the studio in which Mrs Holford's daughter posed is the same one that Silvy used to photograph all his sitters in his first season as a portrait photographer, including, among many others, royalty and aristocracy, politicians and leading actors and actresses. Similarly, the props are not unique to this portrait; they also appear in a number of the portraits taken before and after the sitting by Mrs Holford's daughter. All of the above suggests that the *déshabillé* image of this young girl operates within the same logic of production and consumption as Silvy's other portrait photographs. Furthermore, the fact that this portrait left Silvy's studio with his credit on the reverse strongly suggests that it was not the type of image that would jeopardise his reputation for elegance, both in the execution of his *cartes* and in his person.

To suggest that this image would not have compromised Silvy's reputation does not mean, however, that it was in any sense conventional. Around 12,000 images are preserved in the Silvy daybooks, and of these only one other features a young girl apparently dressed in her underclothes.[5] 'The Daughter of the Hon. Mrs Charles Lindsay' does not have her chest exposed but her pose is coquettish and her feet are unaccountably bare (fig.40). Similarly, very little imagery of young girls *déshabillé* has come to light from the studios of Silvy's contemporaries.[6] Although it could be argued that such a marginal aspect of *carte* imagery does not merit a sustained investigation, it is my contention that the very strangeness of the photograph of Mrs Holford's daughter *déshabillé* suggests that we should give it our full attention. What if, for example, it constitutes evidence of a type of imagery of which we were previously unaware, one that was deliberately not preserved for posterity?

Before we turn to the larger issues outside the frame of the picture it is important to take account of the other images of 'Mrs Holford's daughter' taken in Silvy's studio.[7] Although the actual sequence of images from the Holford sitting is not known to us, it is logical to suggest that the sequence relates to the increasing level of undress for the child: fig.38, fig.39, fig.41 and fig.36.[8] In figure 38 Mrs Holford's daughter wears an elaborately trimmed tunic over her chemise (one that may or may not have been pulled down to expose a portion of her chest), and appears to be staring intently at an indistinct object on the floor of the studio. Figure 39 reveals that this object was the hem of a striped skirt belonging to a woman who may or may not be Mrs Holford; considering her dress, which suggests that she may be of a slightly inferior social status to her young charge, and seemingly mature age, she may be a governess or a maid, an aunt or even a grandmother.[9] In figure 39 the woman forms the central, dominant element; her elaborate walking dress and bonnet enhance her stature and diminish that of the little girl who is now dressed in her chemise (the sleeves of which have been slipped off her shoulders). The position of the woman's right hand apparently serves to pin her charge's arm in

40. Camille Silvy, *'The daughter of the Hon. Mrs Charles Lindsay'*, 1861
Albumen proof print, 8.6 by 5.8 cm (3⅓ by 2⅝ in)
Silvy daybooks, vol.4, no.4601, National Portrait Gallery
Collection, London

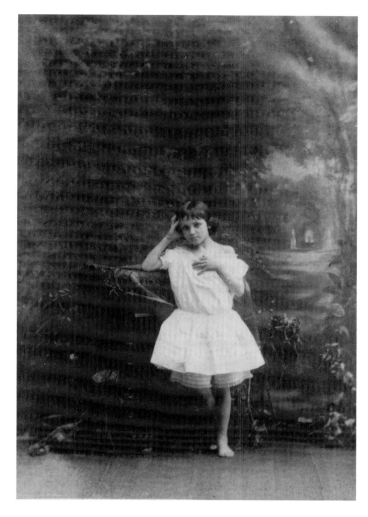

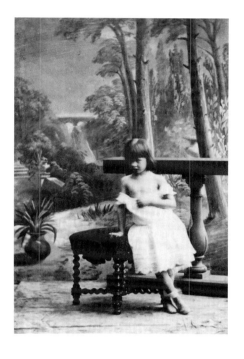

41. Camille Silvy, [*Mrs Holford's Daughter*], c.1860
Albumen print mounted as a *carte-de-visite*,
8.55 x 5.6 cm (3⅓ x 2¼ in)
Ken & Jenny Jacobson Collection, UK

(Please note, in comparison to fig.36, blurred face and
changed position of feet.)

a certain position; it may be that her left hand is similarly deployed. And so it would seem that a fidgety child is being kept still for the camera by a female relative or servant. The suggestion of impropriety has been dispelled. Or has it?

The presence of the older woman at the sitting does not necessarily mean that this portrait photograph was not intended to titillate. Nothing in the four images, nor in the daybooks, accounts for the child's exposed chest and so, when the undressing of a child is paired with the suggestion of physical coercion (fig.39), the possibility of a very different relationship between the two sitters is raised; instead of being a member of the Holford family or one of their servants, the woman may have been a prostitute or brothel-keeper who wished to derive a financial gain from the sale or distribution of photographs of her actual or pretended daughter. The ambiguous relationship between

the woman and the child, combined with the child's exposed chest, brings to mind an episode in the Victorian erotic memoir *My Secret Life*:

> On a later occasion, after he has violated a ten year-old girl, [Walter] reports this conversation with the woman who sold the girl to him: 'We talked afterwards. She was not the mother, nor the aunt, though the child called her so; the child was parentless; she has taken charge of her and prevented her going to the workhouse. She was in difficulties, she must live, the child would be sure to have it done to her some day, why not make a little money by her? Someone else would if she did not. So spoke the fat, middle-aged woman.[10]

Although a female sex trafficker seems an unlikely client for Silvy's studio, the idea is not entirely far-fetched. Not only did 'respectable' aristocratic women patronise his studio at this time but also their *demi-monde* counterparts; and so it would almost certainly have been the case that some of his sitters were engaged in casual prostitution. Also, we cannot discount the possibility that the woman was passing herself as a governess or nanny, and that the photographer was duped as to the pair's actual relationship. These readings of the photographic sitting are much less persuasive than that of a child of a good family being photographed in the charge of a relation or friend. And yet even if the image was not made to titillate, it still may have done so.

In seeking to determine whether the images of Mrs Holford's daughter could have invoked eroticised readings on behalf of Victorian viewers, it is important to examine whether there is any congruence between the images and nineteenth-century erotic or pornographic imagery.[11] Although a great deal of photographic material that we would deem titillating, erotic or pornographic has been preserved, the published material rarely features children, female or male.[12] One of the few nineteenth-century images that does fall into this category features a very young girl, her chemise untied and pulled down to expose her back and buttocks, about to be birched by a man and a woman (fig.42). It is by Félix Jacques-Antoine Moulin (1802–1875), the Parisian studio photographer who specialised in genre scenes, portraits, copies after artworks, stereoscopic views, *académies* (nude studies for the use of artists) and, although he did not widely advertise the fact, pornographic images. Moulin, according to E. Anne McCauley,[13] was jailed in 1851 after photographs by him were seized as obscene, but he went on to follow the course pursued by many Parisian commercial photographers; he sought to register many of his nude studies as *académies* at the *dépôt légal*, and in so doing, contributed to the creation of a class of imagery that was neither explicitly erotic nor exactly artistic.[14] Although this hybrid genre is worthy of a detailed study in itself, for the purposes of this essay it is the congruence between Moulin's image of the little girl being birched and some of his better-known *genre* studies that is of particular interest (figs 43 and 44). It is clear that

Above and below, left and right:

42. Félix Jacques-Antoine Moulin, *Untitled*
[A Child being Chastised], 1853
Salt print, 21.5 x 17 cm (approx. 8⅞ x 6⅝ in)
Serge Nazarieff Collection, Geneva

43. After Félix Jacques-Antoine Moulin,
['Atelier photographique'], 1853
Albumen copy print after original salt print,
19.5 x 13.8 cm (7⅝ x 5⅜ in), taken by William
Bambridge, 1865, in the album 'Calotypes', vol.III, p.35
The Royal Collection, Windsor Castle, ref.2906030.

44. After Félix Jacques-Antoine Moulin,
['Atelier photographique'], 1853
Albumen copy print after original salt print,
19.4 x 16.4 cm (7⅝ x 6⅜ in), taken by William
Bambridge, 1865, in 'Calotypes', vol.III, p.36
The Royal Collection, Windsor Castle, ref.2906031

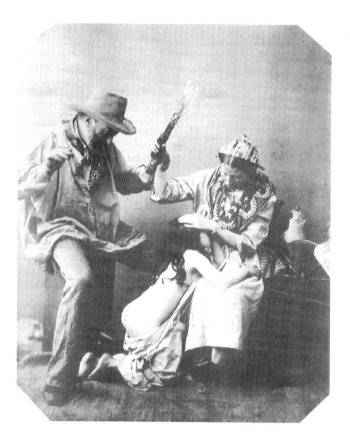

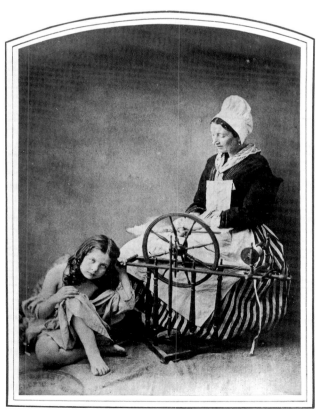

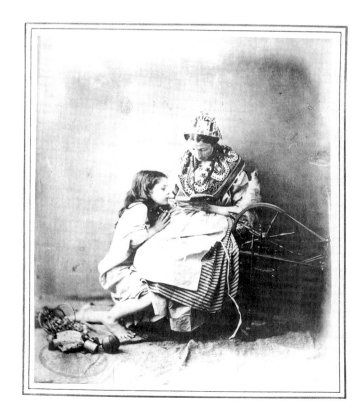

these two picturesque *genre* studies, prints of which were acquired by Prince Albert for his extensive photographic collection, were made in the same studio and with the same models as the 'chastisement' image (see fig.42).[15] Did the domestic nature of these two studies serve to neutralise the suggestion of titillation in the latter? Or did the titillating nature of the chastisement image eroticise, for example, the bare feet of the child model when posed as a dutiful daughter? Poverty could signify the picturesque, but it could also signify the sexual.

Much of the literature that attends to the idea of childhood and/or child sexuality in the Victorian period asserts that a dualistic notion of childhood prevailed based upon the tension between the traditional, religious idea of the child as born into sin and the Enlightenment idea of the child as born innocent of sin. Importantly, these competing conceptualisations of childhood had a strong class dimension. For example, in 1857 the medic William Acton wrote in his tract *The Function and Disorders of the Reproductive Organs* of 'well-brought up children' that 'no sexual notion or feeling has ever entered their heads',[16] whereas in 1861 the campaigning journalist Henry Mayhew wrote of what he identified as 'the extreme animal fondness for the opposite sex' of so-called 'street children'.[17] Mayhew asserted the significance of his study of 'the female children of the streets' on the basis that they belonged to 'the sex who, in all relations of life, and in all grades of society, are really the guardians of a people's virtue',[18] but despite this explicit linkage between the urban poor and their respectable counterparts, female sexuality was generally addressed in the period by reference to the poor or disenfranchised alone.

The idea that middle-class women were free from a knowledge of sin allowed them, symbolically at least, to guard the national virtue. Although it is often seen today as hypocritical, preserving a woman as respectable by sparing her from domestic work and from the knowledge of licentiousness played an important role in the social relations of the period: it served to enforce a distinction between the middle and the working classes. It is intriguing to note in this context that the journalist William Stead's 1885 report on the London vice trade, 'The Maiden Tribute of Modern Babylon', was touted by him as a first-time journalistic exposé.[19] According to the report, in the capital 'little girls [as young as 11] were bought and sold for vicious purposes',[20] and urban children as young as five were subject to sexual assault.[21] The suggestion that this was news to at least some of the readers of the *Pall Mall Gazette* is supported by Charles Lutwidge Dodgson's letters of complaint to the Prime Minister, Lord Salisbury, and to the *St James Gazette* arguing that such information should not be made public in the press in case it exacerbated the problem by introducing women and boys to a knowledge of vice. As is well known, the Criminal Law Amendment Act of 1885 which raised the age of consent to 16 became popularly known as 'Stead's Act', an acknowledgement of the significance of

45. Julia Margaret Cameron, *The Infant Undine*
[*Elizabeth Keown*], 1864
Albumen print, 27.1 by 20.9 cm (10⅝ x 8¼ in)
From the Overstone Album in the Collection of the
J. Paul Getty Museum, California

his campaigning journalism for a legislative extension of female childhood. Twenty-five years earlier (at the time that Mrs Holford's daughter was photographed) the age of consent was 12, and sex with a minor between 10 and 12 was a misdemeanour not a felony. Although one might assume that the fact that sex with a 12-year-old was legally sanctioned meant that all pubescent girls were viewed as sexually available, it seems that this sexualisation would have been conceived almost entirely in class terms. While the vice trade 'revelations' in the *Pall Mall Gazette* may have indeed shocked the middle-class female reader, it was very clear from the articles that their daughters were not those at risk.

Although we can never be certain which discourses were and were not available to respectable metropolitan women, it certainly seems plausible that, when looking at the image of Mrs Holford's daughter (see fig.36), a male viewer might know that it could have currency as erotic imagery, whereas a female viewer might not. It is not only, however, by reference to pornography and child abuse that images of children become eroticised; nor is it always the case that the viewer taking pleasure in such imagery is male. Carol Mavor and Carol Armstrong have both analysed Julia Margaret Cameron's images of women and children as embodiments of a maternal desire that is manifested in the photographic print by signifiers of an eroticised and eroticising touching, one of which is an insistence on the signs of making.[22] And although the photographs of young girls nude and *déshabillé* made by Dodgson have caused modern-day scholars to debate whether he was or was not a paedophile, it is important to bear in mind that the respectable Oxford mothers of his child sitters consented to his photographic sessions featuring their daughters (and were often given prints by Dodgson from these sessions). This is again strongly suggestive of a maternal pleasure in looking at the partially dressed or undressed child.

Of the 133 photographs classified as embodying a religious theme in the catalogue raisonné of Cameron's *oeuvre*, over half feature a partially draped or nude child. In addition to playing the role of Jesus, St John and the infant Samuel, partially draped children were made to personify a range of mythological and fictional characters: from Cupid to 'The Infant Undine' (fig.45), from 'Paul and Virginia' to the 'Water Babies'. Although Cameron's practice (incorporating large-format prints, differentially-focussed renderings, and themes borrowed from literature, art and Christian typology) is almost a direct inversion of *carte* photography, the idea of a maternal erotics is suggestive for the images of Mrs Holford's daughter. In photographing (what were, in the main, *village*) children in this way, Cameron both preserved these young bodies as infantile and extended her role(-play) as mother. In the case of the portraits by Silvy discussed here, the evidence points to Mrs Holford (whether she was present at the sitting or not) as the person who

commissioned the sitting and therefore as responsible for (or consenting to) the unconventional depiction of her child. Dressed in her chemise and knickerbockers for the camera, the young girl is, in effect, infantilised: Mrs Holford's daughter is far too old for 'petticoats'.[23] Although this infantilisation seemingly celebrates the maternal bond, it is my contention that there is another form of maternal pleasure at work here. Because 'petticoats' were worn by both boys and girls, the figuring of a little girl with a boyish crop in this costume threatens her identity not only as a female child but also as Mrs Holford's daughter, as (in effect) Mrs Holford in miniature. Subjecting her to a state of undress that would be sexualised if it were staged on a young woman genders the boyish child as female. According to this analysis, Mrs Holford's daughter may have been coerced into appearing before a camera in her underclothes, but she was not made to do so for the pleasure of men.

In conclusion, I would like to suggest that our own preoccupations should not obscure the possibility that, in the mid-nineteenth century, the eroticised body of the female child was a means by which to address a subject other than child sexuality. Taking the cultural theorist Michel Foucault as our model in seeing the discourse of sex in the nineteenth century as not repressed but relocated, we can suggest that there may have been another way of reading the image of Mrs Holford's daughter. It may be that the eroticised child was a means by which to address or acknowledge what is seldom pictured: the sexuality of respectable women. For such women it may indeed have been possible to gaze at Mrs Holford's daughter in her chemise without calling to mind the vice trade; in this instance the eroticism at work would have been in an imagined substitution of themselves for the child.

NOTES

1. The photograph is an albumen print, the term now used to designate the most common type of photographic print in the period, the sensitising chemicals for which were held in a layer of dried egg-white.

2. Miniature prints of other genres, or types, of photograph were occasionally mounted in this way.

3. It is thought that Silvy may have been the first to open a *carte* studio in England. For a (somewhat romanticised) account of Silvy's time as a studio photographer in London, see Nadar (Gaspard Félix Tournachon), *Quand j'étais photographe*, 1900 (Paris: Le Seuil, 1994), pp 278–84.

4. The Silvy daybooks are in the collection of the National Portrait Gallery, London.

5. There are no similarly depicted young boys. It is important to bear in mind when making these assessments that the daybooks are not a fully comprehensive record of Silvy's output: of the over 17,000 entries (some of which are variant poses), dates, names and proofs are not always supplied, and there are errors of labelling.

6. There is no British-based photographer of the same period whose daybooks have been preserved and so it is difficult to make similarly quantifiable assessments. For a detailed study of Silvy's portrait practice, see J. Hacking, 'Full Length: Camille Silvy's Repertory' in *Photography Personified: Art and Identity in British Photography 1857–1869*, Ph.D thesis (University of London: Courtauld Institute of Art, 1998),

pp 159–206. For an extensive study of the practice of the Parisian photographer responsible for popularising the *carte*, see E.A. McCauley, *A.A.E. Disdéri and the Carte de Visite Portrait Photograph* (New Haven, CT, and London: Yale University Press, 1985). One image that has survived is a *carte* by the studio of Charles Wright of High Holborn in London that depicts a little girl in a plain chemise seemingly having her feet dried by another, fully clothed young girl; it is in the same British private collection as figs 36 and 41.

7. Most sittings at a fashionable *carte* studio would have resulted in one (glass) negative approximately 20 by 25.5 centimetres, with three or four different exposures relating to different poses, each one doubled, resulting in six or eight miniature portraits per negative. The only surviving negative (National Portrait Gallery, London) from Silvy's studio has three variant poses; as four proof versions from the Holford sitting have been preserved, this is likely to mean that at least two negatives were made, and therefore that at least two more poses were taken.

8. The images of Mrs Holford's daughter (and the image of the daughter of the Hon. Mrs Charles Lindsay) preserved in the Silvy day-books (figs.38, 39 and 40) were the subject of a short article I wrote in 1999; J. Hacking, 'Pretty Babies', *British Journal of Photography*, no.7241 (8 September 1999), pp 22–3. The two other variants that are reproduced here (figs 36 and 41) are preserved in a British-based private collection and are mounted as *cartes-de-visite*. Figs 38 and 40 are entered in the daybooks in the order I am suggesting here; as regards figs 36 and 41, it is highly speculative as to which was taken first.

9. There are other entries in the daybooks in the name of Holford but none of them are of this young girl or the woman in the striped skirt. It is difficult to trace further information about Mrs Holford or her daughter because we do not have a first name for either nor a title such as 'Lady'. Initial searches for a child actress of this name have not as yet yielded any results. Although we may never discover the actual social status of Mrs Holford, the fact that the daybooks record the

name of the other young girl photographed by Silvy in her chemise as 'The daughter of the Hon. Mrs Charles Lindsay' suggests there is nothing to preclude Mrs Holford and her daughter from being 'respectable'.

10. Quoted (without page reference) in Steven Marcus, *The Other Victorians: A Study of Sexuality and Pornography in mid-Nineteenth-Century England* (London: Corgi, 1969, orig. 1966), pp 158–9.

11. From the material that has been preserved, it appears that there was, by the late 1850s, a thriving trade in explicit pornographic imagery, mainly in the form of stereographs. From what is preserved, Paris is assumed to have been the centre of this trade.

12. *Victorian Children* by Graham Ovenden and Robert Melville (London: Academy Editions, 1972) does include a number of photographs featuring young girls in various states of undress, but many of these are now thought to be modern works passed off as Victorian photographs. These include the erotic photographs of young girls attributed to the otherwise unknown J.T. Withe and John Allison Spence, and some of the photographs attributed to Oscar Rejlander (1813–1875), Charles Dodgson and John Thompson [sic]. Related studies attributed to 'Withe' and to Rejlander are found in Graham Ovenden and Peter Mendes, *Victorian Erotic Photography* (London: Academy Editions, 1973).

13. E. Anne McCauley, 'Braquehais and the Photographic Nude' in *Industrial Madness: Commercial Photography in Paris, 1848–1871* (New Haven, CT, and London: Yale University Press, 1994), p.155.

14. 'Metamorphosing into the titillating "French postcard" at the turn of the century, photographic académies teetered precariously on the undefined line between art and pornography and represented the legal tip of a much larger and mysterious iceberg of illicit imagery'; *ibid*, p.149. As McCauley explains, in Second Empire France, each photographic image that was created for commercial sale was supposed to be registered at the *dépôt légal* and was therefore subject to censorship.

15. There is a manuscript inscription at the beginning of the album, in which the photographs reproduced here are preserved, that reads 'All the Photographs in this Volume were collected and arranged by His Royal Highness the Prince Consort, 1853–1854'. As the majority of photographs in the album are copy prints made after Prince Albert's death in 1861 (the two images by Moulin are copy prints by William Bambridge taken in 1865), it is generally assumed that the copies were made to replace the original 'calotypes' (also known commonly as 'salt prints') collected by the prince. The copies are pasted into the album over the originals.

16. Quoted in Marcus 1969, *op. cit.*, p.14.

17. Henry Mayhew, *London Labour and the London Poor; Cyclopaedia of the Condition and Earnings of Those That Will Work, Those That Cannot Work, And Those That Will Not Work*, vol.1 (London: Griffin, Bohn and Company, 1861) [The London Street-Folk], p.468. This is the additional volume from 1861; volumes one to three were published in 1851.

18. *ibid.*, p.477.

19. [W. T. Stead,] 'The Maiden Tribute of Modern Babylon', *The Pall Mall Gazette: An Evening Newspaper and Review*, vol.XL.II, no.6336, (6 July 1885), typescript copy in the collection of the British Library.

20. *ibid.*, p.9.

21. *ibid.*, p.45.

22. Carol Mavor, 'To Make Mary: Julia Margaret Cameron's Photographs of Altered Madonnas' in *Pleasures Taken: Performances of Sexuality and Loss in Victorian Photographs* (London: I.B. Taurus, 1996, orig. 1995), pp 43–69; and Carol Armstrong, 'Cupid's Pencil of Light: Julia Margaret Cameron and the Maternalization of Photography', *October* (Spring 1996), pp 115–41.

23. 'Petticoats' were dresses or smocks that are similar to chemises but worn as outerwear (and often adorned with ribbons), such as those seen in the portrait of the 'Enfants de Lady Scott' (vol.1, no.415, of the Silvy daybooks). A small number of entries in the daybooks refer to the child dressed in this manner as 'baby'.

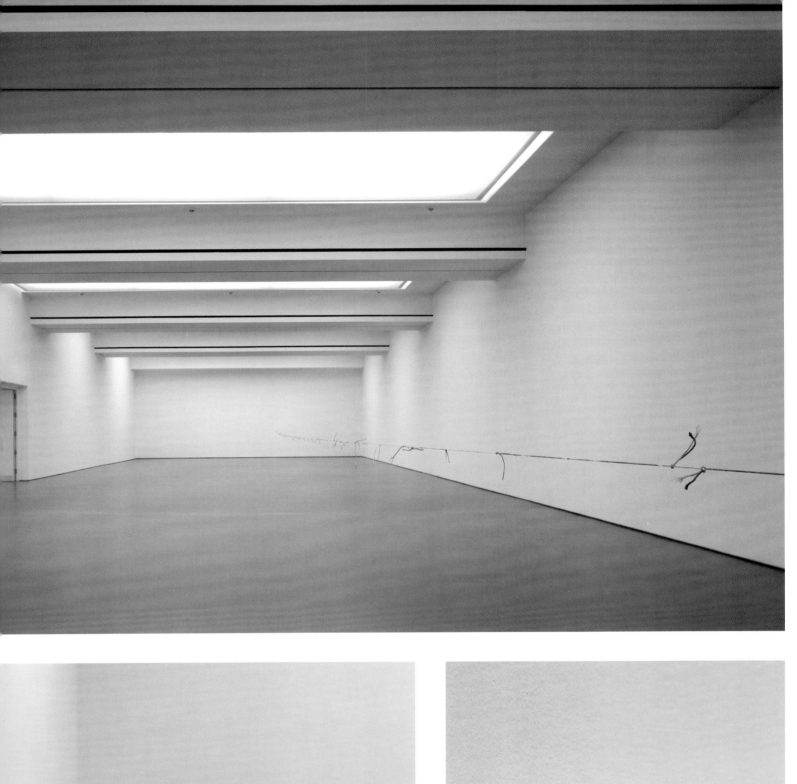

Anthony Downey

127 Cuerpos: Teresa Margolles
and the Aesthetics of Commemoration

Death is most frightening,
since it is a boundary.
ARISTOTLE

A length of thread, stretched tight from one wall to another, spans the wide, corridor-like gallery space of the Düsseldorf Kunstverein (fig.46). At more or less waist height, it cuts off one third of the gallery along its longitudinal axis, leaving the viewer with the majority of the space in which to walk and examine the thread. On closer inspection, this turns out to be 127 separate pieces of cotton thread that have been tied together using a basic knot. On each of these threads there are uneven stains; mottled, reddish-brown traces that call to mind the colour of red wine dried on a white tablecloth. And that is it. Apart from this enigmatic installation by the Mexican-born artist Teresa Margolles (b.1963), there is nothing else to look at in the Kunstverein on this day in 2006. Whilst this may appear 'minimalist' in the extreme, and Margolles' work does draw upon a minimalist aesthetic in its display, the sheer, if not vertiginous, 'emptiness' of the room encourages us to look more closely at this length of thread. There is, after all, nothing else to look at – nothing else in which to take visual refuge.

Our first encounter with Margolles' *127 Cuerpos* (2006) is first and foremost an aesthetic experience; we sense the work through our eyes and therefore experience thought through our eyes, so to speak. Our physical reaction to it, alongside its impact on our senses, is crucial insofar as we tend to 'walk the line' and perceive it in our act of movement rather than static contemplation. Eventually we spot on the wall, mid-way down the gallery and facing the work, a placard with a disconcertingly pragmatic text on it. A casual viewer might overlook this, were it not for the fact that with apparently so little to see we go in search of more information – and more context within which to formulate a response. The text reads thus:

> *Remnants of thread used after the autopsy to sew up bodies of persons who have suffered*
> *a violent death. Each thread represents a body.*

A little research, a quick glance at the press release for example, and we discover that Margolles not only lives and works in Mexico City, but that her subjects, with few exceptions, are invariably the victims of violent crime. This textual element undoubtedly changes our relationship to *127 Cuerpos* and, as a consequence, our interpretation of it. We move away from what is effectively an aesthetic response to an extra-visual interpretation of words: a two-sentence statement of fact that engages another realm, that of the socio-politics and economics of death itself. This is to observe the extent to which an individual's place within a social order – their economic, social, cultural and political standing – will undoubtedly have a bearing not only on the circumstances of their death

but the treatment of their bodies thereafter. It is with this knowledge and empathic under-standing that Margolles, who holds a Diploma in Forensic Technique, searches through the morgues of Mexico City – with the local authorities' explicit permission – and details what she refers to as the 'life of the corpse'. And it is in this apparently contradictory statement – the 'life of the corpse' – that we find much of what makes Margolles' work both provocative and, dare I say, necessary.

With the above points in mind, this essay will engage in a relatively basic inquiry: how are we to approach this work as an aesthetic object and, coextensively, how are we to interpret it in a cultural-historical and socio-political context? How can we still experi-ence this *aesthetically* after reading that text? And how can we stop a theoretical reading from making the act of seeing it incidental rather than central to our experience? The task here is to render the aesthetic responsive to the socio-cultural realm without prescribing the work as (and thus reducing it to) a series of abbreviated critical and theoretical paradigms. This, I would argue, is the heuristic (if not ethical) imperative placed upon contemporary art criticism and, to further such an approach, I will begin again with the actuality of the work before contextualising it further with other aspects of Margolles' *oeuvre*. It is crucial here that I also observe the long lineage of art forms that have taken death as their subject, and the various historical antecedents that precede and inform works such as *127 Cuerpos*. By way of a conclusion I will propose – as I will have argued from the outset – that *127 Cuerpos* does not represent death as such, but both death and the reciprocal symmetry of forgetting (absence) and remembering (presence) associ-ated with the act of dying.

<p style="text-align:center">*</p>

I earlier noted that the length of thread first encountered in the Düsseldorf Kunstverein effectively blocked off, along the longitudinal axis, one third of the space. To use the word 'block', however, would suggest that there was a physical impediment whereas the division seemed more symbolic. You are on one side of the space, the inhabited, larger side – the side of the sentient 'viewer' – and all else, the uninhabited, is on the other side. In dividing the space in such a way, Margolles is not only drawing attention to the struc-tural design and architecture of the elongated corridor-like gallery, she is also presenting the viewer with a boundary: a border-line that proscribes space and our transit within and across it. The prohibition against entering the other side of the gallery, more emblem-atic than physical, seems somehow caught up with the prohibition against entering the realm (or touching the body) of the dead. This is not to second-guess Margolles' reasons for placing the string where she has; on the contrary, it is to extend the conceptual possibilities associated with *127 Cuerpos*. Life and death are often divided, sometimes in the most arbitrary manner imaginable, along similar lines of division: the fine line, that

is, between the living and the dead; the inside and the outside; this world and the 'next'; between the act of exhalation and the moment of expiration.

And what of the actual string itself? I have already noted that it is effectively an aggregate of 127 pieces of cotton thread previously used to sew up the bodies of victims of violent crime after autopsy. This extra-visual fact produces a more profound interpretation: in life these individuals would not necessarily have been known to one another, but in death they are umbilically linked in a series of knots. To use the term 'umbilical', which usually refers to birth, in relation to an object that registers death is to allude to further conundrums in this work: the simple knots in the thread recall the *postpartum* staunching of the umbilical cord (and the emergence of the knot-like navel, or *omphalos*) that ensured life; whilst the sinuous thread connotes the *vena umbilicalis* (umbilical vein) that nourishes embryonic life. Each piece of thread has been used to 'conceal' the very moment of revealing the cause of death: the knife wound, the bullet, and the damage done. The act of concealment, in the use of the thread, is here 'revealed' or laid bare, just as the trace of life – blood – and its corporeal significance is also revealed in the actual blood and bodily fluids that stain the thread. The thread is both testament to life (blood) and its ultimate termination (the staunching of post-autopsy blood and fluids). And each piece of thread is an actual, rather than symbolic, testament to a life once lived: this is not, in essence, an abstraction of death but its manifestation in a perceptible object. The brutish and yet distanced detail of a violent death has been reified into the literal fact of the dividing line – an umbilical length of thread – between life and death, between the space within which you physically stand (the space of the gallery) and the other space in which you cannot: the liminal space of the dead or, less metaphorically, the other side of the thread. Life and death are, of course, umbilically conjoined; the former is often described in terms of presence, the latter in terms of absence – and both, in turn, garner meaning through *not* being the other. Moreover, the substitution, if that is the right word, of a piece of thread for a body, is an act of *re-membering* (*em-bodying*), a bringing back together and recuperation of the forsaken body. *Postmortem*, in this instant, begets *postpartum*.

In bringing us into proximity with death (or the visceral remains of others), Margolles refers to life too. Our being in the gallery and the umbilical/autopsy resonances of the thread itself – our proximity to both life and death – plays upon our realisation of being alive as opposed to being dead. We may ask to what extent does this work resemble a seventeenth-century *vanitas* or *memento mori* still-life painting? Such paintings would depict 'beautiful' and desirable objects, but invariably include a reference to mortality in the form of a human skull, a burning candle, flowers on the cusp of decay, or sometimes a sprightly bubble about to burst. The allegorical message of a *vanitas* painting was

47. Teresa Margolles, *En el Aire* (*In the Air*), 2003
Installation with bubble machines producing bubbles
with water that has been used to wash dead bodies
after autopsy, dimensions variable
Courtesy the artist and Galerie Peter Kilchmann, Zurich,
photo: Axel Schneider

a relatively simple one: in life we are everywhere surrounded by death, and life itself
is brief.

I do not want to reduce *127 Cuerpos* to just a *memento mori* or a modern-day re-
enactment of a *vanitas* painting, but it is significant that Margolles has also used actual
bubbles in previous work. Employing a machine for making bubbles, *En el Aire* (*In the
Air*; 2003) used real rather than reproduced (painted/drawn) bubbles that filled the entire
gallery (fig.47). Upon entering this space the viewer was greeted with an air of enchant-
ment, the transient playfulness of bubbles being a reminder, perhaps, of childhood
pursuits. The bubbles floated, descended and burst against the walls, floor and, on
occasion, the viewer. The effect was beguiling and not without pleasure. Again, however,
the accompanying text brought us up short:

Bubbles made from water from the morgue that was used to wash corpses before autopsy.

The dead, as in *127 Cuerpos*, are here present in the very water that cleansed their
bodies before autopsy, the very same morgue water that now (albeit after disinfection)
bursts against our skin. In blurring the distinction between the living and the dead – they
both inhabit and to some degree interact in the same time/space continuum – Margolles
repeatedly draws our attention to the pervasiveness of death in life and their opposi-
tional symmetry: the fact of life in the face of death. In *Vaporización* (2004) a similar but
more invasive event occurs. In a dimly lit room we enter into what first appears to be a
sort of sauna; we breathe in vaporised air and it soaks into our skin and clothing like a
fine mist of imperturbable rain (fig.48). This air, however, is 'vaporized water from the

economic, and political conditions'.[11] The individuals, so carefully archived by Margolles in works such as *127 Cuerpos* and *The Cloth of the Dead*, are representative of an under-class – prostitutes, drug-dealers, pimps and the unfortunates caught in the cross-fire of drug-related and domestic violence – who not only occupy the margins of a social order but whose lives, until now that is, went largely unnoticed beyond their immediate environments.

The socio-economics and politics of death, its causes, and its effect on those who are left after the event, are inflected here through an aesthetic of commemoration. What we have in Margolles' work is the irreducibly aesthetic dimension of all art practice seen through the prism of the socio-political and cultural-historical specificities of a particular moment in time. In contemplating the death of others we are confronted with the *aporia* that surrounds our deaths: that is, the fundamental *impasse* of thought itself when it comes to a representative of death itself rather than its representation. The 'real' of death in Margolles' work, crucially, is also a counter-modern gesture: modernity itself has increasingly disavowed the fact of death in life. We 'pass away' out of sight now in hospices. We do not see real dead bodies, only their gothic representations in the excessive violence of cartoons and TV police dramas. We have disclaimed knowledge of death in a series of visually and verbally euphemistic gestures, and wrapped it up in a form of consumerism that does exactly that: consumes, that is, the 'real' of death. And this is perhaps indicative of the ultimate commodity fetish: the quest for eternal life. Works such as *127 Cuerpos* refuse to mediate death as a comforting euphemism and, in doing so, offer a counterpart to the elision of death as a subject in our comfortably disassociated (Western) world. In Margolles' work, finally, we find a confirming, and no doubt discomforting, aesthetics of commemoration that clearly places it both within a sculptural, formal tradition of art-making, and an ethics of direct socio-political and cultural engagement.

NOTES

1. *Dermis* (1996) was a collaboration with SEMEFO (Servicio Médico Forense; 1990–9). Its members, apart from Margolles, included Carlos López, Juan Manuel Pernás, Juan Luis García Zavaleta, Arturo Angulo, Arturo López, Victor Busurto and Antonio Macedo.
2. The Sudarium of Oviedo is a bloodstained cloth kept in the cathedral of Oviedo in Spain and considered by some to be the actual cloth that was wrapped around the head of Jesus when he was entombed. The Shroud of Turin is not, strictly speaking, a sudarium insofar as it covered the body rather than the face.
3. Ewa Kuryluk, *Veronica and her Cloth: History, Symbolism and Structure of a 'True' Image* (Oxford: Blackwell, 1991), p.180.
4. *ibid.*, p.30.
5. *ibid.*, p.143; emphasis added.
6. Jacques Derrida, *Aporias* (Stanford, CA: Stanford University Press, 1993), p.8.
7. *ibid.*, p.23.
8. *ibid.*, p.21.
9. Udo Kittelman and Klaus Görner, 'Meurte Sin Fin', in *Meurte Sin Fin* (Ostfildern-Ruit: Hatje Cantz Verlag, 2004), pp 41–7 (p.41).
10. *ibid.*, p.41.
11. *ibid.*, p.41.

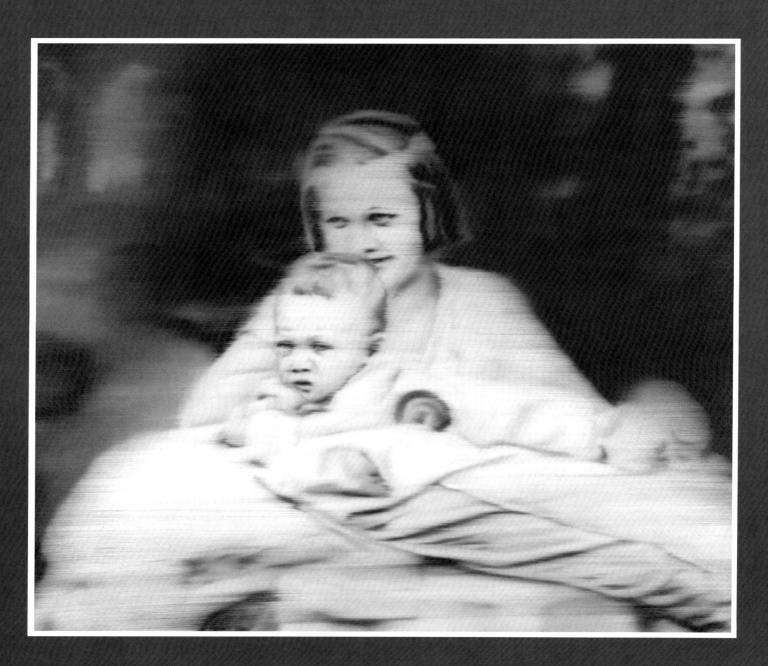

Gerhard Richter, *Tante Marianne*, 1965 (see fig.73)

Section III: WHEN?

As David Bellingham remarks in his essay, art objects are travellers through time as well as space. Indeed the adventures of Bellingham's subject, the *Jenkins Venus*, are as unexpected and unpredictable as the ups and downs of fortune inflicted on the hero of a picaresque novel, Tom Jones or Don Quixote. Like Goltzius' print of his mother, the dove sculpture by Jacob Epstein discussed by Bernard Vere is made and remade. Marcel Breuer's chair discussed by Elisabeth Darby may be as she says 'a design classic', yet its form transpires to be as subject to periodic adaptations, transformations and even mutations as either of the above.

The painting by Gerhard Richter that Anna Moszynska writes about may be more constant, but our perception of it has altered with the passage of time, and its curious, concealed history now comes to light. Or rather, not its history but a fragment of the hidden history of Germany that it, however obliquely, reflects. Of course like all material things it will one day become subject to time, its petty erosions and disasters: fire, flood or neglect. Like people, art objects are not eternal but are subject too to life and death. But it does not seem so. The face in the painting stares back at us seemingly unchanging, unabashed by our embarrassment. The woman, that subject of the painting, dead now for more than six decades, is of course beyond time.

We too are travellers through time. One of the periodic catechisms of a life in art is to go and see the same art object again and again at different periods of our lives – that they may act each as a mirror into our changing age, taste and desire. I am told that the cells in a human's body are replaced every seven years. This is not true of an art object which is more static, more immutable. It always belongs to the past in which it was made, and also to the various pasts in which it has been adored or despised. With research the art historian can lead us back like an archaeologist to a different time: the art object can be both a mirror of ourselves and a window into the past.

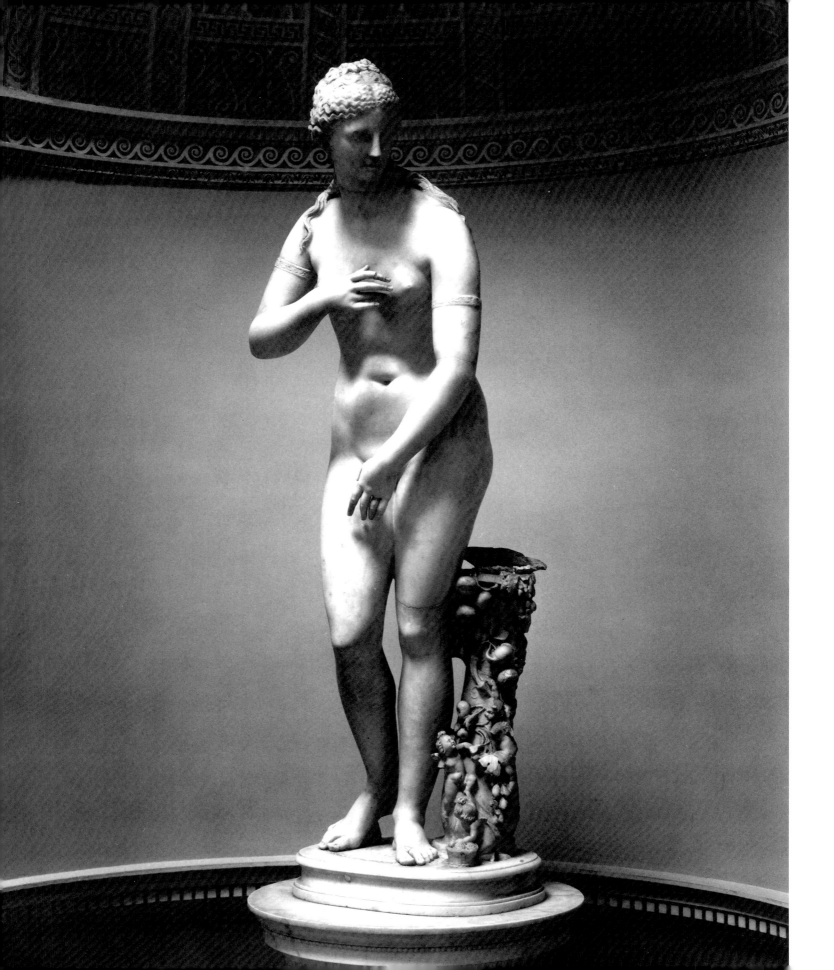

David Bellingham

The *Jenkins Venus*: Reception in the Art World and the Market

In 1802 a traveller visited Newby Hall in Yorkshire and was starstruck by the strange beauty of one statue in particular:

> A beautiful naked *Venus*, antique; of the same delicate workmanship, inimitable grace, and scientific proportions, as the celebrated statue *de Medici*. It is, indeed, the jewel of this collection; and said to have been bought at so high a price as induced Mr. Weddell to conceal from his friends the enormous expence in which this indulgence of his favourite propensity involved him. At her left side is the trunk of a tree (for a supporter) and Cupid leaning upon it; fruits and flowers of the most admirable sculpture entwine the trunk, which is crowned by a large shell, another emblem of the goddess, in which she sailed to Cyprus.[1]

Opposite:

49. *Jenkins Venus*
1st century BC/1st century AD
Cararra marble, height 163 cm (64⅛ in)
Courtesy Newby Hall Estate

50. Bronze bust of the Emperor Titus Vespasian
Attributed to William Danielsz. [sic] Van Tetrode
(1528–1588), height 28.5 cm (11¼ in)
© Christie's

Two hundred years later, on Thursday 13 June 2002, the same ancient Greco-Roman sculpture of a standing nude female entitled 'The Jenkins Venus' appeared at a Christie's London auction of mixed types of European furnishings (fig.49).[2] Its context within the sale was significant of its strangeness, being the only antiquity in the catalogue. Equally significant was the juxtaposition of several Renaissance sculptures as lots immediately preceding it. Thus lot 111 was a sixteenth-century bronze portrait bust of the Roman Emperor Vespasian (fig.50). These neoclassical bronzes provided the perfect frame for the authentic ancient statue, signifying its *difference* in a number of binary oppositional aspects: dark bronzes compared to its white marble; Romans to its Greek; males to its female; heads to its body; realistic portraits to its idealism; aged images to its youthfulness; mortals to its immortal; implicitly dressed to its explicitly nude; modern copies to its antiquity. Its twenty-first century significance within the context of the art market had thus been perfectly constructed by Sarah Hornsby, Head of Antiquities at Christie's London. The *Jenkins Venus* stood, literally and metaphorically, head-and-shoulders above the surrounding lots. Its supreme importance, within a sale of '*Important* European Furniture, Sculpture, Tapestries and Carpets' (my italics), was enhanced by its having its own supplementary catalogue, complete with soft-focus cover photograph (fig.51), and by the estimate being only available upon request.

Art objects are travellers through time and sometimes, like this one, through space. Their forms change not only because they age and are damaged, sometimes deliberately, but also because they undergo restorations without respect for their pristine state, or are framed in new physical and ideological contexts. Thus this sculpture's particular post-antique history had transformed its status from one of countless copies of earlier Greek statues produced for Roman imperial consumption, into a renowned and highly collectible Grand Tour celebrity marble.

Greek Aphrodite

The statue is usually dated as a late first or early second-century AD Roman copy of an earlier Hellenistic statue from the second century BC. However, because no details of the ancient provenance have survived, this dating must remain hypothetical. The artwork is similar in type to two much more famous statues: the *Medici Venus* in the Uffizi, Florence; and the *Capitoline Venus* in the Capitoline Museum, Rome. The Medici and Capitoline types are generally thought to be later than what was lauded by ancient writers as the earliest public female nude, the *Knidian Aphrodite*, the lost original of which was created by Praxiteles around 340BC.[3] The Medici type stands in *contrapposto* with its weight on the left leg, which therefore requires support to stop the heavy marble figure from toppling over. The support varies between a dolphin ridden by a Cupid (Medici), and a water urn and towel (Capitoline). The support of the *Jenkins Venus* is the most complex of all, formed of an *alabastron* vase surmounted by a shell, entwined with a vine, and peopled by three diminutive Cupids who gather fruit into a basket at the base of the statue. The Cupids are of course the love-children of the goddess, whilst the fruit/vine motifs relate to her fertility role. The *alabastron* is equally significant: its function in antiquity was as an elegant feminine storage vessel for perfume; whilst the flat scallop shell which forms its lid was not only a fertility symbol associated directly with Aphrodite Anadyomene ('rising from the waves'), but was also used as a cosmetics container/make-up palette. In ancient literature the use of cosmetics is regularly associated with the enhancement of female sexual attraction. Therefore what is often dismissed as a mere decorative prop by modern viewers is actually an important collection of visual signs which enrich the statue itself with meaning.

The heads of the three statues turn to their left, whilst their right hands attempt to cover their breasts, and their left their pudenda. This pose has historically been seen as a gesture of modesty, giving the statue type its historical name of 'Venus Pudica' ('Modest Venus'). But the hand gestures are arguably presenting a more ambiguous sign to the viewer, which equally draws attention to both the nudity and sexual zones of the woman. Indeed, it can be argued that the figure, who in antiquity was the goddess of female eroticism as much as of romantic love, is an empowered woman who deliberately conceals/reveals the source of her sexual power, in an act of mutual flirtation with the viewer. It has usually been assumed that nude female statues are intended primarily for the male gaze. This might be a mistaken reconstruction of ancient ways of seeing. The power of Aphrodite (the Greek name of the Roman Venus) appears to operate as much for women as for men in ancient literature. Thus in Homer's *Iliad*, for many centuries the main educational text for the Greeks, we find the earliest literary allusion to Aphrodite:

51. Cover illustration from Christie's catalogue, 13 June 2002

'Come with me: Alexandros sends for you to come home to him.
He is in his chamber now, in the bed with its circled pattern,
Shining in his raiment and his own beauty; you would not think
That he came from fighting against a man; you would think he was going
Rather to a dance, or rested and had been dancing lately.'
So she spoke, and troubled the spirit in Helen's bosom.
She, as she recognised the round, sweet throat of the goddess
And her desirable breasts and her eyes that were full of shining,
She wondered, and spoke a word and called her by name, thus:
'Strange divinity! …'

Then in anger Aphrodite the shining spoke to her:
'Wretched girl, do not tease me lest in anger I forsake you
And grow to hate you as much as now I terribly love you …'[4]

In this passage, not only is Aphrodite's own sexual power described through the eyes of Helen of Troy, but also the goddess herself refers to male beauty in her sensual description of Alexandros (Paris). Aphrodite's sexuality is simultaneously attractive and frightening to Helen: 'Strange divinity!' is all that she can utter. As with many of the Greek gods and goddesses, Aphrodite's power is of a binary oppositional nature; if we refuse to honour and imitate her sexual power, love can turn to angry hatred.

It is somewhat curious, given the frequently brazen and aggressive nature of Aphrodite/Venus in the literary sources, that the pubic areas of the statues are not more naturalistically carved: there is no visible pubic hair, nor is there any genital parting. It is possible that these features were added in paint, but even if this was the case, it remains strange given that the equivalent male region is generally carved in a realistic manner. Literary sources and occasional archaeological evidence inform the modern viewer that marble statues were originally painted. The flesh of female figures was left unpainted to signify the housebound lifestyle of the aristocratic woman, whereas hair and facial features were painted. Pliny the Elder states that the Greek painter Nikias (*c*.350–300BC) painted the statues of Praxiteles with coloured wax burnt onto the marble (the 'encaustic' technique).[5] It is also interesting that Nikias was renowned for his painstakingly realistic employment of paint for his images of women, suggesting that details such as the pubic region may indeed have been painted in the pristine versions of Venus. The alternative argument is that Greek culture was acomoclitic, and that pubic hair was considered ugly and was removed by aristocratic women, and consequently by their goddesses too; however, this would still not account for the absence of the genital parting.[6]

How did the ancient viewer look at statues of Aphrodite/Venus? The modern viewer must remember the bisexual nature of Greek erotic discourse. The writer Lucian preserves a dialogue between two men about whether sex with women or boys was better, and the discussion significantly takes place at the Temple of Aphrodite at Knidos.[7] The two men refer to the sexual arousal evoked by both the *front* and the *rear* of the statue, and relate a story about a man who was accidentally locked into the temple at night and attempted sex with the statue. It is difficult for the twentieth-century viewer to readapt to these powerful ancient (male) sexual responses to images of Venus because of the more widespread and permissive use of erotic imagery in modern culture. It is also clear that the original architectural frame of such statues enabled and even encouraged the viewer to admire the statue from all angles:

> Its shrine is completely open, so that it is possible to observe the image of the goddess from every side; she herself, it is believed, favoured its being made that way. Nor is one's admiration of the statue less from every side.[8]

Whether or not the head of the *Jenkins Venus* is original, its idealised facial features and coiffeur are typical of statues of the goddess. At first sight the head appears small in relation to the body. This is partly due to the effect of the chignon arrangement of the hair, which has the effect of making the head itself appear smaller. It may also be smaller for technical reasons; the figure leans forward and extra weight at its apex would have created instability. The *Knidian Aphrodite* herself has a small head, and as that statue, unlike the Medici and Capitoline Venuses, also sports an armlet, the *Jenkins Venus* may well be a closer version. The head has pierced ears which would have originally held metal earrings; this is not uncommon in antique female statues and, like the armlet, the jewelry combined with the lack of clothing would enhance the nudity of the rest of the figure. Like the Medici and Capitoline statues, the head is averted from the gaze towards the viewer's right. As with the movement of the hands, this is an ambiguous visual sign: it acts as a further gesture of modesty, but also serves to attract the viewer to the idealised 'Grecian profile' of the face. The statue wears an armlet on her upper left arm (that on her right is a modern restoration). This is decorated with dolphins, creatures often associated with Cupids, as on the support of the *Medici Venus*. Because, apart from possible original earrings, this is the only cultural object worn by the statue, it serves to accentuate her nudity, and draws the viewer's gaze towards the horizontal line of the breasts.

Roman Venus

Thus it can be seen that a statue such as the *Jenkins Venus* would have been read in quite a different manner by the ancient viewer. In antiquity she was an awesome goddess, one

to be admired for her strange beauty and sexuality, but at the same time feared for her ability to punish stubborn or unwilling lovers. This, however, was only one of the statue's possible meanings in antiquity. If the statue is indeed a later Roman copy of a Greek original, whereas the original would more likely have been purely regarded as a cult statue, designed to stand in a temple as a venerable icon, statues were regularly recontextualised in the Roman period. In art history, such recontextualisations of the same image require revised readings. Both Roman literary sources and archaeological provenance indicate that statues such as the *Jenkins Venus* were created for a more secular context. Cicero was a leading Roman statesman in the first century BC and his correspondence with the Greek art dealer Atticus provides useful information about Roman attitudes towards art:

> As for those herms of yours in Pentelic marble with heads of bronze, about which you wrote me, they are already providing me in advance with considerable delight. And so I pray that you send them to me as soon as possible and also as many other statues and objects as seem to you appropriate to that place, and to my interests, and to your good taste …[9]

This indicates that the Roman statesman is collecting such statues for a number of reasons: to decorate his many Italian country villas; to signify his taste for Greek 'old masters'; to symbolise his own philosophical, religious and political interests; and last but by no means least, to demonstrate his wealth. It is also interesting that he relies heavily on the 'good taste' of his cultured Greek agent, a relationship that recurs between Grand Tourists and local Roman agents in the eighteenth century. The Roman copy, although perhaps lacking the unique value of an original work of art, has however become a more sophisticated multi-semantic object, intended to provide many meanings to the connoisseur of Greek art history. Archaeology has revealed that Roman villas, such as the Villa of the Papyri at Herculaneum or Emperor Hadrian's Villa at Tivoli, were decorated with sophisticated multivalent sculpture programmes which simultaneously created visual art histories and at the same time reflected the ideological standpoints and cultural interests of their patrons.

Materials were of some significance in the classical world, as is evident in Cicero's appreciation of the combination of Pentelic (Athenian, i.e. high-cultured) marble and bronze (i.e. expensive) for his herms. The *Jenkins Venus* had always been considered to be of Parian (Greek) marble, until the marble was recently scientifically analysed and discovered to be of Carrara (Italian) marble. Carrara is the Roman/Italian equivalent of Greek Pentelic, with its high-cultural associations from the discovery of the quarry in the time of Julius Caesar through to its use by Michelangelo (1475–1564). The scale of the

figure is also significant. The height (including the plinth) is 1.63 metres (1.55 metres, excluding plinth), which is the height of a relatively short adult woman. Because of its diminutive scale it is unlikely to have been created as a cult statue for a temple; in ancient literature immortals are always described as over life-size, and smaller statues were generally preferred for representations of mortals. The cult statue of the *Knidian Aphrodite* is 2.05 metres tall, whereas the *Medici Venus* is only 1.53 metres tall, possibly suggesting a more decorative secular context for the derivative types, including the *Jenkins Venus*.

The *Barberini Venus*

It is this ancient Roman, as opposed to Greek, way of seeing art that was reborn in the Renaissance and Neoclassical periods. The *Jenkins Venus*, along with most other ancient art objects, disappeared beneath the ruins of Rome for some fifteen hundred years before being rediscovered by the excavations of a powerful Renaissance Roman family. There is no record of the finding of the *Jenkins Venus*, but it was almost certainly excavated from the territories of the famous Barberini family, who were the first post-antique owners of the statue. The earliest reference to the statue is to be found in an inventory of 1671, which records the art collection of Cardinal Antonio Barberini.[10] This brief but detailed description is important because it casts fresh light on recent interpretations of the statue, which have all been based on a later inventory of 1738.[11] The 1671 description records: 'An ancient statue of a nude Venus of seven and a half palms [1 palm = approx. 22 cm], missing an arm, a leg and feet, with a prop decorated with little Cupids; 300 scudi [in value].' It is most significant that the major features such as the statue's head and the prop were apparently intact at this point in its history, because later commentators have doubted the originality of both.

The *Jenkins Venus*

The eighteenth-century sources relating to the 'Barberini Venus' are often vague and/or contradictory, consisting as they do of gossipy society letters, as well as deliberately falsified documentation of the statue to assist its successful and smooth passage through the art market. Some sources suggest that the sculpture was discovered in 1763 in the cellars of the Palazzo Barberini by the Scottish painter and dealer Gavin Hamilton (1723–1798). Hamilton is said to have purchased it for the same 300 scudi for which it had been valued in the 1671 inventory of one hundred years earlier. According to this account, Hamilton had it restored by either Pietro Pacili or the more famous Bartolomeo Cavaceppi. He then sold it to the most famous of the English art dealers based in Rome, Thomas Jenkins (1722–1798). In 1764 Jenkins displayed it to potential English Grand Tourist buyers, falsely marketing it as an intact ancient statue. Even the great German

classical art expert Joachim Winckelmann was taken in by Jenkins' presentation. His letter of 23 June 1764 states that Jenkins himself had found the Venus in an 'unknown Roman house. It is worthy of Praxiteles … and is so well preserved that not even a finger is missing. It is a delightful beauty, and is alone worthy of a journey to Rome.'[12] The statue's modern soubriquet of 'The Jenkins Venus' is attributed to Winckelmann's references to it in his letters, but this is rather misleading as Winckelmann only ever refers to it as 'Die Venus Hrn. Jenkins', which translates as 'the Venus of Mr. Jenkins'; it was not Winckelmann's intention that this should become its grand title.

In December of the same year (1764) William Weddell of Newby Hall, Yorkshire, arrived in Rome. William Weddell (1736–1792) was the son of a York grocer, who had inherited about £70,000 from his uncle, a successful player on the stockmarket, and purchased Newby Hall.[13] Upon the death of his father in 1762, at the age of 26, William inherited the Newby Estate, and proceeded to transform himself into a quasi-aristocratic gentleman. The *nouveau riches* could buy into aristocratic culture by investing their newly acquired wealth in classical art and architecture, as well as join the Grand Tourists in Rome. Thus Weddell arrived in Rome in December 1764, and immediately began to purchase paintings for his house and antique sculptures for his planned sculpture gallery. As a further visual sign that he had 'arrived' on the English socio-cultural scene, he had his portrait painted by Pompeo Batoni (1708–1787) (fig.52). Weddell displays his new-found knowledge of the antique by confidently pointing out to the viewer the famous reclining statue of *Ariadne* in the Vatican museums.

Jenkins sold the Venus to Weddell in the Spring of 1765, along with 19 cases of other classical marbles, as well as 86 paintings. The following account is from the diary of Joseph Farington, and relates a conversation that took place some 30 years later, on 18 December 1795, at the Royal Academy club with the sculptor Joseph Nollekens (1737–1823), who was acquainted with Weddell and sculpted his portrait:

> Nollekens related to me what He knows of the transaction between Mr. Weddel & Jenkins, relative to the statue of Venus. – Nollekens says, the Trunk of the figure, and one of the thighs, & part of the leg, is antique. The Head, Arms, and the other thigh and leg are modern. The figure was in the possession of the Dowager Princess Barberini, an expensive woman, who had the care of her Sons property while a minor. When she occasionally wanted money she was accustomed to apply to her Custodini (Keeper of the Rooms) to offer such articles for sale as would Produce the sum required; and He accordingly applied to the Artists, or Dealers, or Gentlemen traveling & made bargains with them. This Venus He sold to an Italian Sculptor for a Small Sum: but the Head which had been put on not suiting the figure well, Jenkins looked among collections for one

which would match better; and finding a Head of Agrippina with a veil falling from the Hair, He had the Veil chizzeled away and the Head trimmed and set on the body of the figure. – He then exposed it advantageously and finally sold it to Mr. Weddel; but Nollekens never could learn on what conditions.[14]

A week earlier, lunching with the famous Neoclassical artists, sculptor John Flaxman (1755–1826) and painter Robert Smirke (1752–1845), the diarist had in fact learnt what Nollekens 'never could learn': 'Jenkins, the Ciceroni, Banker & dealer in works of art, obtained from the late Mr. Weddel of Yorkshire, £2000, and an Annuity of £100 for his life, for a statue of Venus.'[15]

If this is the true amount of a financial transaction that Weddell himself had refused to divulge, but which contemporaries believed to be the highest amount paid for an antiquity in the eighteenth century, then Jenkins had sold the statue for between 20 and 30 times the amount paid by Hamilton to the Barberini.[16] Furthermore, since Weddell lived for another 27 years, Jenkins would have received an additional £2,700 from the annuities, thus making a gross profit of about six thousand per cent! Details of the earlier transaction between Hamilton and Jenkins remain unknown, but they are said to have shared the profits of similar restored antiquities, including the Minerva which was also sold to Weddell and remains opposite the Venus at Newby Hall.[17]

The importance of owning such statues in the eighteenth century is clear from the effort put into tracking them down, restoring them to a pseudo-pristine condition, and selling them for exorbitant prices. To put the price Weddell paid for the *Jenkins Venus* into perspective, the valuation of 300 scudi in the seventeenth-century inventory can be compared with the 250 scudi that Caravaggio (c.1569–1609) was paid on average for each canvas painted during his final ten years. Although an allowance would have to be made for inflation, Weddell's 18,500 scudi would have purchased a number of quality Old Master paintings!

Having sold the *Jenkins Venus*, it remained Jenkins' responsibility to obtain an export licence prior to transporting it from Rome to England. Jenkins, having sold the work on the basis that it had been found in pristine condition, and having even deceived Winckelmann in this respect, now appears to have approached Winckelmann again for his written description for the purpose of the export licence. On 19 June 1765 Winckelmann wrote that 'The Venus of Mr. Jenkins has gone to England for the King: I now find that the leg and arms are new, and that the head is from another Venus and is not as good as the beautiful torso.' Three days later he adds that: 'the beautiful Venus of Mr. Jenkins is bought for the king through the consul at Livorno. A leg and both arms are new, and the head does not belong to the statue. For these reasons I have had no

Opposite:
52. Pompeo Batoni, *William Weddell of Newby Hall,* **1760**
Oil on canvas, 234 x 183 cm (92⅛ x 72 in)
Courtesy Newby Hall Estate

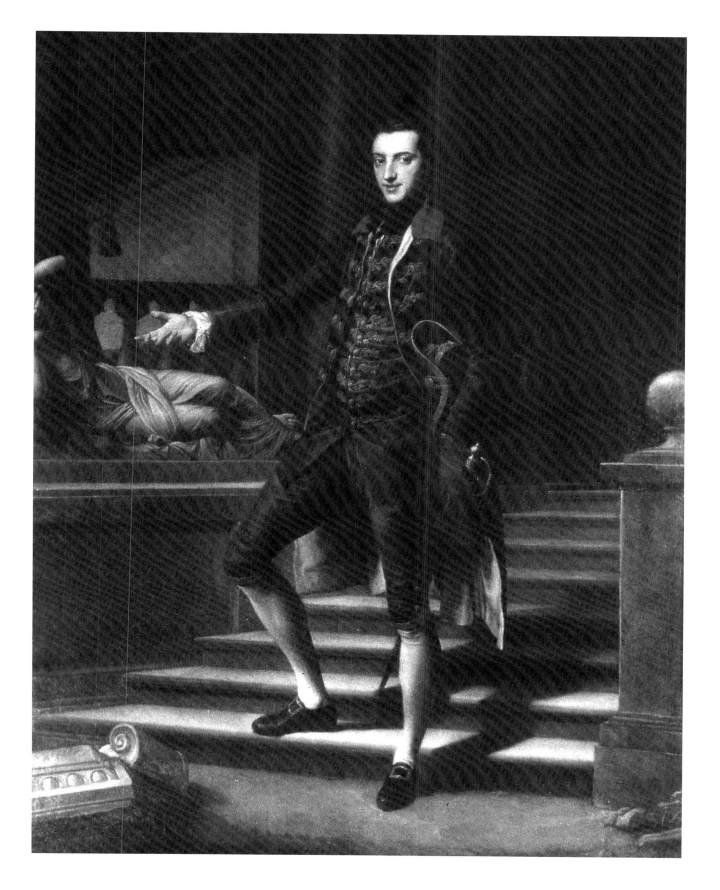

difficulty in obtaining the export license.' In order to reduce the export fees, as well as to avoid the possibility of its receiving an export bar by the papal authorities, Jenkins now deliberately down-valued the sculpture by emphasising the extent of the restorations; he also submitted the price as being the original Barberini estimate of 300 scudi. To speed up the process, Jenkins falsely asserted that the statue was destined for the English king, and outrageously added that the Pope had allowed it to leave Rome because of 'the fortunate circumstance of its being a naked female'!

This last comment prompts a discussion of the ways in which the Venus would be viewed in the eighteenth-century context. Most of the surviving judgements come from men, and the discourse tends to centre around which of the various Venus statues was the most beautiful.

The *Jenkins Venus* is rarely mentioned in this 'league table' because she left Rome quickly and found herself in the relatively rarely visited north of England. However, it is significant that Winckelmann, at least at first sight, considered her 'worthy of Praxiteles … a delightful beauty … and alone worth the visit to Rome'. The German proto-art historian's comments are aesthetic, whilst most comments were more sexually orientated as well as patronising – quite a change from the more respectful, albeit sexual, comments of antiquity. Thus, the *Medici Venus* was described in 1691 as having a 'decent bashfulness which is so becoming an ornament of the Fair Sex … with her other hand she covers the Part which Ladies blush to discover, which she does also without touching it.'[18] These two opposing ways of viewing the Venus, as a purely aesthetic ideal or as a more sensual physical presence, can be viewed as a test of not only aesthetic appreciation but also of the ethics of the gaze. Thus Pierre Bourdieu commented that: 'Only pure pleasure – ascetic, empty pleasure which implies the renunciation of pleasure … is predisposed to become a symbol of moral excellence and the work of art a test of ethical superiority.'[19] In this respect Venus functions as a powerful ambiguous visual sign which challenges our aesthetic morality.

Venus in Yorkshire

Weddell returned to Newby Hall later in 1765 and persuaded Robert Adam (1728–1792) to redesign and 'modernise' the interior of his sculpture gallery (fig.53). It is clear from surviving pen-and-ink plans that the gallery's star object was to be the *Jenkins Venus*, along with a magnificent marble Roman sarcophagus. The entire rationale of Adam's decorative scheme was to frame these two objects in the most prominent manner. The sarcophagus was placed at the terminal point of Adam's triple-roomed vista, with the Venus in the left-hand niche of the central domed and top-lit rotunda. Her pendant statue in the right-hand niche was the Minerva, thus creating a binary oppositional pairing

FIRST ROOM

1. Statue of a Faun.
2. Statue—Bacchus and a Satyr
3. Statue—Geta.
4. Statue—Ganimede and an Eagle.
5. Statue—Galatea.
6. Urn.
7. Urn.
8. Statue of Epicurus.
9. Antique Tripod—Bust of Hercules.
10. Statue of Silenus.

MIDDLE ROOM

11. Bust—Female, unknown.
12. Statue of a Slave.
13. Bust—Caracalla.
14. Statue—Sitting Muse.
15. Bust—Septimius Severus.
16. Statue—Venus. Originally in the Barberini Collection at Rome.
17. Bust—Female, unknown.
18. Bust—Caligula.
19. Statue—Minerva.
20. Bust—Alexander.
21. Bust—Minerva
22. Statue—Faustina.
23. Bust—Jupiter.

THIRD ROOM

24. Terminus.
25. Bust—Man, unknown.
26. Bust—Augustus.
27. Sarcophagus—Dacian King.
28. Statue of Apollo.
29. Sarcophagus—Sitting Figure of Marius
30. Bust in Basalt.
31. Antique Bath.
32. Bust in Basalt.
33. Antique Tripod—Figure of an Ibis.
34. Antique Tripod—Bust of W. Weddell, Esq.
35. Bust of Lucilla.
36. Negro's Head in Basalt.
37. Statue of a Boy Playing on a Pipe.

53. Plan of sculpture gallery showing Venus at position 16, Newby Hall, Ripon, North Yorkshire

Courtesy Newby Hall Estate

symbolic of Pleasure and Virtue. When seen from the entrance doors leading from the library at the other end, the sculptural programme (fig.54) appears to lead from figures of mortal life, through philosophy and the choice between sensual pleasure (Venus) and philosophical virtue (Minerva) towards Death and the afterlife (the sarcophagus). A generation after the gallery's completion, visitors were impressed by the awe-inspiring nature of Adam's gallery and its sculptures, particularly as approached from the library:

> candles … cast 'a dim religious light' over this apartment, and assist the magic effect with which the mind is impressed when we look through the door in the recess at the opposite extremity of the room. Here we throw a glance into the *penetralia* of the temple – the museum, or gallery of statues; a series of the most precious antique marbles which taste could select, and money procure.[20]

This passage reminds us of the importance of light in the viewing context of sculpture, with flickering candlelight enhancing the strangeness of the antique sculptures.

54. View of Robert Adam's Sculpture Gallery, Newby Hall, showing (left) the *Jenkins Venus* (sensuality) and (right) the Minerva (virtue), with the Roman sarcophagus (death) at end of the vista

Courtesy Newby Hall Estate

Likewise the close relationship between taste and money continues to be important in the assessment of the *Venus*. Her new physical context, placed in a candlelit interior on a Neoclassical cylindrical pedestal by Adam, and framed within a niche, denies the viewer the possibility of viewing her rear, and thus profoundly alters the intended circular viewing strategy as described in ancient literature.

Within the next two hundred years, the *Jenkins Venus* was renamed the *Barberini Venus* as a reference to its original and more famous Italian Renaissance provenance. In 2002 the present owner of Newby Hall, Richard Compton, decided to sell the *Venus* at auction. He was aware of the gap that this would create in the sculpture gallery and therefore decided to have a copy made using the latest technology. A laser scan was created and sent to Italy, where a robot diamond-cutter carved out a polyurethane replica. This was then copied in Carrara marble by the leading Italian sculptor Roberto Pedrini. The marble was the same type as the original (in spite of the tradition that it was Greek Parian), and Pedrini employed the ancient Roman copying process known as `pointing', whereby points on the model are transferred across to the marble. The point marks can still be seen on the polyurethane model (fig.55). The resulting copy (of a copy!) arrived at Newby Hall in 2005 and now stands in the same niche with the same label – '*The Barberini Venus*'. Compton's new copy has an interesting status in relation to the statue's history. It has been produced with meticulous care, using state-of-the art laser technology combined with traditional sculptural craftsmanship. As a production of our own 'authenticity' culture, it has even deliberately preserved the joins of the 'original' statue's restorations, and created a deliberate patina (using tea!) in order to pay homage to the heritage and history of the statue. Although a copy, so was the *Jenkins Venus* itself, and the statue will no doubt attract the admiration of the contemporary viewer for its own reasons. Richard Compton described the moment when he first saw the new *Venus*: 'It is a very exciting moment. It is wonderful. I was almost in tears as we unpacked it and it looks fantastic. It looks 2,000 years old.' But where is the *Jenkins Venus*?

Venus in Qatar

On Thursday 13 June 2002 'The Jenkins Venus' was sold to an anonymous telephone bidder at a Christie's London auction for £7,926,650.[21] This remains the British auction record for an antiquity, and the world record for an ancient marble.[22] The purchaser was later discovered to be one of the world's most important art collectors, Sheikh Saud al-Thani of Qatar. Since 1998 the sheikh has been buying important art for five new museums in the capital city of Doha.[23] His second cousin, the Emir of Qatar, intends to transform his country into an international cross-cultural centre. Before the *Venus* departed for her new and exotic Middle Eastern home, the British Department for

55. Polyurethane copy of the *Jenkins Venus*, now at Newby Hall, North Yorkshire, *c*.2000–02
Polyurethane, height 163 cm (64⅛ in)
Photo: D. Bellingham, courtesy Newby Hall Estate

Culture, Media and Sport on 7 August 2003 imposed a temporary two-month export bar on her.[24] This was because the statue was deemed to fulfill the Waverley Criteria (1952) for important heritage objects. It would appear, however, that this sudden after-the-fact political attention was only due to the record price and subsequent media attention to the sale; other important antiquities of lesser monetary value are regularly exported without hindrance. The Keeper of the Department of Greek and Roman Antiquities in the British Museum argued that it fulfilled the criteria because it was an integral part of the architecture of Newby Hall's sculpture gallery, and it was of great importance for Grand Tour studies. The sheikh and his agents ironically argued that it was a heavily restored figure, as Jenkins had argued in the eighteenth century, and that the United Kingdom possessed other significant Grand Tour sculpture collections, such as the Townley Collection in the British Museum.

The *Jenkins Venus* now enters a new phase in its reception history. Traditionally, Middle Eastern Islamic culture has found large-scale figurative art distasteful, and the nude female subject-matter might be considered particularly controversial. It will be interesting for future art history to observe how she is received once she goes on public display in this non-Western environment. She is likely to achieve something of the high status she enjoyed in Rome. Within the context of the history of art and the art market, it remains a wonder that a heavily restored and composite copy can achieve such a degree of notoriety and high monetary value in two different historical periods. Meanwhile, as her Yorkshire twin, or clone, begins to be exposed to a revived British interest, it remains to be seen whether that postmodern laser-sourced statue, although likewise a copy, will be received as an art object in her own right.

NOTES

1. Richard Warner, *A Tour Through the Northern Counties of England and the Borders of Scotland*, 2 vols (Bath: R. Cruttwell, 1802), p.258.

2. Christie's (2002), 'Important European Furniture, Sculpture, Tapestries and Carpets', Thursday 13 June 2002, LOT 112.

3. R.R.R. Smith, *Hellenistic Sculpture* (London: Thames & Hudson, 1991), pp 79–83; figs 99 and 100.

4. Homer, *Iliad*, trans. R. Lattimore (Chicago: Chicago University Press, 1951), bk.III, ll.390–99; 413–15.

5. Pliny the Elder, *Natural History*, XXXV.xl.133.

6. For discussions of pubic hair in antiquity, see H. Licht, *Sexual Life in Ancient Greece* (London: Routledge, 1942); M. Kilmer, 'Genital Phobia and Depilation' in *Journal of Hellenic Studies*, vol.102 (1982), pp 104–12; and A. Hollander, *Seeing Through Clothes* (Berkeley, CA: University of California Press, 1993).

7. Lucian, *Amores*, sections 13–14, trans J.J. Pollitt in J.J. Pollitt, *The Art of Greece: Sources and Documents* (Cambridge: Cambridge University Press, 1990), p.86.

8. Pliny the Elder, *Natural History*, bk.XXXVI, section 20, trans J.J. Pollitt in Pollitt, *op. cit.*, p.84.

9. Cicero, *Letter to Atticus*, vol.I, 8, 2, trans. J.J. Pollitt in J.J. Pollitt, *The Art of Rome: Sources and Documents* (Cambridge: Cambridge University Press, 1983), pp 76–7.

10. M.A. Lavin, *Seventeenth-Century Barberini Documents and Inventories of Art* (New York: New York University Press, 1975), p.325.

11. Christie's (2002), *op. cit.*

12. J. Winckelmann, *Briefe*, ed. W. Rehm, vol.III (Berlin: Walter de Gruyter, 1956), p.103; my translation.

13. Leeds Museums and Galleries, *Drawing from the Past: William Weddell and the Transformation of Newby Hall* (Leeds: Leeds Museums and Galleries, 2005) provides a good modern study of Weddell as art collector.

14. J. Farington, eds K. Garlick and A. Macintyre, *The Diary of Joseph Farington*, vol.II (New Haven, CT, and London: Yale University Press, 1978), p.448. For the most recent assessment of the statue's modern restorations see Christie's (2002), p.164: 'The 18th Century restorations have been attributed to Cavaceppi. These include parts of the hair, tip of the nose, right arm and armlet, lower left arm, part of left buttock, lower right leg, two toes of left foot, two heads of Erotes, small areas on support, profiled base around the central original base. It has been suggested that the ancient head may be from another statue, perhaps veiled, with reworking of the veil at the back as hair.'

15. *ibid.*, p.439. For other anecdotal sources of the price paid by Weddell to Jenkins see: A. Michaelis, *Ancient Marbles in Great Britain* (Cambridge: Cambridge University Press, 1882), pp 527–9. Prices vary between £1,000 and £6,000.

16. One pound sterling was worth approximately four Italian scudi; the Barberini were paid 300 scudi (approximately £70).

17. Farington, J. *op. cit.*, p.448: 'The figure of Minerva in the possession of Mr. Weddel, was found in a vineyard near Rome and bought by Nollekens for 60 Crowns. It is a draped figure, and, when found, wanted a head. Jenkins having met with a Head which matched the statue offered Nollekens 125 pounds for the figure. – They at last agreed to make it a joint concern, with an allowance to Nollekens as the figure was the most valuable part. – It was then offered & sold to Mr. Weddel for £600. – Nollekens says it is a very fine figure and worth £1000, and Mr. Townley would give that sum for it.'

18. M. Misson, *A New Voyage to Italy*, vol.1 (London: R. Bentley, 1695), p.186.

19. Farington, *op. cit.*, pp 489–91.

20. Warner, *op. cit.*, p.254.

21. Christie's Sale, *Important European Furniture, Sculpture, Tapestries and Carpets*, Thursday 13 June 2002, LOT 112.

22. The *Jenkins Venus* remained the world record at auction for an antiquity until 7 June 2007, when Sotheby's New York sold a bronze statuette of *Artemis and the Stag* for $28.6 million (approximately £14 million). This in turn was surpassed in December 2007 when Sotheby's New York sold the tiny (8.25 centimetre) limestone Mesopotamian *Guennol Lioness* for $57 million (£28 million).

23. C. Hastings, 'The Art World's Biggest Spender is Placed under House Arrest' in *The Telegraph* (13 March 2005); J. Dalley, 'Pushing the Boat out for Art' in *The Financial Times* (24 March 2007).

24. For the most comprehensive modern discussion of the condition and status of the *Jenkins Venus*, see Department for Culture, Media and Sport, *Export of Works of Art, 2002–2003*, Case 25.

On the Wings of a Dove: Jacob Epstein's *Doves – Third Version*, 1914–15

Bernard Vere

Between the years 1913 and 1916 Jacob Epstein (1880–1959) was a sculptor much obsessed by sex. Aside from his best-known work, *Rock Drill* (1913–15), which fused phallic and maternal elements in a machinic context, the titles of his works alone attest to his interest in themes of birth, reproduction, renewal and regeneration: *Birth*, two versions of *Venus* and two versions of *Mother and Child*. Two pregnant figures in 'flenite' (Epstein's term for serpentine stone) continue the theme. Within this astonishingly prolific period lie the three sculptures that Epstein produced of doves, or pigeons, mating. They raise questions that are significant not only with regard to their placement within Epstein's career and preoccupations, but also within the wider context of modernism at this time: the role of the collector and patron; the purpose of serial production; the importance of 'primitive' art; the geometric character of abstraction; and the relationships between the arts.

The three versions of *Doves* were never exhibited together during Epstein's lifetime and there is still some confusion over which of the first two versions was the initial work of the series. The first two versions were both produced in 1913. *Doves – First Version* is the smallest of the three and is now in the Hirshhorn Museum in Washington, D.C. (fig.56). *Doves – Second Version* was executed in a distinctive pink Parian marble (fig.57). This version was certainly exhibited at the Doré Gallery's 'Post-Impressionist and Futurist' exhibition during October 1913, and was probably the version exhibited at Epstein's one-man show at the Twenty-One Gallery in London that December. It is now in the Israel Museum, Jerusalem. *Doves – Third Version* (fig.58) was, unlike the other

Below, left and right:

56. Jacob Epstein, *Doves – First Version,* 1913
Marble, 35 x 49.5 x 18.4 cm (13¾ x 19½ x 7¼ in)
Hirshhorn Museum and Sculpture Garden, Smithsonian Institution, Washington, D.C., gift of Joseph H. Hirschhorn, 1966

57. Jacob Epstein, *Doves – Second Version*, 1913
Parian marble, height 47 cm (18½ in)
The Israel Museum Collection, Jerusalem, photo
© The Israel Museum, Jerusalem by Avshalom Avital

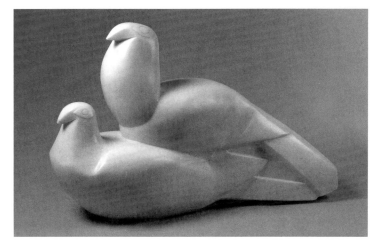

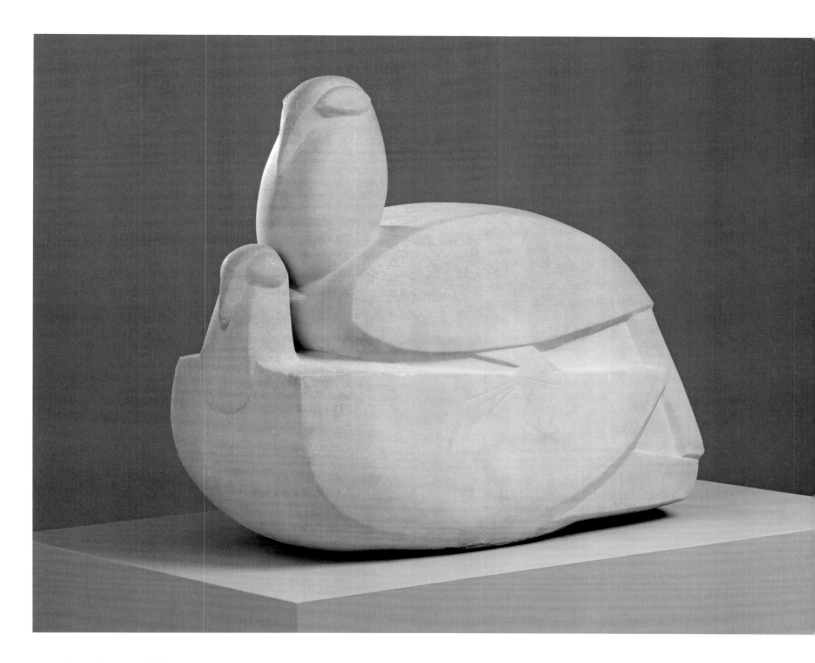

58. Jacob Epstein, *Doves – Third Version*, 1914–15
Marble, height 64.8 cm (22½ in)
Photograph © Tate, London, 2009

two, made in response to a commission. In April 1914 the American collector John Quinn wrote to Epstein to ask him to carve a version of the *Doves*, and Epstein responded at the beginning of the following month that he was willing to do this. Shortly after the original commission, Quinn wrote again to Epstein emphasising that he wanted a replica of one of the first two versions. The work was delivered to Quinn in 1915, and when bought at auction in 1973 it became part of the collection of the Tate. In fact, *Doves – Third Version*, the largest of the three, is not a simple replica of either of the first two versions, and its differences from them are both important and instructive.[1]

John Quinn (1870–1924) is a name that is barely known today. A lawyer, he was described by Alfred H. Barr, Jr, the founding director of New York's Museum of Modern Art, as 'the greatest American collector of the art of his day'.[2] Since other contenders for this accolade were Gertrude Whitney, Albert Barnes and the Stein family, this gives some indication of the respect in which he was held by his contemporaries. A further indication of his importance to the modern art world is his role in the Armory Show of 1913, the exhibition that is commonly held to have introduced avant-garde art to the USA, where he was both the biggest lender to the exhibition and the biggest buyer; he also delivered a speech at its opening. Quinn also acted as a patron for Augustus John and donated £150 per annum to the journal *The Egoist*. *Doves – Third Version* entered a collection that already included works by Cézanne, van Gogh, Picasso, Matisse, Rouault, Dufy, Brancusi, Jacques Villon and Duchamp. Quinn died in 1924 and, although a lawyer, his will contained no stipulation that the collection should be kept together. Whether by oversight or deliberate omission, the absence of such a clause allowed his estate to sell the collection at auction, and works from it now form part of the Arensberg Collection in Philadelphia, the Goodyear Collection in the Albright-Knox Museum, the Columbus Gallery of Fine Arts and the Museum of Modern Art in New York, amongst others.

A third figure also played a significant role in the history of *Doves – Third Version*. Ezra Pound (1885–1972) was corresponding with Quinn and was a friend of Epstein, as well as being a major figure on the London art scene. In comparison to the vast literature on Pound's own work as a poet, or his role in promoting literary figures such as T.S. Eliot and James Joyce early in their careers, little attention has been paid to his role as a promoter of artists.[3] Yet Pound wrote many articles on the visual arts and Epstein thought enough of his opinions to reproduce Pound's review of his 1914 Goupil Gallery show in his autobiography.[4] In that piece Pound singled out one of the first two versions of *Doves* (almost certainly the second) for special praise, claiming it had 'that greatest quality of art, to wit: certitude'.[5] Pound also had very definite views on the relative merits of the first two sculptures, writing to Quinn: 'By the way, if you're still getting Jacob's "Birds" for God's sake get the two that are stuck together not the pair in which

one is standing on its legs.'[6] Pound's view had first been expressed in an essay on Epstein for *The New Age* where he set out what he knew of Epstein's work, including: 'Two sets of pigeons. The heavier and the closer is the better.' However, Pound's main aim in the article was to take the art market to task for its refusal to buy Epstein's work. That Epstein should still find himself in need of buyers in 1915 goes some way towards disproving the theory that publicity automatically generates sales. By the time that Quinn commissioned the third version of *Doves*, Epstein's career had already been marked by a succession of controversies. In 1908 his sculptures for the façade of the British Medical Association in the Strand had faced accusations of obscenity and sparked a long-running debate in the national press. This was followed by Epstein's sculpture for the tomb of Oscar Wilde, completed in 1912. This was well received in Britain, but found less favour in Paris where Wilde lies in Père Lachaise cemetery. The French police thought the sculpture obscene and it was covered by a tarpaulin until the First World War.

Prominent amongst Pound's targets was 'that sink of abomination, the Tate Gallery', which had 'rushed into the sloughs of stupidity by refusing, in a more or less indirect manner, perhaps, yet still, refusing one of the finest of Epstein's works, when it was offered as a gift. This is, to put it mildly, robbing the public.'[7] In a letter written almost 20 years later Pound repeated the charge and revealed the identity of the work, condemning once again 'the peedling Tate Gallery' for 'refusing Epstein's *Birds* as a gift – which mattered; and presumably buying his later tosh at a high figure'.[8] Had the Tate accepted such a gift of either of the first two versions, it is highly unlikely that it would have bid for *Doves – Third Version* in 1973. The Tate would have owned one of the first two works, but, as the other of these was already in a public collection, it would have had no prospect of owning all three.

Epstein was not amused to learn of Pound's advice to Quinn. He had written to Quinn shortly after Pound had done so, saying that he 'would get at the birds again and despatch it'.[9] In response Quinn cabled Epstein, 'Want birds that are stuck together, not pair one standing on its legs',[10] and in a following letter he mentioned that it was Pound who had given him this advice. Epstein responded: 'Why Pound should implore you "for God's Sake" not to get the other birds passes my understanding … let Ezra stick to his poetry and leave the sculpture alone.'[11] But Pound was never likely just to stick to poetry and *The New Age* article was not solely an attack on the Tate, but also a chance for him to espouse his views on the role of patronage in modernity. Throughout his career, Pound was fascinated by the role of patronage, particularly during the Renaissance, and on the lookout for ways in which this could be replicated at the start of the twentieth century. Schemes for achieving this included the 'Bel Esprit' project, in which 30 people would each pledge 10 pounds a year to guarantee T.S. Eliot an annual income, and, less

happily, his courting of state patronage from Benito Mussolini's fascist Italy.[12] But both these projects lay in the future and the appeal in *The New Age* was simply for collectors to buy work from Epstein:

> Is it or is it not ludicrous that [Epstein's] 'The Sun-God' (and two other works which I have not seen) should be pawned, the whole lot, for some £60? And that six of the other works are still on the sculptor's hands? And this is not due to the war. It was so before this war was heard of.
>
> One looks out upon American collectors buying autograph MSS of William Morris, faked Rembrandts and faked vandycks [sic]. One looks out on a plutocracy and the remains of an aristocracy who ought to know by this time that keeping up the arts means keeping up living artists.[13]

It was this article that initiated the correspondence between Pound and Quinn referred to above. Quinn, who *had* purchased an autographed William Morris manuscript, understandably took Pound's comments to apply to him and wrote to Pound defending his position: 'If there is a "liver" collector of vital contemporary art in this country, for a man of moderate means, I should like to meet him.'[14] Pound, backtracking a little, tells Quinn that 'I heard from W.B. Y[eats], after I had written the article (after it was in print), that you had bought "an Epstein". ("an Epstein", not half a dozen)', before becoming more explicit on the thrust of his essay: 'My whole drive is that if a patron buys from an artist who needs money (needs money to buy tools, time and food) the patron then makes himself equal to the artist, he is bringing art into the world. He creates.'[15] Pound revised his view of Quinn's collection in the light of the collector's letter to him. He saw that Quinn's objectives were not far out of line with his own. A collector who buys from an unknown artist is the equal of the artist. If he buys from an established artist, the collector is merely a consumer. Besides, argues Pound, the potential financial rewards are infinitely greater. Quinn's commission from Epstein represents just the sort of patron that Pound is searching for and he tells Quinn that if he can 'hammer this into a few more collectors you will bring on another Cinquecento.'[16]

Insofar as the third version of *Doves* was a commission, it cannot be placed easily in the lineage of serial production, one of the hallmarks of modernism from Claude Monet's (1840–1926) *Haystacks* to Andy Warhol's (*c*.1928–1987) *Marilyns*. There is no way of knowing whether Epstein himself would have carved a third version without Quinn's letter. However, the *Doves* motif can also be extended into the two versions of *Venus*, where the figure rests on a pair of mating birds. Quinn, as noted above, had asked for a replica, but no two versions of these birds are identical. What are the differences between them and what might they signify?

As Pound pointed out, the major differences between the first two *Doves* is the space between the birds, with the 'heavier and closer' second version being better than 'the pair in which one is standing on its legs'. It was surely the Hirshhorn first version that Pound had in mind in 1917 when he wrote of a 'wretched and rolling-pin travesty of his original and impressive mating pigeons'.[17] It is this elimination of space that is continued into the third version with an even greater emphasis on abstraction. Compared even to the second version in the Israel museum, the third version is heavier and closer still. The breast of the male bird has moved closer to the neck of the female. The feet, which had been carved in relief in the previous two versions, are now simply striations into the surface of the marble. The massing is heavier and the wings of the birds form solid, flat shapes, unlike the rounded contours of the second version. The third version is by far the largest of the three, which also suggests that Epstein was not merely fulfilling a commission when he produced it. It can be seen as a response to a further controversy. Unlike the Strand statues or the Oscar Wilde statue, this controversy was not marked by calls for censorship or played out in the national press. It was, however, the most important in terms of modernist aesthetics.

The 1913 exhibition at the Twenty-One Gallery, Epstein's first one-man show, which included the second version of *Doves* as one of only five sculptures displayed, aroused the ire of *The New Age* critic Anthony M. Ludovici. Although *The New Age* was generally sympathetic to modernism, Ludovici attacked Epstein in no uncertain terms:

> To understand what I think of Jacob Epstein is not difficult. When the plastic arts can no longer interpret the external world in terms of a great order or scheme of life, owing to the fact that all great orders or schemes are dead, they exalt the idiosyncrasy or individual angle of the isolated ego [...] the art has no interest whatsoever, save for cranks and people who have some reason of their own in abetting or supporting purposeless individualism à outrance. To these, the particular angle of vision of a minor personality has some value – to me it has none.[18]

This intemperate article would probably not be known today were it not for the reaction it produced from the philosopher and critic T.E. Hulme (1883–1917). Hulme first met Epstein in 1911 in his studio, where he saw Wilde's (then uncompleted) tombstone. Hulme and Epstein were to become exceptionally close. Epstein sculpted Hulme, a sculpture that would also later enter the Quinn collection, and Hulme set out to write a book on Epstein, though his death in the First World War prevented its completion. However, we know that Hulme intended to include photographs of all three *Doves* in the work, as copies of these exist amongst his papers. Hulme captioned all three versions 'Pigeons' and, as the works were always exhibited at the time with the title *Group of Birds*, it may

well be that all three works did not acquire the softer designation *Doves* until the sale of the third version at the auction of the Quinn collection in 1927.[19] 'Mr. Epstein and the Critics', Hulme's response to Ludovici, was as belligerent as Ludovici's original article. 'The most appropriate means of dealing with him', writes Hulme, 'would be a little personal violence'.[20] But amongst the insults and threats directed at Ludovici, something of Hulme's philosophy can be made out. So-called 'Primitive Art' was still in need of defence in 1913, even more so was art, like Epstein's, that was clearly inspired by the 'primitive' and had wilfully turned its back on the European tradition exemplified by the Renaissance. Dismissing the widely held contemporary prejudice that 'primitive art' was entirely alien to Western man, Hulme stated his belief that both it and Epstein's work were expressive of certain universal formulas and, if they appeared to express emotions that 'it is unnatural for a modern to have',[21] this was because the present era, inaugurated with the ideals of the Renaissance, was on the point of breaking up, allowing these older attitudes to re-emerge.

Hulme took these ideas much further in his long lecture of the following year, 'Modern Art and Its Philosophy'. In arguing for the value of primitive art, Hulme had been following the work of Wilhelm Worringer (1881–1965). Worringer believed that art could be representative of one of two opposed urges: the urge to empathy and the urge to abstraction. If the urge to empathy is correctly represented it results in a beautiful work of art, one that stresses unity and 'the happy pantheistic relationship of confidence between man and the phenomena of the outside world'.[22] If on the other hand, the work is inspired by the 'urge to abstraction', it is as the result of a 'differently directed volition', one that proceeds from 'an immense spiritual dread of space'.[23] Abstraction offers the possibility of 'taking the individual thing of the external world out of its arbitrariness and seeming fortuitousness, of externalising it by approximation to abstract forms and, in this manner, of finding a point of tranquillity and refuge from appearances'.[24] The art that results emphasises a simple line, geometrical regularity and the inorganic.

On Hulme's own account his lecture 'Modern Art and Its Philosophy' is 'practically an abstract of Worringer's views'.[25] But Hulme takes things further. As we have seen, he believed the Renaissance attitude, exemplar of Worringer's 'urge to empathy', was on the point of dissolution. This would allow for the return of the inorganic, and Hulme believes this change is heralded first of all in the visual arts, more specifically by Epstein: 'Finally I recognised this geometrical character re-emerging in modern art. I am thinking particularly of certain pieces of sculpture I saw some years ago, of Mr Epstein's.'[26] As Alan Munton has pointed out, the dating of this experience to 'some years ago' appears to mean that he cannot be referring to the works, including the second version

of *Doves*, that he had seen only a few months before and which he had defended from attack by Ludovici.[27] Nevertheless, we might expect that any work Epstein completed after Hulme's lecture would, consciously or otherwise, reflect the close relationship between the two men. As Pound was to opine later, 'I prefer [Wyndham] Lewis in his clearest and cleanest diagrams; Epstein of the pigeons, as he was when most clearly in touch with Hulme and Hulme's ideas'.[28] Lewis himself put it even more succinctly when he warned a friend, 'Hulme is Epstein and Epstein is Hulme'.[29]

When Hulme describes 'other arts like Egyptian, Indian and Byzantine', which epitomise the historical urge to abstraction, he could almost be describing *Doves – Third Version* (a reference to the human body aside) 'where everything tends to be angular, where curves tend to be hard and geometrical, where the representation of the human body, for example, is often entirely non-vital, and distorted to fit into stiff lines and cubical shapes of various kinds'.[30] Hulme returns to the problem of abstract sculpture in the round, the three-dimensionality of which tends to militate against abstraction, and once again offers a solution that mirrors the sequence of Epstein's *Doves*: 'In archaic Greek sculpture, for example, the arms are bound close to the body, any diversion of the surface is as far as possible avoided and unavoidable divisions and articulations are given in no detail.'[31] Looking at *Doves – Third Version*, with its greater abstraction and elimination of the feet of *Doves – First Version*, its retention of the shape of the marble block that it was carved from (an important tenet of modernist carving at this point), one can see how in it, too, 'the abstract and inorganic is always used to make the organic seem durable and eternal'.[32]

This, though, was not the full development of the 'new geometrical art' that Hulme was seeking: 'As far as one can see, the new "tendency towards abstraction" will culminate, not so much in the simple geometrical forms found in archaic art, but in the more complicated one associated in our minds with the idea of machinery'.[33] Once again, it is Epstein's work to which Hulme turns, to 'The drawings for sculpture in the first room of his exhibition' at the Twenty-One Gallery:

> The subjects of all of them are connected with birth. They are objected to because they are treated in what the critics are pleased to term a cubistic manner. But this seems to me a most interesting example of what I have just been talking about. The tendency to abstraction, the desire to turn the organic into something hard and durable, is here at work, not on something simple, such as you get in the more archaic work, but on something much more complicated. It is however, the same tendency at work in both. Abstraction is much greater in the second case, because generation, which is the very essence of all the qualities which we have here called organic, has been turned into something as hard and durable as a geometrical figure itself.[34]

59. Jacob Epstein, *Rock Drill*: reconstruction
1973–4 by K. Cook and A. Christopher after the
lost original, 1913–15
Polyester resin, metal and wood,
height 250.1 cm (98½ in)
Birmingham Museums and Art Gallery

The sculpture with which these ideas have come to be most closely associated is the original version of *Rock Drill* (fig.59). Here is machinery. Here is the body as 'abstract mechanical relations ... the arm as a lever and so on'.[35] If Hulme believed that the future of art lay with the *Rock Drill*, then he would have been disturbed by Epstein's own decision – taken between the exhibition of the full sculpture at the London Group of March

60. Jacob Epstein, *Torso in Metal from the 'Rock Drill'*, 1913–16

Bronze, height 70.5 cm (27¾ in)

Photograph © Tate, London, 2009

1915 and the exhibition of the *Torso in Metal from the 'Rock Drill'* (1913–16; fig.60) at the following year's London Group exhibition – to reduce the work by removing the drill, the figure's legs along with its right arm, and to cast the work in traditional bronze, a decision that went directly against Hulme's aesthetics: 'You will find a sculptor disliking the pleasing kind of patina that comes in time on an old bronze'.[36] To consider fully the motivations behind, and implications of, Epstein's decision is beyond the scope of this essay. We know, however, from Epstein's letter to Quinn that he was still working on *Doves –Third Version* in March 1915, the same month that Epstein exhibited the complete version of *Rock Drill* for the only time. Stephen Gardiner believes that the carving was complete by that July, but that the work was not shipped to Quinn until December (a delay caused in part by the First World War). In the intervening period, Epstein wrote to Quinn saying that he believed the new sculpture was superior to the *Doves — Second*

Version.[37] It is clear that he had gone beyond his patron's wishes for a simple replica and was pleased with the result. At around the same time he must have taken the decision to reduce *Rock Drill* to the *Torso*. Epstein's work undergoes a profound change at this time, with only *Venus – Second Version* retaining anything of Hulme's theories (and even here, the solution that Epstein employs for the pair of mating birds on which Venus stands is substantially similar to *Doves – Third Version*). The rest of the war years were taken up with conventional bronze portrait busts. In an unpublished review of Epstein's Twenty-One Gallery exhibition, Hulme had divided Epstein's career into a 'more or less archaic period' and an 'entirely personal and modern method of expression', the problem for Hulme being, in Munton's words, that 'apart from the *Rock Drill* the sculptor continued to do archaic work'.[38] But *Doves – Third Version*, carved after Hulme's lecture and after *Rock Drill*, sits on the cusp of that distinction. On the one hand it is a return to the archaic, a return that becomes more entrenched with its incorporation into *Venus – Second Version*. On the other hand it has the clean lines and abstraction that Hulme predicted the coming art would have. Moreover, because it deals with the abstraction of the organic, and specifically the organic at the moment of reproduction, it represents the more complex type of abstraction that Hulme thought befitted the modern world, rather than the archaic. Of all the versions of *Doves*, possibly of all Epstein's extant sculpture, *Doves – Third Version* represents the work in which Epstein was 'most clearly in touch with Hulme and Hulme's ideas', to recall Pound's phrase; it is a work that illustrates the ways in which criticism, patronage and art engaged in symbiotic, if at times uneasy, relationships during modernism.

NOTES

1. For the titles of the sculptures and their chronology I have followed Evelyn Silber, *The Sculpture of Jacob Epstein, with a Complete Catalogue* (Oxford: Phaidon, 1986), p.134, cat. nos 48, 50 and 55. The Israel Museum has recently proposed that its sculpture was made first, based on a list of works 'as accurate as the memory of the sculptor will allow', which appeared as Appendix Two of Arnold L. Haskell, *The Sculptor Speaks: Jacob Epstein to Arnold L. Haskell, A Series of Conversations on Art* (London: William Heinemann, 1931), where the work in the Israel Museum is dated to 1913 and that in the Hirshhorn to 1914. Leaving aside the reliability of the sculptor's memory of the sequence of works almost 20 years after their execution, there are compelling stylistic reasons, discussed below, for retaining Silber's chronology. The claim for the primacy of the Israel Museum's work is made by Raquel Gilboa in her piece on 'Doves' in exh.cat. *Jacob Epstein*, ed. Adina Kamien-Kazhdan (Israel Museum, Jerusalem, Summer 2002–Summer 2003), pp 18–21. *Doves – Third Version* can, however, be established as the final work in the series.

2. Barr quoted in Timothy Materer, ed., *The Selected Letters of Ezra Pound to John Quinn, 1915–24* (Durham, NC, and London: Duke University Press, 1991), p.3.

3. Three works that do deal with Pound and the visual arts are exh.cat., *Pound's Artists: Ezra Pound and the Visual Arts in London, Paris and Italy*, Kettle's Yard, Cambridge, 14 June–4 August 1985, and Tate Gallery, London, 11 September–10 November 1985 (London: Tate Gallery, 1985); Harriet Zinnes, ed., *Ezra Pound and the Visual Arts* (New York: New Directions, 1980); and Rebecca Beasley, *Ezra Pound and the Visual Culture of Modernism* (Cambridge: Cambridge University Press, 2007).

4. See Jacob Epstein, *Epstein: An Autobiography*, revised edn. of *Let There Be Sculpture* (London: Studio Vista, 1963), pp 57–8. Pound's review

originally appeared in *The Egoist*, 16 February 1914.

5. Pound in Epstein, *op. cit.*, p.57.

6. Ezra Pound to John Quinn, letter postmarked 9 March 1915 in Materer, ed., *op. cit.*, p.21. The year of the letter is given as 1914 in Silber, *op. cit.*, giving the misleading impression that Quinn commissioned *Doves* after receiving Pound's advice. The year 1915 must be the correct date as Pound's letter is written in response to a letter from Quinn that references Pound's 1915 article on Epstein in *The New Age*.

7. Ezra Pound, 'Affirmations III: Jacob Epstein', *The New Age*, 21 January 1915, p.311.

8. Ezra Pound, letter to John Drummond, 30 May 1934, in D.D. Paige, *The Letters of Ezra Pound, 1907–41* (New York: Harcourt, Brace and Company, 1950), p.258.

9. Jacob Epstein to John Quinn, letter dated 28 March 1915, quoted in Stephen Gardiner, *Epstein: Artist Against the Establishment* (London: Michael Joseph, 1992), p.138.

10. John Quinn to Jacob Epstein, cable of 15 April 1915, quoted in Gardiner, *ibid.*, p.138.

11. Jacob Epstein to John Quinn, letter dated 28 April 1915, quoted in June Rose, *Daemons and Angels: A Life of Jacob Epstein* (London: Constable, 2002), p.93.

12. See Lawrence Rainey's chapter 'From the Patron to *Il Duce*: Ezra Pound's Odyssey' in *Institutions of Modernism: Literary Elites and Public Culture* (New Haven, CT, and London: Yale University Press, 1998), pp 107–45.

13. Pound, 'Jacob Epstein', *The New Age*, 21 January 1915, p.312.

14. Letter from John Quinn to Ezra Pound, quoted in Materer, ed., *Letters of Ezra Pound to John Quinn*, p.19.

15. Pound to Quinn, letter postmarked 9 March 1915, *ibid.*, pp 21, 23.

16. *ibid.*, p.23.

17. Ezra Pound [pseud. B.H. Dias], 'Art Notes', *The New Age*, 22 November 1917, p.74. The order here might simply reflect the order in which Pound became aware of the two works.

18. Anthony M. Ludovici, 'Art. The Carfax, the Suffolk Street and the Twenty-One Galleries', *The New Age*, 14:17, 18 December 1913, pp 214–15.

19. *The Tate Gallery 1972–4: Biennial Report and Illustrated Catalogue of Acquisitions* (London: Tate Gallery, 1975), p.133. *Doves – Third Version* was auctioned at the Quinn sale as lot 712 with the title *Two Doves*. Also in the sale was lot 695, *The Late Lieut. T.E. Hulme, RMA*.

20. T.E. Hulme, 'Mr Epstein and the Critics', *The New Age*, 25 December 1913, p.252. Epstein requested that the piece be republished in Haskell, *op. cit.*, as Appendix One, where he calls it 'the sanest article written about me', p.151.

21. Hulme, *op. cit.*, p.251.

22. Wilhelm Worringer, *Abstraction and Empathy: A Contribution to the Psychology of Style*, trans. Michael Bullock (Chicago, IL: Ivan R. Dee, 1997), p.15.

23. *ibid.*, pp 9, 15.

24. *ibid.*, p.16.

25. T.E. Hulme, 'Modern Art and Its Philosophy' in *The Collected Writings of T.E. Hulme*, ed. Karen Csengeri (Oxford: Clarendon Press, 1994), p.271.

26. *ibid.*, p.271.

27. Alan Munton, 'Abstraction, Archaism and the Future: T.E. Hulme, Epstein and Lewis' in *T.E. Hulme and the Question of Modernism*, eds Edward P. Comentale and Andrzej Gasiorek (Aldershot, UK, and Burlington, VT: Ashgate, 2006), p.76. Hulme first met Epstein in 1911, making it likely that this is the work he is referring to. Munton entertains the possibility that Hulme's 'years' is a slip for 'months', which could then include *Doves – Second Version*.

28. Ezra Pound, 'Collected Prose: 1929' in *Ezra Pound and the Visual Arts*, ed. Harriet Zinnes, *op. cit.*, p.305.

29. Lewis, quoted in Richard Cork, *Vorticism and Abstract Art in the First Machine Age*, 2 vols (Berkeley and Los Angeles, CA: University of California Press, 1976), vol.1, p.161. The friend was Kate Lechmere, who was romantically involved with both Lewis and Hulme.

30. Hulme, *op. cit.*, pp 271–2.

31. Hulme, *op. cit.*, p.275.

32. *ibid.*

33. Hulme, *op. cit.*, p.282.

34. Hulme, *op. cit.*, pp 283–4.

35. Hulme, *op. cit.*, p.284. Munton points out that, although the sculpture was substantially complete by the time that Hulme gave his lecture, he does not name *Rock Drill*. It may be that Hulme had not yet seen the sculpture, but he had certainly seen at least one study for it in Epstein's show and had actually separated this out from his discussion of the other drawings in 'Mr Epstein and the Critics'. As Munton says, this is puzzling, given that the sculpture comes so close to the art that he is calling for. The work illustrated in *The New Age* to accompany 'Mr Epstein and the Critics' is a back view, which Hulme gives a simple account of, omitting what Epstein would later call 'the progeny' encased in the driller's ribcage. Other studies for *Rock Drill* exist and another is listed in the catalogue, but none show the biomorphic 'progeny' in sufficient detail to prevent it being read simply as part of the musculature of the driller. It is possible that during the period between 'Mr Epstein and the Critics' and 'Modern Art and Its Philosophy', Hulme became aware of the existence of the progeny, which clearly connects the work with the concerns over birth and reproduction of the other drawings, and removes the need for the distinction between them. This would also account for Hulme's claim, in the passage quoted above, that *all* the drawings were connected with birth.

36. Hulme, *op. cit.*, p.279.

37. Jacob Epstein to John Quinn, letter of 24 November 1915, cited in Silber, *op. cit.*, p.135. The letter says it is superior to the 'first', but 'first' in this context clearly means the sculpture Quinn had asked him to replicate, i.e. *Doves – Second Version*.

38. Hulme's review is in the Tate archive, TG 8135/35. Much of the material in it was later subsumed into 'Mr Epstein and the Critics', but the periodisation of Epstein's career was not retained. I owe my awareness of this review to Alan Munton's essay, where he also discusses it. His quote here is from Munton, 'Abstraction, Archaism and the Future: T.E. Hulme, Epstein and Lewis' in *T.E. Hulme*, p.80.

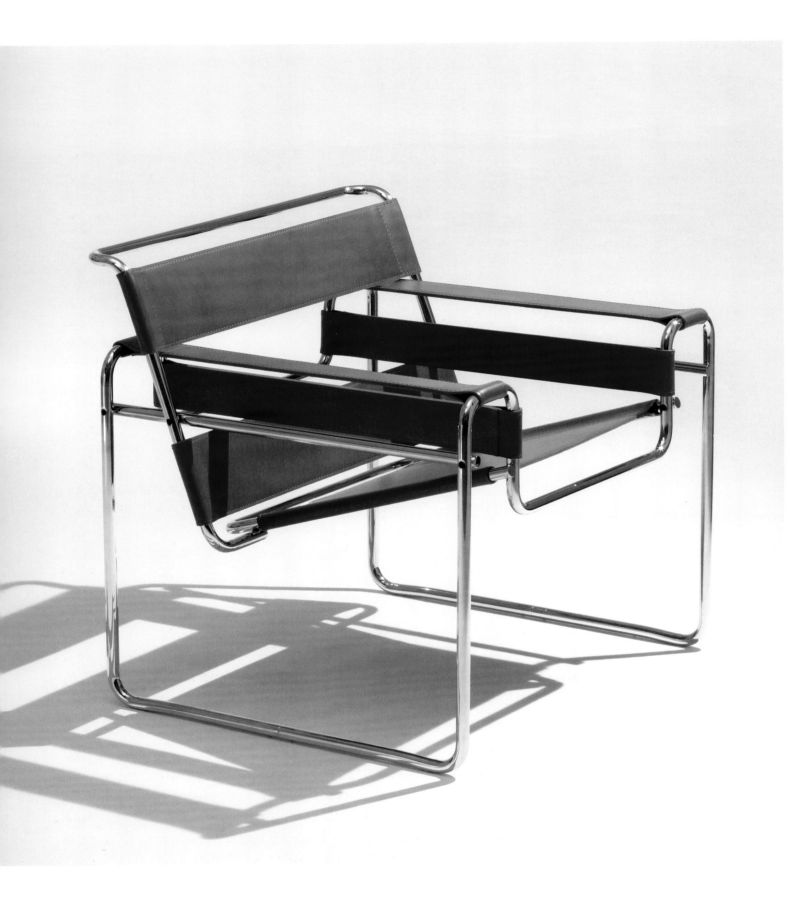

Elisabeth Darby

Marcel Breuer's *Wassily* Chair: A Design Icon of the 1920s

Turn the pages of almost any book on twentieth-century design and you are sure to find an image of Marcel Breuer's *Wassily* chair of 1925 (fig.61).[1] Frequently it will be labelled an 'icon' or a 'classic' of modernist design. Is this label appropriate? Why is the *Wassily* still manufactured today, over 80 years after it was first produced? And why do some examples sell for tens of thousands of pounds at auction while others can be bought off the Internet for only a few hundred pounds? Finally, what were the motivations behind Alessandro Mendini's (b.1931) redesign of the chair in 1978 (see fig.72), which transformed the simple upholstery of the original into a riot of patterned shapes?

Marcel Breuer's *Wassily* was one of the first chairs in tubular steel to be produced. It was designed in 1925 when Breuer (1902–1981) was a teacher at the Bauhaus, the art school in Germany founded in 1919, where he had been a student from 1920 until 1924.[2] The chair was initially made in limited numbers in his studio,[3] but between 1926 and 1927 it was manufactured and marketed as chair B3 (B for Breuer) by Standard-Möbel (Standard Furniture), the firm founded by Breuer and fellow Hungarian Kálmán Lengyel in 1926.[4] From 1929 the bentwood firm of Thonet made the chair, but production ceased in the early 1930s. The chair was relaunched in 1962 by the firm of Gavina in Bologna, when it was renamed the *Wassily* chair in recognition of fellow Bauhaus teacher Wassily Kandinsky's enthusiasm for the design when it first appeared. Knoll International, which took over Gavina in 1968, has continued to produce the chair up to the present day.

In early production models the tubular steel was given a protective nickel-plated finish. These examples are recognisable by their yellowish tone and by the fact that, in time, the plating becomes matt. Chromium plating, which was more durable but also more expensive, was offered from 1928. Breuer at first intended to use a woven horsehair fabric for the upholstery, but this proved expensive and difficult to work with. The chair was subsequently offered with canvas and, from 1927, with *eisengarn* (iron cloth), a tightly twisted cotton fabric coated with wax and paraffin, which was impervious to rot and allowed the chair to be used both inside and outside. The option of leather for the upholstery is a post-Second World War development.[5]

Metal, in sheet and tubular form, had been used before for furniture – for fixings, decorative elements and also for structural parts.[6] The application of tubular steel to furniture in the 1920s was in part the result of technical developments. By 1885 the firm of Mannesmann in Germany had developed a type of seamless steel tubing that was used, for example, for aircraft during the First World War and for bicycles, but it was too rigid and heavy for other applications such as furniture. By 1921, however, thinner and less

rigid tubing had been developed (by Maschinenfabrik Sack GmbH), and the possible uses for it expanded to include furniture.[7] This technological improvement coincided with the emergence of modernism and the perceived need for a material for furniture that accorded with the new architecture and interiors of the machine age.

From the first decade of the twentieth century, the increasingly mechanised nature of contemporary life (evident, for example, in the development of powered flight, the growing number of motorised vehicles and the more widespread use of electricity) prompted a search for an architecture and design that would reflect this new culture. Moreover, after the carnage and devastation of the First World War, the desire to create a new and better world for everyone, free of conflict and social inequality, became the idealistic goal of many of the *avant-garde*. However, it was not really until the mid-1920s, with economic and social stability more or less restored in Europe after the War, that modernism emerged as a coherent programme in architecture and design that seemed to express the ideals of the technological age.[8]

Illustrated here by Le Corbusier's (1887–1965) *Villa Savoye* at Poissy of 1929 (fig.62), modernist architecture was characterised by a skeletal internal support structure that permitted a flexible plan and replaced massive walls with flat planes, devoid of ornament and punctuated by large windows. The open and light interiors of such buildings, however, posed the question of how they should be furnished. In his *Pavillon de l'Esprit Nouveau* (fig.63), erected for the Paris 1925 exhibition and intended as a prototype for mass housing, Le Corbusier designed modular units (*casiers standards*) for both storage and as room dividers; but for seating he relied upon existing types – machine-made, mass-produced bentwood furniture, and club armchairs from Maples furniture store. In their simple, anti-historicist forms and in their emphasis on functionality, these types seemed to equate with the ideas of modernism. However, they still had some overtones of the past, principally because they were made in the traditional material of wood.

Above, left and right:

62. Le Corbusier, *Villa Savoye*, Poissy, 1929

63. Le Corbusier, *Pavillon de l'Esprit Nouveau*, interior, 1925

Accordingly, when tubular steel, which had no such associations, became available for furniture, the *avant-garde* abandoned bentwood to devote their energies to this material.

Before analysing Breuer's *Wassily* chair, it is important to consider in more detail why tubular steel was so rapidly adopted as the most suitable material for modernist furniture in the 1920s. Firstly, tubular steel furniture *looked* modern because it generally made no reference to past styles nor did it employ any ornamentation that might allude to historical sources. It also looked machine-made (although in fact some handwork was involved in production in the 1920s) and used an industrial material; it therefore reflected the modernists' desire to infuse work with the spirit of the technological age. The inherent strength of steel permitted elements within the design to be much more slender than they would have been if executed in wood, and the homogeneous nature of the material allowed it to be formed into curved shapes without splitting or splintering as was possible with wood. Moreover, tubular steel is resilient in itself, so that padding and upholstery are not strictly necessary for comfort: thin strips of fabric can be used instead to support the sitter. In consequence, tubular steel furniture is physically light, and can be easily moved. It is also *visually* light and open in structure: like modernist architecture, it lacks any sense of mass or bulk, as is clearly evident from the view of one of the Master's houses at the Bauhaus (fig.64) in which the openness of the *Wassily* chair allows one to see right through the interior. As Breuer himself suggested in 1928:

> the furniture, and even the walls of the room, is no longer massive, monumental, apparently rooted to the ground or actually built-in. instead [*sic*] it is broken up airily, sketched into the room as it were; it impedes neither movement, nor the view through the room.[9]

Tubular steel was also regarded as durable and hygienic and, in the absence of dense upholstery, furniture in this material was seen as easy to clean and maintain. These were important considerations in post-First World War Europe: the new society was to be a healthy one, and durability was desirable in the difficult economic climate. Breuer summed up the practical advantages of tubular steel thus:

> a well-constructed steel chair will be better able to cope with static loads than an equally well-constructed wooden chair, which means that for the same static loads, a steel chair can be substantially lighter. A chair made of high-grade steel tubing (a highly elastic material) with tightly stretched fabric in the appropriate places, made a light, completely self-sprung seat which is as comfortable as an upholstered chair, but is many times lighter, handier and more hygienic, and therefore many times more practical in use.[10]

It was also believed that, if mass-produced, tubular steel could provide inexpensive furniture that could be afforded by everyone and could be used in every sort of location – the home, office and in institutions of all kinds. It was regarded, therefore, like modern architecture, as universal and non-elitist; unlike different woods, steel gave no indication of the owner's wealth, class or status.

Perhaps most importantly, tubular steel furniture was seen as evolving from functional requirements and from the materials and techniques employed in its creation: it was 'styleless' in Breuer's view because 'it is not expected to express any particular styling beyond its purpose and the construction necessary therefore'.[11]

The use of tubular steel in the *Wassily* chair was a radical departure for Breuer as a furniture designer, which he himself acknowledged in 1927: 'It is my most extreme work both in its outward appearance and in the use of materials; it is the least artistic, the most logical, the least "cosy" and the most mechanical.'[12] As a student on the preliminary course and in the workshop at the Bauhaus, Breuer had been exposed to a variety of materials and techniques, but his earlier furniture designs had been executed exclusively in wood (fig.65). The dramatic leap from wood to tubular steel apparently came about as a result of Breuer's appreciation of the resilience, lightness and strength of the handlebars of his new Adler bicycle. He approached Adler who rejected a request to assist him, whereupon he purchased some bent precision steel tubing from Mannesmann and, with the aid of a plumber, developed prototypes and then the final version of what later became known as the *Wassily* chair.[13]

The earliest prototype (fig.66) for the *Wassily* of 1925 still had the four legs of a conventional chair, but fairly quickly (fig.67) the front and back legs on each side were amalgamated with a runner on the floor. This change distanced the chair from traditional types of seat and made it easier to move, as the runner caused less damage to the floor

65. Marcel Breuer, filmstrip, 1926
As published in the *Bauhaus* magazine, July 1926
Courtesy Bauhaus-Archiv (Inv. Nr. 10837)

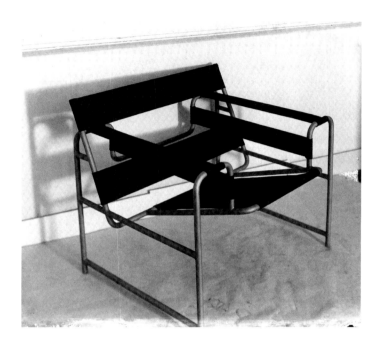

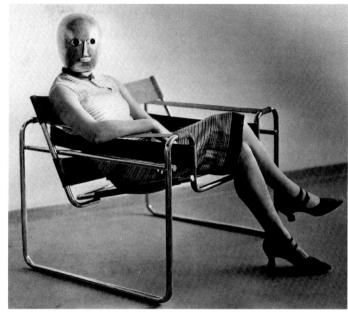

Left and right:

66. Marcel Breuer, *Wassily* prototype, 1925
Courtesy Bauhaus-Archiv (Inv. Nr. 7403-2)

67. Marcel Breuer, *Wassily*, 1925, with Bauhaus student in Oscar Schlemmer mask
Courtesy Bauhaus-Archiv (Inv. Nr. F1218a)

than separate legs. The new design also created a more fluid, continuous structure which reflected Breuer's understanding of the intrinsic nature of the material and its method of manufacture. This amalgamation of elements is evident elsewhere in this version of the design produced at the Bauhaus (for example, at the sides of the chair). By reducing the number of parts in this way, Breuer also reduced the number of joints and therefore potentially weak points in the design. In addition, the cost of production was lowered. Moreover, between the prototype and this early version, Breuer largely abandoned welded joints in favour of screwed ones. In particular, the back of the seat was no longer welded into a U-shaped back frame, but the two uprights of the back stopped just under, and were screwed to, the sides of the seat.[14] Screwed joints not only strengthened the design but also served to reduce the cost of the chair, by eliminating the need for expensive and skilled welding techniques.

When Standard-Möbel took over production of the chair in 1926, further modifications were made. The chair in figure 68 retains the complete U-shaped back of the prototype but this is screwed under the back rail of the seat rather than being welded to it. In the definitive version, produced by Standard-Möbel and Thonet (see fig.61), the side uprights of the back were joined across the top to stabilise the whole back and provide a more unified design. Thonet later made further changes[15] and since the 1960s, when production of the *Wassily* was resumed by Gavina and then Knoll, other alterations have been made, most notably the introduction of leather as an upholstery option.

It is clear from this account of the development of the design that the dating and identification of the *Wassily* models are not as straightforward as they might seem: they involve a similar level of scrutiny of materials and construction accorded an eighteenth-century piece of furniture. The changes to the design also affect the market value of the chair. Early models are rare and fetch high prices at auction: a canvas and nickel-plated Standard-Möbel version of 1926 with U-shaped back was included in *The Chair* sale at Christie's in May 1999 with an estimate of £30,000–£40,000; it sold for £56,500.[16] However, a canvas and chromium-plated definitive version by Standard-Möbel of 1927–8 sold at Sotheby's in November 1996 for its lower estimate of £15,000.[17] The market value of post-1960 *Wassily* chairs is much lower because most people would probably prefer to buy a completely modern example.

As Breuer indicated in his assessment of the *Wassily* chair, it was not only an 'extreme' design in terms of its material, but also in its 'outward appearance'. From the early indi-

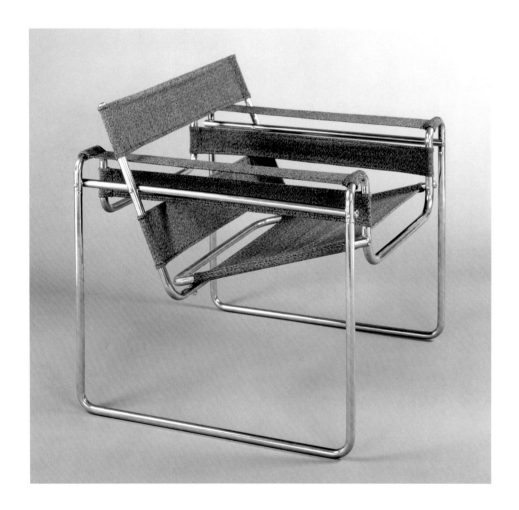

68 Marcel Breuer, *Wassily* Standard-Möbel, 1926
Courtesy Bauhaus-Archiv (Inv. Nr. 3827)

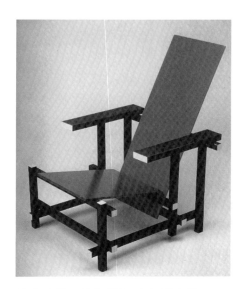

69. Gerrit Rietveld, *Red/Blue* chair, 1918–23

vidualistic and ornamented chair of 1921 (see fig.65, top) Breuer had moved towards increasingly simplified, geometric and lighter forms, replacing patterned upholstery woven directly onto the frame with simple strips of fabric. The form of the *Wassily* chair also has a geometric configuration, and adopts an angled seat and back that brings to mind Gerrit Rietveld's (1888–1964) *Red/Blue* chair of 1918–23 (fig.69), a design that prompted one commentator to observe 'here, out of space, function and material a new shape, according to the demands of modern times, has emerged'.[18] However, by exploiting the strength and resilience of steel tubing, Breuer was able to reduce the support structure further than Rietveld and utilise fabric strips for the seat and back rather than the solid panels of the Dutch design.[19] In Breuer's *Wassily* the steel tubing frame's transparent cubic space, and its reflective surface, together with the minimal upholstery, enhance the sense that the designer has reduced a conventional club armchair (of the type Le Corbusier used in his *Pavillon de l'Esprit Nouveau*: see fig.63) to a skeletal apparition of its basic components. The sitter never touches the steel frame but appears suspended, almost floating, in air – a concept entirely in keeping with the age of aircraft travel, but one that is only hinted at in Rietveld's design.

The idea of the sitter being suspended in air evidently preoccupied Breuer for, shortly after designing the *Wassily*, he made a filmstrip at the Bauhaus (see fig.65). It shows his development as a chair designer between 1921 and 1925 and suggests that, sometime in the future, we would dispense with chairs altogether and sit on resilient air columns. The filmstrip also makes clear that in all his chairs Breuer articulated his materials to emphasise the different parts of the design; in the case of the *Wassily*, Breuer distinguished between the structural function of the hard tubular steel and the softer, supporting role of the strips of upholstery.

The evolution of the *Wassily* reflects not only Breuer's rapid understanding of this new material and his desire to make the chair structurally sound, but also his awareness of the difficult situation in Germany in the mid-1920s. Postwar inflation and instability had called for practical and economic solutions in architecture and design that were aimed at the mass market. As has been suggested, Breuer's reduction of the number of component parts and welded joints helped to reduce costs as much as improve the design structurally. His concern that tubular steel furniture should be economically viable and widely available is evident from the following statement of 1927:

> The severe rationalisation of components – the use of the same components in different types of furniture, the possibility of reducing them to two-dimensional parts (over fifty club armchairs can be packed into a space of one cubic metre, with obvious advantages for transport), and a full regard for industrial and manufacturing considerations all contributed to the social yardstick of a price which could be paid by the broadest possible

mass of the population. And I might say that without meeting this yardstick, I could not have found the project particularly satisfactory.[20]

To emphasise Breuer's position, the *Wassily* chair can be compared to Le Corbusier's *Chaise à dossier basculant* (fig.70), designed in collaboration with Charlotte Perriand and Pierre Jeanneret and produced in 1928 in France, where the economic situation was less difficult and the social commitment was less imperative; this was, after all, the period when the luxurious and elitist Art Deco style reigned supreme in France.

Le Corbusier's design is based on a colonial or safari chair, a type of folding wooden seat that was a popular source of inspiration for designers in the 1920s and 1930s because of its practicality and its suggestion of the mobility of modern life. Although Le Corbusier's chair does not fold up, the back does pivot as in a safari chair, allowing the sitter to vary his or her posture slightly. Le Corbusier was, in effect, updating a conventional type in the modern material of tubular steel. The *chaise à dossier basculant* still has four legs and could have been made in wood; Le Corbusier's design neither reflected the nature of the material nor the manner of its manufacture in the same way as the *Wassily* chair. Moreover, the construction of the *chaise à dossier basculant* was complex, requiring the cutting and welding of difficult joints in addition to screwed ones. It was expensive to produce and therefore could only be purchased by the economically privileged.[21]

This difference of approach, rooted in the particular national context, also explains why Breuer, preoccupied by the material and by economic constraints, continued to experiment with tubular steel into the early 1930s. The *Wassily* chair, despite his amalgamation of elements, remains a complex structure. In subsequent work, he exploited the strength of the material further to create even simpler and less expensive solutions such as the *Cesca* chair of 1928 (fig.71). This was an early example of a cantilever chair in which the strength of steel permitted the elimination of the back legs altogether, thus further distancing metal furniture from traditional seats and further emphasising spatial considerations and weightlessness.[22] By contrast, Le Corbusier, who regarded furniture as 'equipment', designed the *chaise à dossier basculant* as one of a limited range of chairs needed for the different sitting positions that he identified: he did not continue to experiment with tubular steel after about 1929, and he never fully exploited the intrinsic qualities of the material by designing a cantilevered chair.[23]

In the early 1930s Marcel Breuer abandoned tubular steel for furniture, turning to flat steel, aluminium and plywood instead. There are many possible reasons for this. He may have felt that he had exhausted the possibilities of tubular steel and that other materials, such as aluminium, offered both new challenges and also certain advantages – such as lightness and anti-corrosive properties that obviated the need for expensive protective

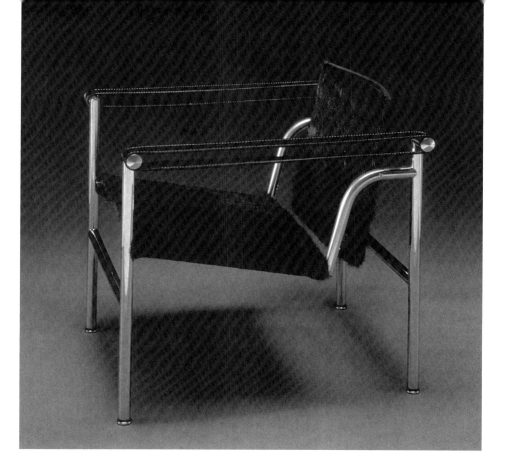

Right and below:

70. Le Corbusier, *Chaise à dossier basculant*, 1928

71. Marcel Breuer, *Cesca* chair, 1928
Tubular steel and cane
Courtesy Bauhaus-Archiv (Thonet, Inv. Nr. 7157 or 7158)

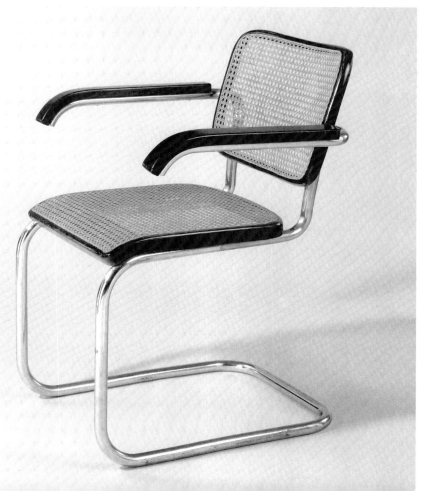

plating. He may also have been aware that although tubular steel furniture became the focus of avant-garde interest from the mid-1920s through to the 1930s, it was not to everyone's taste; many found it too cold and clinical for the domestic environment. In England, for example, where it struggled to find acceptance, the novelist Aldous Huxley wrote of the tubular steel furniture on display at the Paris exhibition of 1930: 'Personally, I very much dislike the aseptic, hospital style of furnishing. To dine off an operating table, to loll in a dentist's chair – this is not my idea of domestic bliss … the time, I am sure, is not far off when we shall go for our furniture to the nearest Ford or Morris agent'.[24] Moreover, tubular steel was not particularly cheap in the 1920s and this, coupled with people's reticence to use it in their homes, meant that the material failed to fulfil its social aspirations: it did not become truly universal or reach its intended mass market.

Whether Breuer was aware of these limitations is unknown, but another reason for his abandonment of tubular steel seems, on his own admission, to have been the result of a lawsuit that awarded artistic copyright for the design of the straight-legged cantilevered side chair to a former partner in Standard-Möbel, Anton Lorenz. Lorenz had acquired the rights to the cantilevered chair designed by the Dutch architect Mart Stam that was shown at the Weissenhof Exhibition in Stuttgart in 1927. As a result of the lawsuit, Breuer was denied royalties on his cantilevered designs.[25] Breuer, who as we have seen regarded tubular steel furniture as 'styleless', was perhaps equally appalled by the notion that 'art' was involved in its design and manufacture; this too may have contributed to his decision not to work with the material again.

Breuer's *Wassily* chair fulfilled many of the modernist goals of the 1920s: its use of industrial steel reflected the machine age; it showed no debt to the past in material, form or ornamentation; it stressed openness and lightness in keeping with the new architecture. Moreover, Breuer's ambitions as a designer, even if not totally achieved with the *Wassily* chair, illustrate the social and egalitarian commitment of the early twentieth-century *avant-garde* in Germany – that inexpensive and practical items should be available to all as part of the process of building a new and fairer society. As such, his chair can be described as a design icon or design classic: it is a work that exemplifies the place and time of its conception.

The iconic status of Breuer's *Wassily* chair began to be recognised in the 1960s, a decade that, building on the achievements of the 1950s, witnessed the widespread acceptance of modern architecture and design. Modernism of the 1920s began to be reassessed and publicised in exhibitions and books,[26] and as a result furniture by leading designers of the movement such as Breuer, Le Corbusier and Ludwig Mies van der Rohe (1886–1969) was put back into production by firms such as Knoll, Cassina and Thonet, and in greater quantity than ever before. Breuer's B3 chair was reissued by Gavina in

1962; it was renamed the *Wassily* by Dino Gavina as if to emphasise its modernist credentials. Breuer commented on these reissues: 'it ... seems to me somehow a little strange to rehash the chair at this point, it ought to be pressed in a prayer book'.[27] Moreover, as awareness and interest in design has continued to burgeon since the 1980s, the desire of the design-conscious to have 'classics' such as Breuer's *Wassily* chair has led not only to the continued production of the chair by the Knoll company, but also to cheap mass-produced imitations. These have been derided as 'poor in workmanship and atrocious in detail'[28] but are a major factor in the widespread recognition of this design icon. There is some irony in this, as the resumption in production of the *Wassily* chair occurred at the same time that the basic tenets of modernism were being challenged.

During the 1960s some critics were actively questioning the idea that universal, time-less and relentlessly modern design was necessarily desirable. They suggested that modernism might actually be a restrictive straightjacket of ideas that had failed either to reach its mass audience or to solve social problems. Instead, in their view, it had developed into formalism with endless similar products feeding the rampant consumerism of the late 1950s and 1960s. This rejection of modernist ideals was reinforced by the recognition – with the emergence of a youth culture – that there were now several markets (not one) for design, and further, through the impact of Pop Art, that popular, temporal enthusiasms should be part of its visual language.

In Italy, this reaction to modernism was represented by the anti-design movement that sought to bypass mainstream Italian production and marketing and reconnect with contemporary society.[29] Studio Alchymia, founded by the architect Alessandro Guerriero (b.1943) in Milan in 1976, offered designers the opportunity to experiment and exhibit prototypes without the constraints of the manufacturing and advertising industries. As its title implies, Studio Alchymia stood apart from the rational and scientific basis of modernism; it suggested that, by magical means, something better would be produced through its endeavours.

Studio Alchymia's first two collections, shown in 1979 and 1980, were entitled *Bauhaus I* and *Bauhaus II*. The rejection of modernism implicit in these ironic titles extended to the reworking of Breuer's *Wassily* chair by Alessandro Mendini (fig.72), one of the main designers and spokesman of the group. Whilst the tubular steel – the key to the chair's iconic status – remained untouched in Mendini's version, the plain strips of fabric of the original were replaced by new upholstery, composed of organic shapes in different colours. The chair was one of a series of redesigns that Mendini conceived at this time. They expressed, on the one hand, doubts as to whether it was possible to produce anything truly new and, on the other, a belief that surface ornamentation was the only means by which design could engage with, and be understood by, contemporary

72. Alessandro Mendini, *Wassily Chair*, 1978
© Atelier Mendini

society. Accordingly, the patterns in *his* '*Wassily*' chair draw on the imagery of the 1950s, a period in which design seemed more integrated into mass culture as Italy attempted to rebuild a new democratic society after the Second World War.

In this design Mendini rejected modernism's commitment to simple, mass-produced functional furniture with universal applications as no longer appropriate in an increasingly pluralist society. Instead, he created a decorative and expensive chair that was produced in limited numbers for a limited clientele. Mendini's *Wassily* chair also undermined the modernist ideal of neutrality: it was not Breuer's 'styleless' chair that receded into the background; rather, it asserted its presence in an interior with the intention of inviting reflection and comment. Mendini thereby suggested that a chair can operate on the same level as a work of art: its purpose is to communicate with the user and the spectator as much as to function as a seat.

Mendini's chair was a design that commented not only on its modernist type but also on design itself. It embodied a radical reassessment of the nature and purpose of furniture relative to the late twentieth century, just as Breuer's *Wassily* chair represented a bold response to the social, economic and cultural concerns of the new mechanised age of half a century earlier. However, perhaps paradoxically, Mendini's choice of Breuer's *Wassily* chair of 1925 as the vehicle through which to question the continued relevance of the ideals of modernism in design, affirms the chair's status as an icon within that movement.

NOTES

1. A number of surveys of twentieth-century design, in which Breuer's chair features, appeared towards the end of the 1990s, but the most recent example is probably *Phaidon Design Classics* (London: Phaidon, 2006), vol.1, no.147.
2. Breuer was born in Hungary and studied first in Vienna before joining the Bauhaus in Weimar as a student in 1920. After qualifying in 1924, he spent a short time working for an architect in Paris before returning as a junior master to the Bauhaus in 1925. The school moved from Weimar to Dessau in that year. For Breuer see C. Wilk, *Marcel Breuer Furniture and Interiors* (New York: Museum of Modern Art, 1981); M. Droste, M. Ludewig, Bauhaus-Archiv, *Marcel Breuer Design* (Cologne: Taschen, 1992).
3. Wilk, *op. cit.*, p.40.
4. *ibid.*, pp 53–4, 56. The firm was later known as Standard-Möbel GmbH. and then Standard-Möbel Lengyel & Co. It issued two catalogues, in 1927 and 1928.

5. For accounts of the *Wassily* chair see Wilk, *op. cit.*, pp 37–40; Derek E. Ostergard, ed., *Bent Wood and Metal Furniture* (New York: The American Federation of Artists, 1987), pp 270–71; *Phaidon Design Classics*, 2006, vol.1, no.147. An example of *eisengard* fabric developed at the Bauhaus for tubular steel furniture is illustrated in Bauhaus-Archiv and M. Droste, *Bauhaus 1919–1933* (Cologne: Taschen, 1990), p.153.

6. For earlier uses of metal in furniture see Ostergard, *op. cit.*, pp 7–10; C. Edwards, *Victorian Furniture Technology & Design* (Manchester: Manchester University Press, 1993), pp 115–25.

7. For accounts of tubular steel furniture see B. Campbell-Cole, ed., *Tubular Steel Furniture* (London: The Art Book Company, 1979); Ostergard, *op. cit.*; C. Edwards, *Twentieth-Century Furniture Materials, Manufacture and Markets* (Manchester: Manchester University Press, 1994), pp 37–8. The *Journal of Design History*, vol.3, nos 2 and 3 (1990), contains useful articles and documents on tubular steel furniture.

8. For a recent survey of modernism in Europe see C. Wilk, ed., *Modernism Designing a New World* (London: V&A Publications, 2006).

9. Quoted in Wilk, *op. cit.*, p.67.

10. Marcel Breuer, 'Metal Furniture' in Werner Gräff, *Innenraume* (Stuttgart: Fr. Wederkind & Co., 1928), quoted in T. & C. Benton, and D. Sharp, *Form and Function: A Source Book for the History of Architecture and Design 1890–1939* (London: Crosby Lockwood Staples/Oxford University Press, 1975), p.226.

11. Wilk, *op. cit.*, p.66.

12. Marcel Breuer, 'Metal Furniture' in Gräff, *Innenraume*, *op. cit.*, p.226.

13. Ostergard, *op. cit.*, p.126; C. Wilk, *op. cit.*, p.37.

14. Another 1925–6 version made at the Bauhaus, illustrated in Droste, Ludewig, Bauhaus-Archiv, *op. cit.*, p.62 (b), has runners and linked side elements, but the sides of the seat are welded into the bottom of the U-shaped back as in the first prototype.

15. For example, in a 1929/30 version, Thonet linked the seat directly with the outer frame, necessitating the addition of a brace under the seat and a stretcher onto the floor. See T. & C. Benton, and D. Sharp, *op. cit.*, p.62(e), and C. Wilk, *op. cit.*, pp.38–9.

16. Christie's London, *The Chair*, 11 May 1999, lot 76.

17. Sotheby's London, *Bauhaus and other important 20th Century avant-garde design*, 1 November 1996, lot 86.

18. *Hollandische Review*, quoted in Christie's London, *The Chair*, 11 May 1999, p.44. For Rietveld's furniture see D. Baroni, *The Furniture of Gerrit Thomas Rietveld* (New York: Barron, 1978) and P. Vöge, *The Complete Rietveld Furniture* (Rotterdam: 010 Publishers, 1993).

19. The dowelled joints used by Rietveld in the *Red/Blue* and other chairs posed structural problems that Breuer resolved through the use of tubular steel. Christie's London, *The Chair*, 11 May 1999, p.44.

20. Marcel Breuer, 'Metal Furniture' in Gräff, *Innenraume*, *op. cit.*, quoted in Droste, Ludewig, Bauhaus-Archiv, *op. cit.*, p.227. Breuer stated in the same article that he initially experimented with duralumin but, because of its high price, he turned to tubular steel.

21. For Le Corbusier's furniture designs see P. De Fusco, *Le Corbusier Furniture* (New York, 1977); C. Benton, 'Le Corbusier Furniture Designs of the 1920s', *Journal of the Decorative Arts Society*, no.6, 1982, pp 7–22; C. Benton, 'Le Corbusier: Furniture' in exh.cat. *Le Corbusier: Architect of the Century* (London, Arts Council, 1987); C. Benton, 'Le Corbusier: Furniture and the Interior', *Journal of Design History*, vol.3, nos.2 & 3, 1990, pp 103–24. The expense of Le Corbusier's design was true of other French tubular steel designs in the 1920s and 1930s, such as those by René Herbst and Louis Sognot. Moreover, tubular steel never gained the widespread acceptance in France that it did in Germany, perhaps in part because, in the postwar climate, it was regarded as being too closely identified with that country. Ostergard, ed., *op. cit.*, p.142.

22. The architect Siegfried Giedion saw cantilevered chairs as being a specific need of the period. There was a demand for a chair 'that would seem to hover above the ground like cantilever concrete slabs or houses on stilts, houses surrounded by air. One was drawn to things that seemed to defeat gravitation. This emotional need is as innate to our time as the buttress to the Gothic and the undulating wall to the Baroque', quoted in M. Page, *Furniture Designed by Architects* (London: The Architectural Press Ltd, 1983), p.177.

23. For Le Corbusier's furniture designs see references cited in note 24.

24. Quoted in Wilk, *op. cit.*, p.69. For British attitudes to tubular steel furniture see also D. Sharp, T. Benton and B. Campbell Cole, *Pel and Tubular Steel Furniture of the Thirties* (London: The Architectural Association, 1977).

25. Wilk, *op.cit.*, pp 73–7. See also Otakar Máčel, 'Avant-garde Design and the Law: Litigation over the Cantilever Chair', *Journal of Design History*, vol.3, nos.2 & 3, pp 125–43.

26. For example, the travelling exhibitions *Fifty Years Bauhaus* (1968) and Hans M. Wingler, *Das Bauhaus* (1962) (Cambridge, MA, and London: Massachusetts Institute of Technology, English edition 1969), based on the archives of the school. Wingler had founded the Bauhaus-Archiv in Darmstadt in 1961; it transferred to Berlin in 1971.

27. J. Fiedler, ed., *Bauhaus* (Cologne: Könemann, 2006), p.624.

28. Fiedler, *op. cit.*, p.627. The reproduction of these 1920s designs also creates a dilemma for museums. The Victoria and Albert Museum, for example, will not exhibit later editions, but the Design Museum, on the basis that these are timeless designs, sees no difficulty in displaying modern examples – or in allowing the public occasionally to sit on some examples.

29. See P. Sparke, *Italian Design 1870 to the Present* (London: Thames and Hudson, 1988); A. Branzi, *The Hot House: Italian New Wave Design* (London: Thames and Hudson, 1984).

73. Gerhard Richter, *Tante Marianne*, 1965
Oil on canvas, 1200 x 1300 cm (47¼ x 51⅛ in)
Private Collection

Gerhard Richter's *Tante Marianne* Revisited

Tante Marianne, created in 1965 by Gerhard Richter (b.1932), has become one of the most notorious paintings of the artist's career since it was put up for auction at Sotheby's in London on 21 June 2006 (fig.73). The sensation surrounding the painting was due not to the amount of money that the work made (at £2,136,000 it did not break the artist's record, although it exceeded the top estimate) but to revelations concerning the painting's subject-matter. These had first come to light the previous year in a book by German journalist Jürgen Schreiber, *Ein Maler aus Deutschland: Gerhard Richter Das Drama einer Familie* (2005; *A Painter from Germany: Gerhard Richter the Drama of a Family*). In it details concerning the artist's family history were revealed in such a way as to upset the artist. The acrimony reached such heights that the painter himself declared bitterly in *The Times* before the sale: 'I can't stand the way so much emotional significance has been loaded on to the picture of Tante Marianne. Schreiber's book is stupid and sensational. I certainly won't be attending the auction: it would hurt too much.'[1] With the benefit of hindsight, it is now interesting to take a step back from the controversy and examine how the painting touches upon matters of collective history as much as upon issues of personal memory.

At first glance there is little on the surface of the work that would seem to warrant its notoriety. With its black and white appearance, the unity of figure and ground and the all-over quality, the image (like Richter's other work at this time) suggests a photograph. Only closer examination of the surface, with its horizontal marks and softened contours, reveals it to be a painting. The work takes considerable time to process visually, not least due to the smudging of the paint. The background features are particularly indeterminate and hard to gauge but indicate an exterior view with a path winding back on the left, trees in shadow on the right. More legible, due to their size, but still slightly blurred, are the two central figures of a young teenage girl with baby. The girl looks away from the camera and out at an angle, shyly smiling towards the near distance, while in front of her a baby boy rests on large cushions placed on a low table. A strong sense of innocence and purity is conveyed by the pale clothing both are wearing and by the white linen of the cushion covers which support the child. The scene conveys an atmosphere of touching intimacy, albeit one separated from us by an incipient sense of the passage of time.

This sensation of temporal distance is augmented by the affect of the painting's art historical associations. The pyramidal arrangement echoes Renaissance images of Mother and Child, Giovanni Bellini's (*c*.1430–1516) *The Madonna of the Meadows* (National

Gallery, London) being particularly notable for its similar foreground placement of figures within the landscape. In terms of Western iconography, this form of composition also traditionally prefigures settings of the *Pietà*.[2] Such references might go some way to explain the particular poignancy emanating from the image here. One wonders how conscious of these art sources the original photographer was at the time of setting up the pose. Whatever the case, the image conveys a scene of great charm and innocence on the one hand, whilst on the other also being heavily pervaded by a feeling of loss and an inescapable intimation of death. The image has a haunting presence: as if time stands still – or what Roland Barthes, in his attempt to characterise the element of death endemic in the photographic image (the subject being always present only in the past), has called the 'funereal immobility' of the photograph.[3]

This quality is further accented in the image by the disarming implications of its period detail. The girl's hairstyle is recognisable as belonging to the 1930s: a time that inevitably intimates, within European portraits, spectres from the intervening years. As the German writer W.G. Sebald (1944–2001) has commented, an extraordinary vertiginous telescoping of time takes place in terms of personal memory when looking back to this particular period in German history. Reminiscing on a missing painting bought by his parents in 1936, Sebald reflects on 'the dark backward and abysm of time. Everything lies all jumbled up in it, and when you look down, you feel dizzy and afraid.'[4] Richter's painting opens up a similar, somewhat fearful interest in the gap: the historical reality confronting us is that of a clearly perceived 'before' and 'after'. The 'before' is the time when the photo was taken, before the outbreak of the Second World War; the 'after' is both the time that Richter selected and used the photograph as a source, and the present moment in which we view it today. For these reasons alone, the painting reaches out to us, soundlessly communicating a message over the tracks of time.

This sense of a temporal gap is emphasised, moreover, by the fact that this *is* a painting. According to the German critic, essayist and philosopher Walter Benjamin (1895–1943), writing in the same decade that the original photograph was taken, the major distinction between a work of art from a reproduction is its 'presence in time and space, its unique existence at the place where it happens to be'.[5] A painting has the 'authority' of 'authenticity' – unlike the photograph which is reproducible. In short, according famously to Benjamin, 'That which withers in the age of mechanical reproduction is the aura of the work of art'.[6] Richter seems to sense this when he speaks of painting as the only means to 'preserve the photo' and 'the only way to reveal what it contain[s], what the photograph still withholds … something which has nothing to do with colour, composition, rhythm or whatever, something I cannot explain'.[7] He draws attention to this inexplicable element, the aura, through his technique of blurring. The more

we look, attempting to grasp the entirety of the image, the more it escapes the controlling gaze of our perception. The fluidity of the paint itself slows down the act of looking, draws it out over time, points to a different consciousness and suggests a threshold of the unknowable held within the real. The very uncertainty of the background, the vague setting with its shadowy darkness, contributes to this particular sensation.

The title at least reveals the identity of the figures. *Tante Marianne* is aunt to the boy baby who is none other than the painter himself: the accentuated solemn and mature mien of the child renders his appearance uncannily similar to photographs of his adult self. The date of the painting is confirmed by the date on the back of the canvas: 'VII 1965'. Given that the baby was presumably aged about five months when the original photograph was taken, and Richter was born in Dresden in February 1932, this rare autobiographical portrait was thus painted 33 years later, when Richter had moved to the west and was living in Düsseldorf. He therefore produced this painting in a totally divergent historical context to that in which the original photograph was made: a different climate (years after the Economic Miracle and period of disavowal of the German past); and a different place (the new, capitalist West Federal Republic). The intervening years had witnessed the triumph of Adolf Hitler and National Socialism; the persecution of the Jews; the invasion of Poland; the outbreak of the Second World War; the horrors of the Holocaust; and the fire-bombing of Richter's home city, Dresden,[8] culminating in the defeat of Germany and the divisive separation of the country into two separate political parts. Thus Richter's life, from baby to mature artist, as indicated by the dates connected to the portrait, spans this entire period.

In fact, the portrait belongs to Richter's earliest surviving works since leaving Dresden – the 'Photo Pictures' – a series that marks an entirely new departure for the artist who had arrived at the Düsseldorf Academy in 1961 after five years of art training in East Germany, where he had been exposed to Soviet Socialist Realism and only to those modernists such as Picasso, Diego Rivera (1886–1957) and Renato Guttuso (1911–1987) who were communists. Now in Düsseldorf he found himself trying to grasp what modern art meant in the West: 'So I started to paint like crazy, from figurative to abstract. Then after a year, I put it all on a bonfire in the courtyard of the academy ... I realized it was time to start from scratch. Photographs were the way forward. I'm shocked now that the story seems clear, because it didn't seem clear at the time.'[9]

Yet in his 'Notes' made at the period he was painting *Tante Marianne*, Richter attests to the tremendous freedom that the photograph offered him: 'Not having to invent any more, forgetting everything you meant by painting – colour, composition, space – and all the things you previously knew and thought. Suddenly none of this was a prior necessity for art.'[10] The photo was 'the most perfect picture'. 'It does not change; it is absolute,

and therefore autonomous, unconditional, devoid of style.'[11] Precisely because painting from the photograph freed him from all compositional and stylistic judgements, he relished using pre-made images which could be loosely copied from a projection, painted in by hand and then mechanically blurred by dragging the wet paint across the contours with a wet brush or a long, straight implement. In a sense Richter became the first photo-realist painter – but unlike his American contemporaries, including Richard Estes (b.1932) and Robert Cottingham (b.1935),[12] he chose to blur the image. As he has said himself, it was his discovery of American artists of his own generation who used photographic images – Robert Rauschenberg (1925–2008) and in particular Andy Warhol (1928–1987) – that helped to free him after his arrival in the West. However, rather than stressing the surface of his source material as Warhol had done, Richter directly arouses the curiosity and emotions of the viewer through his painterly treatment and the fluidity of brushwork.

The subject material of the 'Photo Pictures' ranges from portrait snapshots of celebrities, actresses and strangers, to images of nurses, prostitutes and even war. With the images culled from postcards and newspaper cuttings, and other people's family portraits (which he enjoyed for their anonymity), the paintings on the whole reflect the wider cultural realm and are only rarely made from his personal family photographs. Many of the original sources are known through *Atlas* (fig.74) – the compendium of arranged

74. Gerhard Richter, page from *Atlas* with Helga Matura, 1962
Newspaper photographs, 51.7 x 66.7 cm (20⅜ x 26¼ in)
Städtische Galerie im Lenbachhaus Munich

Left and right:

75. Gerhard Richter, *Horst mit Hund*
(Horst with Dog), 1965
Oil on canvas, 80 x 60 cm (31½ x 23⅞ in)
Agnes Gund Collection, New York

76. Gerhard Richter, *Onkel Rudi*, 1965
Oil on canvas, 87 x 50 cm (34¼ x 19⅝ in)
The Czech Museum of Fine Art, Prague

photo-based images, which Richter began putting together in 1964, the year after he left the Düsseldorf Academy, and which has been exhibited and published in various forms.[13] Given the relative formality of the photograph and its unusually strong auto-biographical connections, it is not surprising to find that the image was kept privately and not inserted into the pages of Richter's working scrapbook.[14]

Tante Marianne is one of a very small series of family portraits, based on photographs, that Richter chose to paint during 1965. Besides his aunt, there is a disarming portrait of his father with a clownish expression entitled *Horst mit Hund* (*Horst and his Dog*) (fig.75) and one of his uncle, *Onkel Rudi* (fig.76). The latter painting (which was later re-photographed by the artist in 2000) shows the 'handsome yet foolish brother' of

Marianne and Richter's mother, dressed in his Nazi uniform, who was killed within a few days of entering the war.[15] In fact, violent or premature death is a recurrent theme in Richter's work, especially in the 'Photo Pictures' of this year. During this time he produced a portrait of the former Nazi medical neurologist, Werner Heyde, who had been arrested in 1959 and had committed suicide five days before his trial in 1964. Like many of Richter's other 'death' subjects, the painting was based on a newspaper photo.[16] As Richter said in a later interview: 'Maybe it is just overdoing it a little to talk about a death theme. But as to whether the pictures have anything to do with death and pain, I think they have.'[17]

Tante Marianne is no exception. In 1944, when he was only 12 years old, Richter learnt that Marianne had died a terrible death at the age of 27. He had already known that his aunt had become mentally disturbed, having often been warned as a child following an unruly episode that he must watch his step for fear of becoming 'crazy like Aunt Marianne'.[18] In fact, the full details were horrific. Marianne had been incarcerated in a psychiatric ward due to suspected schizophrenia. She was forcibly sterilised and moved around various psychiatric clinics in Saxony before being starved to death by Nazi doctors. Further revelations from Jürgen Schreiber linked her treatment to the activities of Richter's late father-in-law, Heinrich Eufinger.[19] Although Richter claims he did not know the full extent of what had happened to his aunt, and certainly not by whom at the time of painting, it is interesting that he chose to paint this particular 'Photo Picture' when he did and that, within a few months he also produced images of his father and uncle, both of whom had served in the Second World War.[20] When viewed together, these 'Photo Pictures' raise fascinating questions concerning the artist's choice of subject matter.[21] Why should Richter choose to paint these particular images of his family exactly when he did?[22] Analysis of the wider cultural climate at the time suggests there are links between this and the apparently personal nature of these paintings which shed interesting light on this question.

Between 16 February and 16 March 1963, the trial of the Nazi war criminal Adolf Eichmann held in Jerusalem in 1961 was written up in the form of a five-part series in *The New Yorker* by the German political theorist, Hannah Arendt (1906–1975). Turned into a book that year, it became the centre of a controversy which according to its author 'was carried from America to England and then on to Europe, where the book was not even available'.[23] Arendt's analysis of what she called 'the pure banality of evil' presented the notion that the era of the Hitler regime, with its gigantic, unprecedented crimes, constituted an 'unmastered past' not only for the Germans and for the Jews, but for the rest of the world, which had also been unable to come to terms with this great catastrophe in the heart of Europe. 'Moreover', according to Arendt, 'general moral

questions, with all their intricacies and modern complexities, which I would never have suspected would haunt men's minds today and weigh heavily on their hearts, stood suddenly in the foreground of public concern.'[24]

What is fascinating about Arendt's study that has bearings on Richter's work is its analysis of Eichmann's character. In her coverage of the trial, Arendt famously stressed the dilemma 'between the unspeakable horror of the deeds and the undeniable ludicrousness of the man who perpetrated them'. Her view of Eichmann as in some ways an unbearably comic, clown-like character constantly comes through the pages of her writing. At the same time, the ordinariness of the man's thinking, his willingness to follow orders, were linked by Arendt to the 'mendacity' that according to her became 'an integral part of the German national character' through those times. The rest of Germany was guilty in her eyes of being party to self-deception and creating the 'moral debacle of a whole nation'. In the final analysis, Eichmann's own crimes appeared to be motivated by desires for personal advancement, thus forming part of the 'strange interdependence of thoughtlessness and evil' which she noted as being one of the most perplexing characteristics to come out of the trial.[25] Could it be that something of this spirit informs Richter's unusual portrayal of his own father in *Horst mit Hund*, where the man seems to be portrayed as a comedic buffoon, or even of his *Onkel Rudi*, a relation whom he was later to describe as young and 'very stupid'?[26]

As far as *Tante Marianne* is concerned, it is significant that Arendt also made direct links in her writing between the gas factories of the Final Solution and the 'euthanasia programme' ordered by Hitler in the first weeks of the war and applied to the mentally sick in Germany until the invasion of Russia.[27] The research for this had already been provided by the German writer, Gerald Reitlinger, in his book *The Final Solution: The Attempt to Exterminate the Jews of Europe 1939–1945* (London, 1953), which incontrovertibly argued that the extermination programme in the Eastern gas chambers grew out of Hitler's euthanasia programme.[28] It seems highly probable that Richter would have absorbed this information, becoming uncomfortably aware of the likely fate of Marianne, at some point either then or during the Auschwitz trial (see below), when these revelations became public. There must have been an immense sense of poignancy for him in reviewing the Marianne photograph, and in all likelihood the news would have prompted him to revisit it in the form of a painting in silent testimony to his loss and to a sense of unspoken guilt, precisely at the time that the subject of '*Aufarbeitung*' (dealing with the past) began to become a pressing concern in Germany and, according to Schreiber, to Richter himself.[29]

Furthermore, the way in which Germany came to terms with accounts of Eichmann's trial has possible bearings on Richter's dispassionate handling of such emotive

subject-matter in the family 'Photo Pictures' of 1965. In 1963 the 32-year-old Swiss German author, Rolf Hochhuth, had had his play *Der Stellvertreter* (*The Deputy* or *The Representative*) first performed in Berlin under the famous, experimental theatre director Erwin Piscator (1893–1966). Some of the principal characters were based on real people: Kurt Gurstein (1905–1945), for example, was a virulent anti-Nazi who because of his scientific expertise was retained in the ranks where, appalled by the events he witnessed, he tried to forestall tragedy by using his official capacity to find fault with cylinders of Zyklon B gas which were on their way to the death camps. Ricardo, a young priest who tries to help fugitive Jews escape in the play, was loosely based on Friar Maximilian Kolbe (1894–1941, canonised 10 October 1982), who in real life had been arrested by the Gestapo upon being found accompanying deportees to death camps and swapping places with the father of a family. Tellingly, he was killed at Auschwitz by enforced starvation followed by lethal injection. In the play Ricardo vainly tries to persuade both his biological father and his Holy Father (Pope Pius XII) that Jews are being exterminated. What is notable is that the documentary basis of the drama, as well as the perceived guilt of the father in remaining silent, was strongly noted by German commentators at the time.

Richter's personal act of recording his familial past during this year also mirrors a drive to documentary testimony found in Peter Weiss' play *The Investigation*, which was premiered in 15 theatres simultaneously in East and West Germany in October 1965.[30] Significantly, according to recent commentators, the play's 'importance and timeliness were recognised immediately, even before its first staging' had taken place.[31] The play is based on the famous Auschwitz trial in Frankfurt which lasted from the end of 1963 to the summer of 1965 and furthered the burgeoning sense of collective guilt already instigated by the Eichmann trial with the additional discovery that it was everyday folk, one's parents and not monsters, who had committed atrocities during the war. The style of the play also has bearing on the matter. Whereas Weiss' previous play, *The Persecution and Assassination of Jean-Paul Marat as Performed by the Inmates of the Asylum of Charenton under the Direction of the Marquis de Sade* (1964), was performed in a spirit of 'grand guignol' and created a powerful impact in its productions both in Berlin and London that year, *The Investigation* was based almost to the letter on actual documentation of the Auschwitz trial, principally on newspaper articles by Bernd Naumann that were published during the proceedings (and later made into a book, introduced by Hannah Arendt in 1966). In its uninflected, factual account of the testimonies of survivors, the play (which famously does not actually specify that the victims were Jews) insistently points to the impossibility of dressing up or dramatising the factual horrors of the war. Criticised for being little more than a 'condensed version of the proceedings

of the trial', for being 'singularly undramatic' and 'sanitised' of all emotions, subsequent critical response chiefly showed a desire for a more mimetic representation of the world.[32] What reviewers failed to see was that the potency of a dispassionate, objective voice offered possibly the most apt way to approach the horror of the subject, and that moreover, the German psyche still needed time to adjust to its own guilt. The dictum of the sociologist and philosopher Theodor Adorno (1903–1969) that 'lyrical poetry is impossible after Auschwitz' is seen to ring true at this critical moment of re-engagement.

Richter's portraits of *Tante Marianne*, *Onkel Rudi* and his father in 1965 parallel the same dispassionate, unflinching and matter-of-fact approach of this contemporary development within German documentary drama, both in terms of content and of style.[33] In turning to paint his own family at this time, using photographs to provide a similarly objective record to that which Weiss found in the factual oral testimonies that lay behind his play, Richter was, even if unconsciously, drawing attention to the difficult historical legacy of the Nazi era. Hardly surprising then, that with his knowledge of Nazism and his direct experience of a similarly totalitarian Soviet regime, Richter should evince a deep distrust of ideology of all types and that he should avoid reference to politics in his work as a whole.[34] Only when persuaded to do so, years later, did Richter refer to German history again in his seminal series of paintings, *18 Oktober, 1977* (1988).[35] (fig.77). In the 15 paintings that comprise the series (and which, once again, are based entirely upon photographs), he once again adopted a similar black and white, deadpan approach to his handling both of the portraits and scenes of the deaths of the leaders of the Red Brigade Faction, the Baader-Meinhof gang, at Stammheim jail.

The quiet, understated, documentary style that lies at the heart of Richter's family 'Photo-Pictures' of 1965 and which inevitably causes us to look back, notably also comes at a time when ironically, the main cultural momentum in Germany was more forward-looking. According to Sebald, Germany's reconstruction prohibited any backward view: 'It did so through the sheer amount of labour required and the creation of a new, faceless reality, pointing the population exclusively towards the future and enjoining on it silence about the past.'[36] In terms of an imperative to begin to face up to the secrets that had remained hidden for almost two decades, there was no protocol to follow so that artists, no less than writers, had to feel their way towards it. Certain of Richter's contemporaries began to do the same from the 1960s: Georg Baselitz (b.1938), confronting the realities of a divided Germany, started to produce fracture paintings in 1966 following a series of disenchanted, dislocated soldier images in his 'Rebel' series; Anselm Kiefer (b.1945), like Richter, turned to the autobiographical photograph, but as in his 'Heroic Symbols' series of 1969 he either collaged the actual images onto paper, presenting himself in a range of 'Heil Hitler' salutes, or kept them for later works which he then

overpainted; Sigmar Polke (b.1941) confronted the uncomfortable realities of the German past in a huge 'polke-dot' painting of 1983 based on a photograph of the queues of German people waiting to enter Hitler's approved *Entartete Kunst* (*Degenerate Art*) exhibition of 1937 in Munich, which over five million people attended; and in 1978 Jörg Immendorff (1945–2007) examined the problems of a divided Germany with the inception of his *Cafe Deutschland* series.

For his part Richter's development of the 'Photo Picture', which started in 1962, came into greater definition in the following year, and as we have seen, was given particular historical edge in the family portraits of 1965. These paintings are thus the most direct pictorial equivalent to the process of the mediated documentary recording, found not only in the drama of the time but also in the type of journalism that sought to understand, through a process of intense objectivity, the legacy of the war years in personal as well as in public terms. As Sebald wrote about Germany, 'when we turn to take a backward view, particularly of the years 1930 to 1950, we are always looking and looking away at the same time'.[37] Given both its historical and personal specificity in terms of the original photograph, this seems to be particularly true of *Tante Marianne*.

In terms of the sale on 21 June 2006 it seems hardly surprising therefore that *Tante Marianne* reached the sum it made at auction – a figure comfortably above the estimate of £1.5–£2 million. The publicity generated by Jürgen Schreiber's book inevitably fuelled further interest in the painting, and fed an already buoyant market in Richter's 'Photo Pictures'. In 2001 his painting *Three Candles* (1982) sold in New York for $5,395,750.

A black and white 'portrait' of the actress Lis Kertelge (1966) sold in the same 2006 sale in an earlier lot (no.6), also over estimate at £1,408,000. Although *Tante Marianne* (lot no.26) was slightly larger, the details of this specific work both in terms of the rarity of the subject and its recent history account for its higher price.

What was particularly notable about the painting's sale was the desire of German museums to try and acquire it. Yet with all the excitement generated by the work at the time and due to the high prices already being attained for Richter's paintings of this period, it was most unlikely that the work could be afforded by a museum.[38] In the event the painting sold on the evening of 21 June to a private Asian collector. However, with the awareness of its significance for Dresden, the purchaser agreed to lend it on an extended loan to the Galerie Neue Meister in 2007. This allowed Richter's home city to acquire a painting of infinite historical importance and one that immensely aids both our understanding of the artist and of the time in which it was painted.

NOTES

1. Gerhard Richter quoted in Roger Boyes, 'Nazi Ghosts Haunting a Family', *The Times*, 17 June 2006.

2. See Sotheby's catalogue for Contemporary Art sale, London, 21 June 2006, p.93.

3. Roland Barthes, *Camera Lucida: Reflections on Photography* (1980), trans. Richard Howard (London: Vintage, 1982), p.6.

4. W.G. Sebald, *On the Natural History of Destruction* (1999), trans. Anthea Bell (London: Hamish Hamilton, 2003), p.74.

5. Walter Benjamin, 'The Work of Art in the Age of Mechanical Reproduction', *Illuminations*, ed. Hannah Arendt, trans. Harry Zorn (London: Pimlico, 1999), p.214.

6. Benjamin, *op. cit.*, p.215.

7. Gerhard Richter quoted in Heiner Stachelhaus, 'Doubts in the Face of Reality: The Paintings of Gerhard Richter', *Studio International*, 184 (September 1972), p.79.

8. According to Sebald, 131 towns and cities were attacked by Allied air raids, 600,000 civilians fell and 3.5 million homes were destroyed. There were 42.8 cubic metres of rubble for every inhabitant of Dresden. Within this city, in February 1945, 6,865 corpses were burned on pyres by an SS detachment which had gained its experience in the Treblinka extermination camp. See W.G. Sebald, *op. cit.*, pp 3 and 98.

9. Michael Kimmelman, 'Gerhard Richter: An Artist Beyond Isms', *New York Times*, 17 June 2002. Between 1962 and 1972 Richter painted between 120 and 130 photo-based portraits, the majority during the years 1964–6. With some notable exceptions, he relinquished the genre for a time but returned to it more intensively from 1988. See Stefan Gronert, *Gerhard Richter Portraits* (Ostfildern: Hatje Kantz Verlag), p.52.

10. Gerhard Richter, 'Notes 1964–5', in Gerhard Richter, *The Daily Practice of Painting* (London: Thames and Hudson, 1995), pp 33–4.

11. Richter, *op. cit.*, p.31.

12. Moreover, according to Robert Storr, 'Only Richard Artschwager's acrylic on cellotex photo-based portraits and cityscapes date from the same year as Richter's first essays in the genre … and these were only exhibited in 1964'. Robert Storr, *Gerhard Richter: Forty Years of Painting*, exh.cat. (New York: Museum of Modern Art, 2002, and tour), p.34.

13. See Helmut Freidel, ed., *Gerhard Richter, Atlas* (London: Thames and Hudson, 2006).

14. Jürgen Schreiber describes how Richter escaped to the West with a box of special keepsakes, including this loose photograph, and which he rarely shows to anyone. See Jürgen Schreiber, *Ein Maler aus Deutschland: Gerhard Richter Das Drama einer Familie* (Berlin: Taschenbuch Verlag, 2005), p.37.

15. Uncle Rudi (also Richter's godfather) was always presented to Richter by his mother as an example to look up to. However, according to Richter, one would call him a playboy today. Richter did not like him very much, thinking him rather ostentatious. See Schreiber, *op.cit.*, p.239. Concerning his father, Richter has stated: 'With my father I had no relationship. When he came back from the War he was a complete stranger to me.' (Schreiber, *op.cit.*, p.37). During puberty Richter rejected his father completely, while his mother apparently used her son as an outlet for her frustration with her husband, presenting him to her son consistently as a loser or failure. About the painting *Horst with his Dog* (*Horst mit Hund*), Schreiber says that Richter still asks himself why he showed his father as such a ridiculous figure and that he would now prefer to dispose of the painting. According to Schreiber, Richter talks about his father, who committed suicide in 1968, almost with remorse, as if he had betrayed him in the past. It was only after his death that Richter discovered the man was not his biological father.

16. Heyde's death was reported as a cover story in *Der Spiegel*, issue no.8, 1964. Other death-related portraits based on news photos include *8 Student Nurses* (1966), eight American women murdered in the dormitory of a Chicago hospital; portraits of *Helga Matura* (1966), a murdered German prostitute; and *Fra mit Schirm* (*Woman with Umbrella*, 1964), an image of the recently widowed Jacqueline Kennedy weeping. Furthermore, implicitly relating to the theme of death (and explicitly to that of Nazism), Richter also exhibited in 1964 in the garden of the Parnass Gallery in Wuppertal, a 'Photo Picture' (since destroyed) of *Hitler* (1962). For an image, see Gronert, *op. cit.*, p.53.

17. Gerhard Richter, 'Interview with Benjamin Buchloh', 1986, *Daily Practice*, p.145. This sentiment was said retrospectively but it also anticipates the extraordinary power of the *18 Oktober, 1977* series (1988), in which *Stern* magazine pictures of the Baader Meinhof gang were used as the basis for a potent cycle, depicting portraits and scenes around the time of their deaths, allegedly from suicide, in Stammheim jail. Richter's choice of contemporary or recent historical subject-matter as the basis for his selection of many of the photographs he has used can be seen in his comment made in 1972: 'Photography had to be more relevant to me than art history: it was an image of my, our, present day reality', from 'Interview with Peter Sager', 1972, *Daily Practice*, p.66.

18. Storr, *op. cit.*, p.40.

19. See Schreiber, *op. cit.*, pp 167–209. Schreiber's research showed that the doctor in charge of her sterilisation, Professor Fischer, was possibly the same man who had overseen the birth of Richter himself. Most importantly, Schreiber provided evidence (deduced from the fact that the invoice sent to Marianne's parents showed no charge made for a coffin, and that as many as 5,773 deaths were recorded between 1939 and 1945 at Grossschweidnitz, the final institution where she was incarcerated) that Marianne had been killed and dumped in a mass grave in February 1945. Her death therefore counted as part of the 250,000 people overall who were killed as part of the Nazi 'euthanasia' programme. Schreiber also discovered that Richter's late father-in-law, Heinrich Eufinger, was the SS doctor responsible for personally implementing the mass sterilisation programme at the hospital next to where Marianne was interned, and was possibly further involved with the euthanasia programme that killed her. He had been head of the gynaecology clinic in Dresden, was an SS *Obersturmbannführer*

and an active member of the Nazi euthanasia programme. Nine hundred forced sterilisations took place under his direction. Not knowing this history at the time, Richter had used Eufinger as the central figure in a painting based on a family photograph with his wife-to-be, Ema, shown as a child in *Familie am Meer*, 1964. See Sotheby's catalogue, 21 June 2006, p.93, for the image.

20. Ironically it was 'Herr Heyde' who established the programme for the extermination of the 'medically undesirable' and who pioneered the gas techniques of the 'Final Solution'. He had continued to practise medicine after the war under an alias before being exposed in 1959. Robert Storr places Richter's painting of him, together with *Onkel Rudi* and *Tante Marianne*, as the one 'that closes the gap between personal experience and public reality, between a painful, guilt-ridden past and a present predicated on selective memory' (p.41). However, for the purposes of this essay, I would argue that it is the three family portraits of 1965, as much as *Herr Heyde*, that reflect a very personal attempt to show the impact of Nazi penetration on daily life. Storr, however, does not attempt to locate the timing of these painted portraits in relation to the documentary literature of the period.

21. Richter has consistently argued that he has 'always loathed subjectivity. Even failure, poor quality, opportunism and lack of character are a small price to pay in order to produce something objective, universal, right' (Gerhard Richter, 'Notes', 1973, *Daily Practice*, p.78), although he has also admitted that the motifs he chose 'never were picked at random: not when you think of the endless trouble I took to find photographs that I could use' (Gerhard Richter, 'Interview with Benjamin Buchloh, 1986', *Daily Practice*, 1986, p.143). Content inspired his choice and, moreover, 'I looked for photographs that showed my present life, the things that related to me. And I chose black and white photographs because they showed all this more effectively than colour photographs.' (Richter, 'Interview', *ibid.*, p.145.)

22. At the time, as he is the first to admit, Richter put a different face on his activities. He was notorious for making statements such as 'I don't

care about anything'. However, on looking back in 2001 he stated, 'I made those statements in order to provoke and in order not to say what I might have been thinking at that point, not to pour my heart out. That would have been embarrassing. I didn't know why I painted Uncle Rudi or Aunt Marianne. I refused to admit any kind of meaning that these paintings could have had for me therefore it was much easier to say what I said' ('Interview with Gerhard Richter', in Storr, *op. cit.*, p.288).

23. Hannah Arendt, *Eichmann in Jerusalem: A Report on the Banality of Evil* (London: Penguin Books, 1994), p.283. Richter would have become familiar with the content due to its notoriety. He referred to Arendt's book and discusses the term 'the banality of evil' in his 2001 interview with Storr. *op. cit.*, pp 293–4.

24. Arendt, *op. cit.*, p.283.

25. *ibid.*, pp 54, 52, 110, 288.

26. Interview with Robert Storr, 2001, in Storr, *op. cit.*, p.40.

27. Arendt, *op. cit.*, p.106.

28. For discussion of this aspect, see Arendt, *op. cit.*, p.107.

29. Schreiber, *op. cit.*, p.234.

30. Altogether it was performed in 40 theatres across Europe including the Aldwych Theatre, London, where it was directed by Peter Brook following his previous success there with another Weiss play, *Marat-Sade*. The point of the massive co-production was to influence the West German Bundestag not to permit the Statute of Limitation on war crimes to expire that year as would have been the case under existing laws. Both the production and the campaign were successful in achieving that goal.

31. James Rolleston and Kai Evans, ed., trans. and intro., in James Rolleston and Kai Evans, *Peter Weiss: The New Trial* (Durham, NC: Duke University Press, 2001), p.2.

32. For further discussion and for an account of critical responses to Weiss' play, see 'Aesthetics' in Robert Cohen, 'The Political Aesthetics of Holocaust Literature: Peter Weiss's *The Investigation* and its Critics', *History and Memory*, Fall/Winter, vol.10, no.2, pp 46–50.

33. Richter particularly liked the 'non-composed' (amateur) photo because it doesn't try to do anything but report on a fact; see 'Notes', 1964, *Daily Practice*, p.23.

34. Even earlier, between the age of 16 and 17, Richter's reading of Friedrich Nietszche and Karl Marx had led him to dispose of God. He later declared that 'by that time, my fundamental aversion to all beliefs and ideologies was fully developed'. See Peter Frank, 'Gerhard Richter', *Artnews*, 72, no.9, November 1973, p.100.

35. See Gerhard Richter and Robert Storr, *18 Oktober, 1977*, 1988 (Ostfildern: Hatje Cantz Verlag, 2001). In targeting and 'executing' *inter alia* ex-Nazi businessmen, the Baader-Meinhof gang, led by Johannes Baader and Ulrike Meinhoff represented the next generation of German youth who felt the need to expose and rectify the guilt of the previous generation. With his own deep distrust of ideology Richter himself, however, thought the gang to be desperate and deluded.

36. Sebald, *op. cit.*, p.7.

37. *ibid.*, pp viii–ix.

38. Schreiber commented wryly that 'Pain makes a painting more expensive'. See Roger Boyes, *op. cit.*

Further Reading

Alberro, Alexander, *Conceptual Art and the Politics of Publicity*, MIT Press, Cambridge, MA, 2003

Anfam, David, *Mark Rothko: The Works on Canvas*, Yale University Press, New Haven, CT, 1998

Arendt, Hannah, *The Banality of Evil: Eichmann and the Holocaust* (1963), Penguin Books, London, 2005

Barthes, Roland, *Camera Lucida: Reflections on Photography* (1980), trans. Richard Howard, Vintage, London, 1982

Bätzer, Nike, 'Human Dignity Shall be Palpable', *Teresa Margolles: 127 Cuerpos*, Kunstverein für die Rheinlande und Westfalen, 2006, pp 169–175

Benton, T., and Campbell-Cole, B. (eds), *Tubular Steel Furniture*, The Art Book Company, London, 1979

Bourdieu, P., trans. R. Nice, *Distinction: A Social Critique of the Judgement of Taste*, Cambridge University Press, Cambridge, 1984

Branzi, A., *The Hot House: Italian New Wave Design*, Thames and Hudson, London, 1984

Breslin, James, *Mark Rothko: A Biography*, University of Chicago Press, Chicago, IL, 1993

Buchloh, Benjamin H. D., and others, 'Conceptual Art and the Reception of Duchamp', *October*, 70, Fall 1994, pp 127–146

Comentale, Edward P., and Gasiorek, Andrzej (eds), *T.E. Hulme and the Question of Modernism*, Ashgate, Aldershot and Burlington, VT, 2006

Cork, Richard, *Jacob Epstein*, Tate, London, 1999

David Reed, exhibition catalogue (including essays by Udo Kittelmann and Martin Hentschel), Kolnischer Kunstverein, Cologne, 1995

David Reed Paintings, *Motion Pictures*, exhibition catalogue (including essays by Elizabeth Armstrong, Paul Auster, Dave Hickey and Mieke

Bal), Museum of Contemporary Art, San Diego, CA, 1998

De Duve, Thierry, *Kant after Duchamp*, MIT Press, Cambridge, MA, 1996

De Marchi, N., and Van Miegroet, H.J., 'Transforming the Paris Art Market, 1718–1750', in N. De Marchi and H.J. Van Miegroet (eds), *Mapping Markets for Paintings in Europe, 1450–1750*, Brepols Publishers, Turnhout, Belgium, 2006

Derrida, Jacques, *Aporias*, Stanford University Press, Stanford, 1993

Drawing from the Past: William Weddell and the Transformation of Newby Hall, Leeds Museums and Galleries, Leeds, 2005

Droste, M., Ludewig, M., and Bauhaus Archiv, *Marcel Breuer*, Taschen, Cologne, 1992

Freidel, Helmut (ed.), *Gerhard Richter: Atlas*, Thames and Hudson, London, 2006

Gardiner, Stephen, *Epstein: Artist Against the Establishment*, Michael Joseph, London, 1992

Gersaint, F.E., *Catalogue raisonné des diverses curiosités du cabinet de feu M. Quentin de Lorangère*, Paris, 1744

Glorieux, G., *A l'enseigne de Gersaint, Edmé François Gersaint, Marchand d'art sur le pont Notre Dame (1694–1750)*, Epoques, Champ Vallon, Paris, 2002

Godfrey, Tony, *Chance, Choice and Irony*. John Hansard Gallery, Southampton, 1994

Godfrey, Tony, *Conceptual Art*, Phaidon Press, London, 1998

Gorham, Deborah, 'The "Maiden Tribute of Modern Babylon" Revisited: Child Prostitution and the Idea of Childhood in Late Victorian England', *Victorian Studies*, 21, no.3, Spring 1978, pp 353–79

Higonnet, Anne, *Pictures of Innocence: The History and Crisis of Ideal Childhood*, Thames and Hudson, London, 1998

Hulme, T.E., *The Collected Writings of T.E. Hulme*, ed. Karen Csengeri, Clarendon, Oxford, 1994

James-Chakraborty, K., *Bauhaus Culture from Weimar to the Cold War*, University of Minnesota Press, Minneapolis, 2006

Kittelman, Udo and Görner, Klaus, 'Meurte Sin Fin',*Meurte Sin Fin*, Ostfildern-Ruit: Hatje Cantz, 2004, pp 41–47

Kosuth, Joseph, *Art after Philosophy and After: Collected Writings, 1966 – 1990*, MIT Press, Cambridge, MA, 1993

Kurland, Justine, *Spirit West*, Coromandel, New York, 2000

Kurland, Justine (photographs) and Raymond, Jonathan (fiction), *Old Joy*, Artspace Books, San Francisco, 2004

Kuryluk, Ewa, *Veronica and her Cloth*, Blackwell, Oxford, 1991

L'art conceptuel, une perspective, exhibition catalogue, Musée d'Art Moderne de la Ville de Paris, Paris, 1989

Leeflkang, Huigen, and Luitjen, Ger, *Hendrik Goltzius*, exhibition catalogue, Rijksmuseum, Amsterdam, 2003

Lippard, Lucy, *Six Years: The Dematerialization of the Art Object from 1966 to 1972*, Praeger, New York, 1973 and University of California Press, Berkeley, 1997

Marcus, G.H., *Functionalist Design: An Ongoing History*, Prestel, 1995

McClellan, A., 'Watteau's Dealer: Gersaint and the Marketing of Art in Eighteenth-Century Paris', *The Art Bulletin*, 78, 1996, pp 439–53

Moorhouse, Paul, *Gerhard Richter Portraits: Painting Appearances*, National Portrait Gallery, London, 2009

Moulin, R., *Le marché de la peinture en France*, Editions de Minuit, Paris, 1967

Naylor, G., *The Bauhaus Reassessed*, The Herbert Press, London, 1985

Ostergard, Derek E. (ed.), *Bent Wood and Metal Furniture: 1850–1946*, The American Federation of Arts, New York, 1987

Pearson, Michael, *The Age of Consent*, David and Charles, London, 1972

Pierce, S. Rowland, 'Thomas Jenkins in Rome', *Antiquaries Journal*, vol.XLV, 1965, pp 200–29

Plax, Julie Anne, *Watteau and the Cultural Politics of Eighteenth-Century France*, Cambridge University Press, Cambridge, 2000

Pointon, Marcia, 'The State of a Child', chapter 4 of *Hanging the Head: Portraiture and Social Formation in Eighteenth-Century England*, Yale University Press, New Haven, CT, and London, 1993

Pollitt, J.J., *The Art of Rome: Sources and Documents*, Cambridge University Press, Cambridge, 1983

Pollitt, J.J., *The Art of Ancient Greece: Sources and Documents*, Cambridge University Press, Cambridge, 1990

Posner, D., *Antoine Watteau*, Weidenfeld and Nicolson, London, 1984

Pound, Ezra, *The Selected Letters of Ezra Pound to John Quinn, 1915–24*, ed. Timothy Materer, Duke University Press, Durham, NC, and London, 1991

Ranciere, Jacques, *The Politics of Aesthetics: The Distribution of the Sensible*, Continuum, London, 2004

Richter, Gerhard, *The Daily Practice of Painting*, Thames and Hudson, London, 1995

Richter, Gerhard, and Storr, Robert, *18 Oktober, 1977* (1988), Hatje Cantz Verlag, Ostfildern, 2001

Rose, June, *Daemons and Angels: A Life of Jacob Epstein*, Constable, London, 2002

Sargentson, C., *Merchants and Luxury Markets: The Marchands Merciers of Eighteenth-Century Paris*, Victoria and Albert Museum, London, 1996

Schreiber, Jürgen, *Gerhard Richter: Ein Maler aus Deutschland*, Pendo Verlag, Munich and Zurich, 2005

Sebald, W.G., *On the Natural History of Destruction* (1999), trans. by Anthea Bell, Hamish Hamilton, London, 2003

Silber, Evelyn, *The Sculpture of Jacob Epstein, with a Complete Catalogue*, Phaidon, Oxford, 1986

Smith, Lindsay, '"Take Back Your Mink": Lewis Carroll, Child Masquerade and the Age of Consent', in *The Politics of Focus: Women, Children and Nineteenth-Century Photography*, Manchester University Press, Manchester, 1998, pp 95–110

Smith, R.R.R., *Hellenistic Sculpture*, Thames and Hudson, London, 1991

Sparke, Penny, *Italian Design 1870 to the Present*, Thames and Hudson, London, 1988

Stachelhaus, Heiner, 'Doubts in the Face of Reality: The Paintings of Gerhard Richter', *Studio International* 184, September 1972

Storr, Robert, *Gerhard Richter: 40 Years of His Art*, exhibition catalogue, Museum of Modern Art, New York, 2002, and tour

Strauss, W.L., *Hendrick Goltzius 1558–1617, The Complete Woodcuts and Engravings*, Abaris, New York, 1977

Vegelin van Claerbergen, E. (ed.), *David Teniers and the Theatre of Painting*, exhibition catalogue, Courtauld Institute, London, 2006

Vidal, M., *Watteau's Painted Conversations*, Yale University Press, London, 1992

Vogtherr, C.M., *Antoine Watteau: 'Das Ladenschild des Kunsthandlers Gersaint'*, Stiftung Preussische Schloesser and Gaerten Berlin Brandenburg, Abteilung Marketing, Berlin, 2005

Vogtherr, C.M., and Wenders de Calisse, E., 'Watteau's "shopsign", the Long Creation of a Masterpiece', *Burlington Magazine*, May 2007, pp 296–304

Watteau 1684–1721, exhibition catalogue, Galerie Nationale du Grand Palais, Ministère de la Culture, Editions de la Réunion des musées nationaux, Paris, 1984

Wilk, C., *Marcel Breuer Furniture and Interiors*, Museum of Modern Art, New York, 1981

Wilk, C. (ed.), *Modernism: Designing a New World 1914–1939*, V&A Publishing, London, 2006

Wingler, H., *The Bauhaus: Weimar Dessau Berlin*, Massachusetts Institute of Technology Press, Cambridge, MA and London, 1978

Wood, Paul, *Conceptual Art*, Tate, London, 2002

Worringer, Wilhelm, *Abstraction and Empathy: A Contribution to the Psychology of Style*, trans. Michael Bullock, Ivan R. Dee, Chicago, IL, 1997

Index

Page numbers in *italics* indicate illustrations;
references to endnotes are indicated by 'n' (eg103n5)

abstraction 70, 132, 138, 139–40, 142
Acton, William 100
Adam, Robert 126–9
Adorno, Theodor 167
al-Thani, Sheikh Saud 129
Albert, Prince Consort 100, 103n15
Aldrich, Megan 19, 21, 31–41
Alexandros/Paris 119
Alloway, Lawrence 71n1
alteration (of artworks) 8, 49–51,
 117, 122, 124, 130, 145, 155–6
Andre, Carl, *Equivalent VII* 10
Antes, Horst 68
anti-design movement 155–6
Aphrodite/Venus 118–22, 132, 136,
 142
arbitrariness 64, 65–7, 70, 71, 106
Arendt, Hannah 164–5, 166, 171n23
Argens, Jean-Baptiste de Boyer,
 Marquis d' 78
Aristotle 105
Armory Show (1913) 134
Armstrong, Carol 101
Art Deco 152
art market/trade 11, 16–17, 18, 117
 in ancient Rome 121
 and Grand Tour 121, 122–4
 in Paris 76–7, 79–80, 81
 see also dealers, art; values,
 monetary
Artforum (magazine) 54, 55
Artschwager, Richard 170n12
Atticus 121
avant-garde 8, 134, 146–7, 154
Ayer, A.J. 56

Baader-Meinhof gang 167, 170n17,
 171n35
Baarsen, Reinier 41n4
Bambridge, William *99*, 103n15
Bantam work 36–7
Barberini family 122, 123, 124,
 131n16
Barberini Venus see Jenkins Venus
Baroque 31–3, 35, 70
Barr, Alfred H. Jr 134
Barratt, Carrie Rebora 15, 18–19, 21,
 22–9
Barthes, Roland 11, 19n4, 160
Baselitz, Georg 167
Batoni, Pompeo 123, *125*
Bauhaus 145, *147*, 148, 149, 151,
 156n2, 157n26
Beckford, William 45–6

Bellingham, David 18, 19, 115, 116–31
Bellini, Giovanni 159–60
Bellori, Giovanni Pietro 7
Benjamin, Walter 160
bisexuality 120
Bochner, Mel 54
Boston 18–19, 23, 26, 28
Bourdieu, Pierre 126
Boutet, Claude, *Art of Painting in
 Miniature* 27
boxes, lacquer 8, 21, *42–51*, *45*, *46*
Breton, André 83
Breuer, Marcel:
 Cesca chair 152, *153*
 Wassily chair 115, *144–57*, *149*, *155*
Browne, Samuel 24
bubbles 107–8
Buchloh, Benjamin 53–4, 56, 170n17
Buddhism 84, 85, 87, 88

cabinets d'amateurs 75, 78, 79
Cameron, Julia Margaret 93, *101–2*
Capitoline Venus 118, 120
Caravaggio 124
Carroll, Lewis *see* Dodgson, Charles
 Lutwidge
carte-de-visite photography 15, 73, *92*,
 94–7, 101, 102n3, 103n6-7
Cary, Samuel 27
caskets, lacquer 8, 21, *42–51*, *45*, *46*
Catherine of Braganza, Queen
 (consort of Charles II) 38
Catholicism 8
Cavaceppi, Bartolomeo 122, 131n14
Caylus, Anne Claude Philippe, Comte
 de 80
chairs 8, 21, *30*, 34–6, *34–7*, 40, *52*, 53,
 58, *59*, 60, 61n22, *144–57*, *149*, *150*,
 151, *153*, *155*
Charles I, King 31, 33, 41n3
Charles II, King 31, 33, 38
Charleston, South Carolina 26
Charlottenburg Castle, Berlin 78
Ch'ien Lung, Emperor of China 40
children:
 images of 15, *92–103*, *94*, *95*, *97*, *99*,
 101, *158–61*
 and sexuality 15, 93, 98, 100–103
China:
 Chinese art influences in Japan 47–8,
 84, 86
 Eight Views of Xiaoxiang 48
 lacquer work 34, 36, *37*, 40, 44, 51n2
'Chinamania' 31, 40

chinoiserie 33–5, 47–8, 50, 84
Christian IV, King of Denmark 33
Christ 101, 110–111, 113n2
Christian typology 101, 110–111,
 159–60
Cicero 121
Civil War (English) 33
Clarke, Richard 28
Clarke, Susanna Farnham (*later*
 Copley) 28
Cleyn, Franz 33
Collard, Frances 40
communism 161
Compton, Richard 129
conceptual art 10–11, 53–61
Confucianism 84
connoisseurship 9, 10
context (of viewing artworks):
 spatial 8, 13–15, 17–18, 19, 65–9, 73,
 126–9
 temporal 15, 18, 19, 69–70, 115,
 120–21, 126, 130, 160–61
Copley, John Singleton 15, 18–19, 21,
 22–9
 Jeremiah Lee 23, *24*, 27, 28
 Moses Gill 22, 23, 24–6, *25*
 Self Portrait 22, 23, 27–8, *29*
copying (of artworks) 129, 130
Corbusier, Le 146, *146*, 151, 152–3,
 154, 157n21
Coromandel lacquer 36, *37*, 39, 41n10,
 41n12
Corregio 71
Cosway, Richard 27
Cotes, Samuel 27
Cottingham, Robert 162
Cromwell, Oliver 33
Crumplin, Colin 65

Darby, Elisabeth 18, 115, 144–57
de Kooning, William 70
dealers, art 7, 45, 75–7, 79–80, 81, 121,
 122–4
 see also art market/trade
death 105–113, 127, 160, 170n16
decay 8, 88, 107, 110, 115
Derrida, Jacques, *Aporias* 112
Diderot, Denis 80
Dijkstra, Rineke 19n6
Dodgson, Charles Lutwidge (Lewis
 Carroll) 93, *94*, 100, 101, 103n12
Dossie, Robert, *Handmaid to the Arts*
 27
Downey, Anthony 10, 15, 73, 104–113

Dresden 161, 169, 170n8
du Halde, Jean-Baptiste 51n2
Duchamp, Marcel 56, 57, 134
Dutton, John 35, 36, 40
Duve, Thierry de 56
Dysart, Elizabeth Murray, 2nd
 Countess of 31, *32*, 33–41
Dysart, William Murray, 1st Earl of
 31

Eco, Umberto 70
Eichmann, Adolf 164–5, *165–6*
ekphrastic approach 9–10, 19n1
Eliot, T.S. 134, 135
engraving 11, 13
 mezzotints 23, 26
Epstein, Jacob 18, 132–43
 Doves 115, *132–9*, *133*, 141–3
 Rock Drill 132, *140–42*, *141*, 143n35
 Venus 132, 136, 142
Estes, Richard 162
Eufinger, Heinrich 164, 170–71n19
Evelyn, John 33–4, 38

Farington, Joseph 123–4, 131n17
Ferry, Blanchette 17
fertility 118, 132
First World War 145, 146
Flaxman, John 124
Foucault, Michel 102
Fowler, Sherry 91n1
France 152, 157n21
 see also Paris
Franchi, Gregorio 46
Frederick II (the Great), King of
 Prussia 7, 78–9, 79–80
Frize, Bernard 65
Frye, Thomas 26

Gardiner, Stephen 141
Garrick, David 71
Gaskell, Anna 19n6
Gavina, Dino 155
Germany:
 Nazism 18, 160, 161, 164–9, 170n8,
 170–71n19-20
 post-war division 161, 167, 169
 Weimar Republic 115, 151, 157n21
Gersaint, Edmé-François 7, 75, 76–7,
 78, 80–81
Giedion, Siegfried 157n22
Gill, Moses *22*, 23, 24–5
Glucq, Claude 78
Godfrey, Tony 8–19, 62–71

Golle, Pierre 41n4
Goltzius, Hendrik 11–13, *12*, 19n3, 19n7, 115
Gombrich, Sir Ernst 7
Görner, Klaus 112–13
Grand Tour 25, 117, 121, 122–3, 130
Graubner, Gotthard 68
Greece, ancient 118–20, 139
Guercino 64, 70
Gurstein, Kurt 166
Guttuso, Renato 161

Hacking, Juliet 15, 73, 92–103
Ham House, Surrey 21, 31–41, *33*
Hamilton, Gavin 122, 123, 124
Harrison, Charles 56
Helen of Troy 119
helmets, Japanese 15, 73, *82–91*, *89*
Henrietta Maria, Queen (consort of Charles I) 41n3
Herbst, René 157n21
Hesselius, John 26
Heyde, Werner 164, 170n16, 171n20
Hideyoshi, Toyotomi 86
Hirshler, Erica 27, 29n1
Hirst, Damien 10
history:
 collective 7, 159, 169
 social 9–10
Hitler, Adolf 161, 164, 165, 169
Hochhuth, Rolf, *Der Stellvertreter* 166
Hockney, David 16–17
Holocaust 161, 164–7, 170–71n19-20
Homer, *Iliad* 118–19
Hornsby, Sarah 117
Hulme, T.E. 137–42, 143n27, 143n29, 143n35, 143n38
Hurd, Nathaniel 25
Hutt, Julia 18, 21, 42–51
Huxley, Aldous 154

Ieyasu, Tokugawa 47, 86, 87
Ikebana (flower-arranging) 84
'Image of Edessa' 110
Immendorf, Jörg 169
'improvement' (of artworks) 49–51, 117, 122, 124
interviews (with artists) 62, 71n1
Islam 130
Italy 155–6
ivory:
 cabinets 33, 42n4
 miniatures *22*, 23, *24*, 26–8

James I, King 31, 33
Janis, Sidney 17
Japan:
 daimyo (warrior-rulers) 83, 84–7
 divisions of artistic production 84
 Edo/Tokugawa period 47, 83–4, 86
 Eight Views of mi 48
 Heian period 85
 influence of Chinese art 47–8, 84, 86
 kawari-kabuto ('spectacular helmets') 15, 73, *82–91*, *89*
 lacquer work 34, 36, 37–8, *39*, 40, 41n14, *42*–51, *45*, *46*, 85, 86
 Momoyama period 85, 91n1
 Tōshō-gu Shrine 47, *47*
 warrior-monks 90
Jeanneret, Pierre 152
Jenkins, Thomas 122–6
Jenkins Venus 19, 115, *116*–31
Jesus Christ 101, 110–111, 113n2
Jones, Sarah 19n6
Jordaens, Jakob 75
Julienne, Jean de 78, 81

Kandinsky, Wassily 145
kawari-kabuto (Japanese helmets) 15, 73, *82–91*, *89*
Kiefer, Anselm 167–9
kinaesthesia 65
Kittelman, Udo 112–13
Kiyomasa, Kato 87
Knidian Aphrodite 118, 120, 122
Koizumi, Gunji 50
Kolbe, Friar Maximilian 166
Kosuth, Joseph:
 'Art after Philosophy' 55, 56, 57
 One and Three Chairs 15, *52–61*, *58*, *59*
Kurland, Justine *14*–15
Kurosawa, Akira 85
Kuryluk, Ewa 111
Kyoto 38, 47, 90

lacquer work:
 Bantam work 36–7
 caskets/boxes 8, 21, 41n14, *42–51*, *45*, *46*
 chairs *30*, 34–7, 40, 41n14, 41n18
 Chinese 34, 36, *37*, 40, 44, 51n2
 Coromandel 36, *37*, 39, 41n10, 41n12
 export market 43, 44–7, 48–51
 Japanese 34, 36, 37–8, *39*, 40, 41n14, *42–51*, *45*, *46*, 85, 86
Lasker, Jonathan 65

Lauderdale, Elizabeth Maitland, Duchess of *see* Dysart, Elizabeth Murray, 2nd Countess of
Lauderdale, John Maitland, 1st Duke of 31, 33, 34, 35, 36, 41n18
Le Corbusier 146, *146*, 151, 152–*3*, 154, 157n21
Lechmere, Kate 143n29
Lee, Jeremiah 23, *24*, 27, 28
Lee, Martha 27
Lely, Sir Peter 31, *32*
Lengyel, Kálmán 145
Leopold Wilhelm, Archduke of Austria 81n4
Levine, Gregory 91n1
Lewis, Wyndham 139, 143n29
Lewitt, Sol 55
Liddell, Alice 93, *94*
linguistics 55, 56–9, 61n11
Liotard, Jean-Etienne 23
Lippard, Lucy, *Six Years* 54
Lorenz, Anton 154
Lorraine, Claude 14–15
Louis XIV, King of France 41n3, 75
Louis XV, King of France 76
Lucian, *Amores* 120
Ludovici, Anthony M. 137, 138, 139

McCauley, E. Anne 98, 103n13-15
Madonna and child 159–60
Mahon, Denis, *Studies in Seicento Art and Theory* 9
Malpas, James 15, 73, 82–91
Manney, Gloria 29
marble 119, 121, 129, 132
marchands merciers 49, 75, 80
Marden, Brice 65
Margolles, Teresa:
 127 Cuerpos 15, 73, *104*–113
 The Cloth of the Dead 110–111, 113
 Dermis 110–111, 113n1
 En el Aire 108
 Vaporización 108–110, *109*
Marie Antoinette, Queen of France 45
Marioni, Joseph 68
mass-production 148, 151–2, 155, 156
Mavor, Carol 101
Mayhew, Henry 100, 103n17
meaning:
 and conceptual art 55–60
 and context 15, 18–19, 57, 73
 and language 55, 56–60, 61n14
mechanisation 146, 147, 160
Medici, Lorenzo de 15

Medici Venus 117, 118, 120, 122, 126
Melville, John 26
memento mori 107–8, 112
memory 7, 106, 110–111, 112, 159, 160
Mendini, Alessandro 145, *155–6*
metaphor 63–4
Mexico City 105, 106
Meyer, Jeremiah 27
mezzotints 23, 26
Michelangelo 15, 121
Mies van der Rohe, Ludwig 154
Minerva 124, 126–7, *128*, 131n17
Ming dynasty 34
miniatures 2, 18–19, 21, *22*–9, *24*, *25*
minimalism 69, 105
 post-minimalism 55–6
modernism:
 and architecture and design 145, 146–8, 154–6
 and communism 161
 and conceptual art 56, 59
 Epstein and 132, 136, 137
 and mass-production 148, 155, 156
 rejection of 155–6
 and serial production 136
Mondrian, Piet 70
Monet, Claude 136
money 16–17, 19n7, 75, 79, 124, 129–30, 131n22, 145, 150, 169
Morel, Catherine 15, 19, 73, 74–81
Morris, William 136
Moszynska, Anna 18, 158–71
Moulin, Félix Jacques-Antoine 98–100, *99*, 103n15
Munton, Alan 138–9, 142, 143n17, 143n35, 143n38
Murasaki Shikibu, *Tale of Genji 45*, 48–9, 50
museums 8–9, 10, 13–14, 21, 65, 73, 157n28, 169
My Secret Life (erotic memoir) 98

Nagamasa, Kuroda 86–7
Naumann, Bernd 166
Nazism 18, 160, 164–9, 170n8, 170–71n19-20
New Age, The (magazine) 135, 136, 137
'New Art History' 9
New York School 70
Newby Hall, Yorkshire 117, 123, 124, 126–9, *127*, *128*, 130
Newman, Barnett 70
Nikias (painter) 119

Nobuiye (armourer) 87
Nobunaga, Oda 90
Nogent 80
Nollekens, Joseph 123–4, 131n17

Oliver, Andrew 24, 25
Oliver, Peter 24
Osborne, Peter 60

Pacili, Pietro 122
paedophilia 15, 93, 101
Panofsky, Erwin 7
Paris 76–7, 79–80, 81
Paris/Alexandros 119
pastels 23, 24, 26, 28
Pater, Jean-Baptiste 78
Pedrini, Roberto 129
Pelham, Peter 23, 26
Perriand, Charlotte 152
Philadelphia 26
Philip, Duke of Orleans 76
photography 8, 11, 14, 53, 93, 98–100,
 101–3, 160, 161–2, 167, 170n17,
 171n21
 carte-de-visite 15, 73, *92*, 94–7, 101,
 102n3, 103n6-7
photorealism 162
Picasso 161
Pietà 159–60
Piscator, Erwin 166
Pliny the Elder 119
Polke, Sigmar 169
Pollock, Jackson 70
Pompadour, Madame de 45
Pop Art 155
porcelain 26
pornography 93, 98, 101, 103n11,
 103n14
post-minimalism 55–6
postmodernism 70, 111, 130
Pound, Ezra 134–7, 139, 142,
 142–3n3-8, 143n17
Praxiteles 118, 119, 123, 126
Preti, Mattia 70
'primitive art' 132, 138
Prince, Sarah (*later* Gill) 25
Prince, Thomas 25
printmaking 11, 13, 23, 26
Prown, Jules David 27, 29n1
punctum 11–12, 19n4

Qatar 129–30
Quinn, John 134–8, 141–2, 143n6,
 143n37

Rae, Fiona 65
Raphael 8, 10
Rauschenberg, Robert 162
reception (of artworks) 9, 18, 45–6,
 83, 130
Reed, David:
 No. 286-2 15, *20*, 21, *62*–71, *66, 67*
 #579 68–9
Reformation, the 8
Reitlinger, Gerald 165
Rejlander, Oscar 103n12
religion:
 Buddhism 84, 85, 87, 88
 Catholicism 8
 Christian typology 101, 110–111,
 159–60
 Islam 130
 Reformation 8
 Shintoism 84, 86
 Taoism 86
Rembrandt 8, 10, 136
Reni, Guido 71
reproduction, sexual 132, 142
restoration (of artworks) 8, 117, 122,
 124, 130, 131n14
Revere, Paul 25
Reynolds, Sir Joshua 7
 *Garrick between Tragedy and
 Comedy* 71
Richter, Gerhard 7, 18, 158–71
 18 Oktober, 1977 167, *168*, 170n17,
 171n35
 Atlas 162–3
 Horst mit Hund 163–4, 165, 167,
 170n15
 Onkel Rudi 163–4, 165, 167, 170n15,
 171n20
 Tante Marianne 114, 115, *158*–71
 Three Candles 169
Rietveld, Gerrit, *Red/Blue* chair 151,
 151, 157n18-9
Rigaud, Hyacinthe 75
Rivera, Diego 161
Roberts, Mary 26
Rockefeller, David 17
Rockefeller, John D. III 17
Rome, ancient 120–22, 130
Rothko, Mark 15–18
 Number I, 1949 17
 *White Center (Yellow, Pink and
 Lavender on Rose)* 15–*16, 17*
Rowell, Christopher 40n2
Ruskin, John 7

Sadamoto, Matsudaira 84, 88
Salisbury, Robert Cecil, 3rd Marquess
 of 100
Sanford, Mary 25
Saussure, Ferdinand de 56, 57–9
Schlemmer, Oscar *149*
Schoonhoven, Jan 68
Schreiber, Jürgen 159, 164, 165, 169,
 170n14-15, 170–71n19
Scollay, Deborah (*later* Melville) 26,
 27
Sebald, W.G. 160, 167, 169, 170n8
Second World War 156, 160, 161, 164,
 170n8
serial production (of artworks) 132–4,
 136
sexual reproduction 132, 142
sexuality:
 and children 15, 93, 98, 100–103
 and classical sculpture 118–20, 126
Shapiro, Joel 68
Shintoism 84, 86
Shroud of Turin 110, 113n2
Silber, Evelyn 142n1
Silvy, Camille *92*, 95–6, *97*, 101–2,
 102–3n3-8
Sirois, Pierre 75
Smart, John 27
Smibert, John 24
Smirke, Robert 124
social history 9–10
Socialist Realism 161
Sognot, Louise 157n21
Song Di 48
Sotheby's Institute of Art 9–10, 19, 83
speed 21
Spence, John Allison 103n12
Stalker, John and Parker, George,
 *A Treatise of Japanning and
 Varnishing* 36, 40, 41n13
Stam, Mart 154
Staniszewski, Mary Anne 59
state apartments 31–3, 41n4
Stead, William 100–101
Storr, Robert 170n12, 171n20
Stourton, James 7
Strange, Edward F. 50
structuralism 56, 57, 59
Studio Alchymia 155–6
sudaria 110–111, 113n2

Tadakatsu, Honda 87
Tale of Genji (Murasaki Shikibu) *45*,
 48–9, 50

Tan, Eugene 15, 19, 21, 52–61
Taoism 86
taxonomy 8–9
television 9, 113
Teniers, David the Younger 81n4
Tetrode, William Danielsz van *117*
theory 9–10, 84
Theus, Jeremiah 26
Thomson, John 103n12
Tollemache, Sir Lionel 31
tubular steel 145–6, 147–8, 152–4,
 155, 157n7, 157n19, 157n21
turquerie 28
Twombly, Cy 70

Uecker, Gunther 68

values, monetary (of artworks)
 16–17, 19n7, 75, 80–81, 124,
 129–30, 131n22, 145, 150, 169
vanitas 107–8
Vasari, Giorgio 7
Venus/Aphrodite 118–22, 132, 136,
 142
Vere, Bernard 18, 115, 132–43
Veronica, St 110–111
Vespasian, Roman Emperor *117*

Warhol, Andy 136, 162
Wassily chair (Breuer) 115, *144*–57,
 149, 155
Watsky, Andrew 91n1
Watteau, Jean-Antoine 7, 19n7
 A L'Enseigne de Gersaint 15, 19, 73,
 74–81
 Pilgrimage to Cythera 78–9
Weddell, William 117, 123–4, *125*,
 126, 131n15, 131n17
Weiss, Peter 166–7, 171n30, 171n32
West, Benjamin 26
Wilde, Oscar 135, 137
Winckelmann, Johann Joachim 7,
 123, 124, 126
Withe, J.T. 103n12
Wittgenstein, Ludwig 55, 56, 57, 59,
 61n14-15
Wood, Paul 54
Worringer, Wilhelm 138

Yoshimichi (armourer) 85, 87
Yoshitsune, Minamoto 87

Zen Buddhism 84, 88